Celebrating

ATLANTIC CANADA

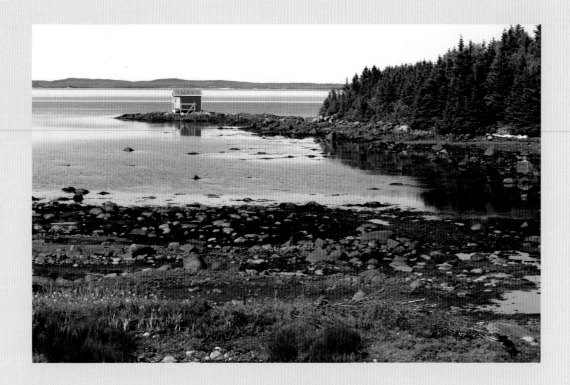

JACK CHIANG

Introduction by Frank McKenna

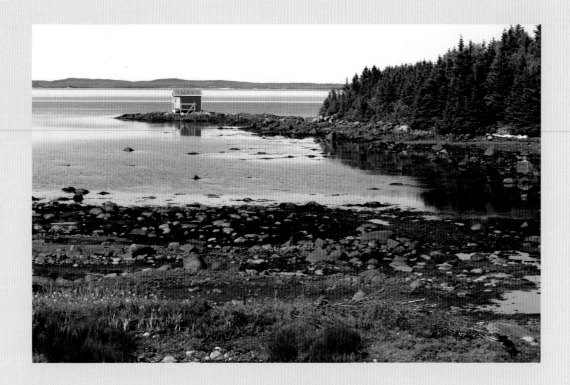

Fitzhenry & Whiteside

Celebrating Atlantic Canada
Copyright © 2006 Jack Chiang

Fitzhenry and Whiteside Limited
195 Allstate Parkway
Markham, Ontario L3R 4T8

In the United States:
311 Washington Street,
Brighton, Massachusetts 02135

www.fitzhenry.ca godwit@fitzhenry.ca

Fitzhenry & Whiteside acknowledges with thanks the Canada Council for the Arts, and the Ontario Arts Council for their support of our publishing program. We acknowledge the financial support of the Government of Canada through the Book Publishing Industry Development Program (BPIDP) for our publishing activities.

 Canada Council for the Arts Conseil des Arts du Canada ONTARIO ARTS COUNCIL CONSEIL DES ARTS DE L'ONTARIO

Library and Archives Canada Cataloguing in Publication
Chiang, Jack
Celebrating Atlantic Canada / Jack Chiang.
ISBN 1-55041-347-3
1. Atlantic Provinces—Pictorial works. I. Title.
FC2004.C44 2006 971.5'0022'2 C2005-907743-3

United States Cataloguing-in-Publication Data
Chiang, Jack.
Celebrating Atlantic Canada / Jack Chiang.
[176] p. : col. photos. ; cm.
Summary: A photographic journey through Atlantic Canada.
ISBN 1-55041-347-3
1. Maritime Provinces – Pictorial works. I. Title.
912.714 dc22 G1120.C55Ce 2006

Cover and interior design by Darrell McCalla

1 3 5 7 9 10 8 6 4 2

Printed in Hong Kong

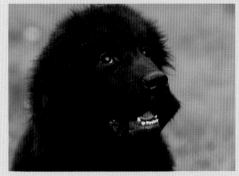

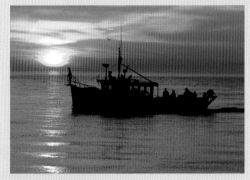

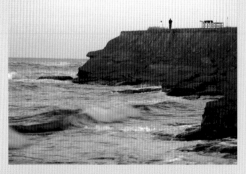

CONTENTS

Introduction

"A man travels the world over in search of what he needs and returns home to find it."
— **George Moore, Irish writer**

THERE IS SOMETHING about Moore's words that Atlantic Canadians understand intuitively. Although so many of us ventured "down the road" by chance or choice in search of the good life, we always feel this abiding attachment to the East Coast, a constant pull that inevitably brings us back to this special corner of the earth.

Over the years, I've been fortunate that my work has taken me to some of the most scenic and captivating places in Atlantic Canada. Many of them are brilliantly captured in this book.

These pages celebrate Atlantic Canada as a land of endless beauty. From Labrador's rugged wilderness to Halifax's star-shaped Citadel; the breathtaking vistas of the Cabot Trail and the tidal wonders of the Bay of Fundy; from the spectacle of Hopewell Rocks to Prince Edward Island's rich red soil and spectacular seascapes.

Visitors to the region delight in discovering serene surroundings we often take for granted: lush, rolling hills and blueberry fields, covered bridges and century-old lighthouses, potato fields and apple orchards in full blossom, and vast expanses of forest ablaze in autumn colour.

Atlantic Canada is also a land of charm with striking dialects, enchanting rhythms, brightly coloured homes and sky-scraping church spires. A place that values family and community above all, and where many still live by the seasons rather than by the clock. And where men and women in outports have braved rough seas and harsh winters for generations, much like their original Aboriginal inhabitants.

It's defined by sleepy towns, charming villages and thriving cities. A place for lovers of quiet valleys and old-fashioned air. A destination for gourmets to indulge in our seafood specialties and sun-seekers who arrive every summer.

Atlantic Canada is also a land that dazzles with its diversity, from the cold blur of a winter blizzard to the warm sand of our tranquil beaches. A place of small provinces with great ambitions, rich in energy and traditional resources but increasingly embracing the new economy.

Where else can you enjoy world-class whale-watching and observe giant icebergs 10,000 years in the making in the same afternoon? What region can boast some of the best salmon rivers in the world, the only Viking settlement in North America and the longest bridge in all of Canada?

For me, *Celebrating Atlantic Canada* conjures simple yet treasured memories. It was the spectacle of wildflowers carpeting the meadows around the family farm. It was the familiar sight of anchored sail boats and quiet piers along the Northumberland Coast. Being swept away in Acadian *joie de vivre* and captivating fiddle jigs. It was a delightful afternoon, punctuated only by crashing waves, chasing grandchildren on the corrugated sand bars that hug Cap-Pelé's coastline. Memories of a sunrise over the wind-swept site of Signal Hill and a sunset overlooking Peggy's Cove.

Atlantic Canada is all that and so much more. In this remarkable collection, Jack Chiang demonstrates yet again his unique talent for capturing our country's rich tapestry.

Celebrating Atlantic Canada guides the reader through a memorable visual journey from the shoreline to the valleys. It is a marvellously evocative portrait in pictures that beautifully captures the very best of the region I call home.

Frank McKenna,
Canada's former Ambassador to the United States. He served as Premier of New Brunswick from 1987 to 1997.

THIS BOOK
IS DEDICATED TO
VERONIQUE AND DR. GREG PATEY
MARY AND FRED LAFLAMME
JOAN AND MR. JUSTICE DOUG BELCH

Celebrating
NOVA SCOTIA

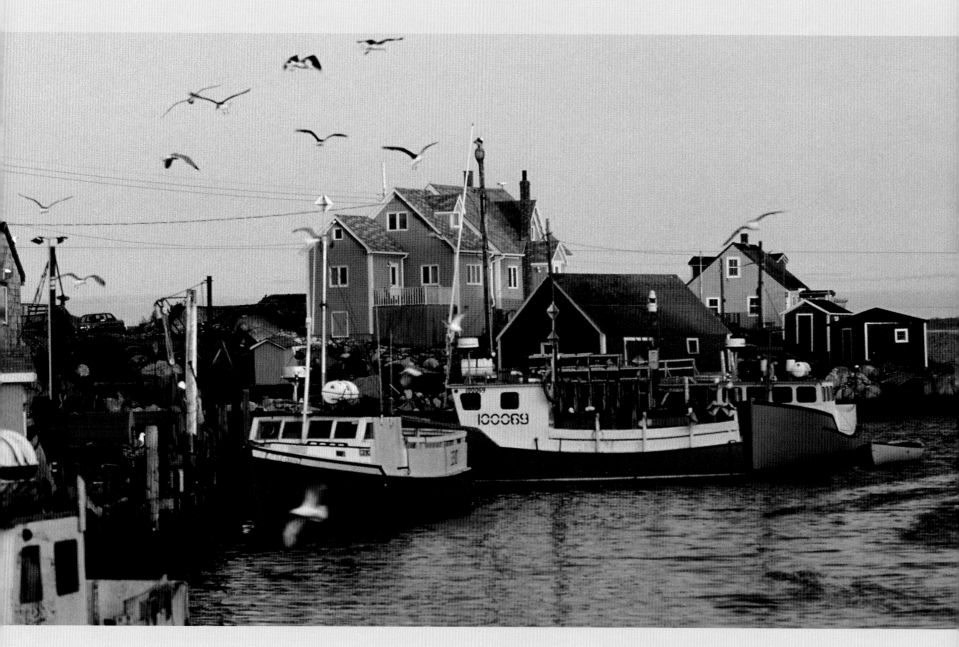

Picture-perfect Peggy's Cove, 43 kilometres west of Halifax,
is Canada's most photographed fishing village.

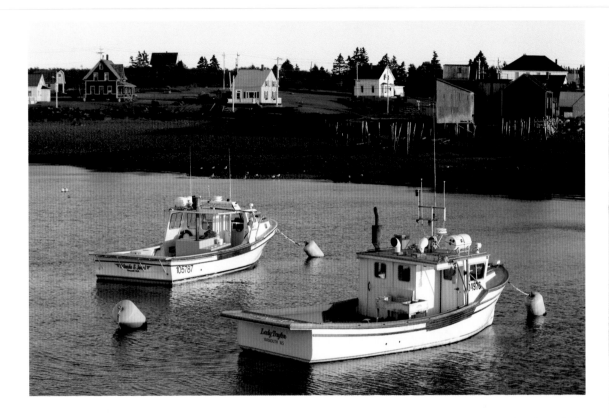

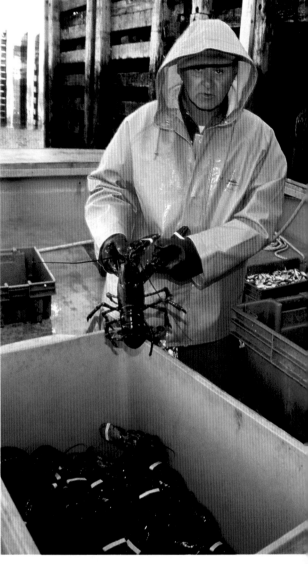

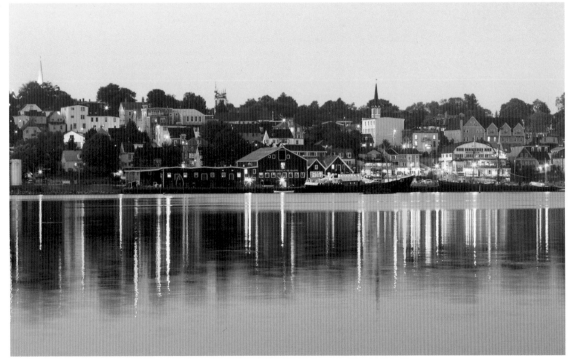

Above: Digby has the world's largest scallop fleet but some, like this fisherman, catch lobsters.

Top left: Freeport is at the western tip of Long Island — a narrow, scenic strip of land west of Digby.

Left: Lunenburg, a well-preserved shipbuilding town of 2,800 people, is a UNESCO-designated World Heritage Site.

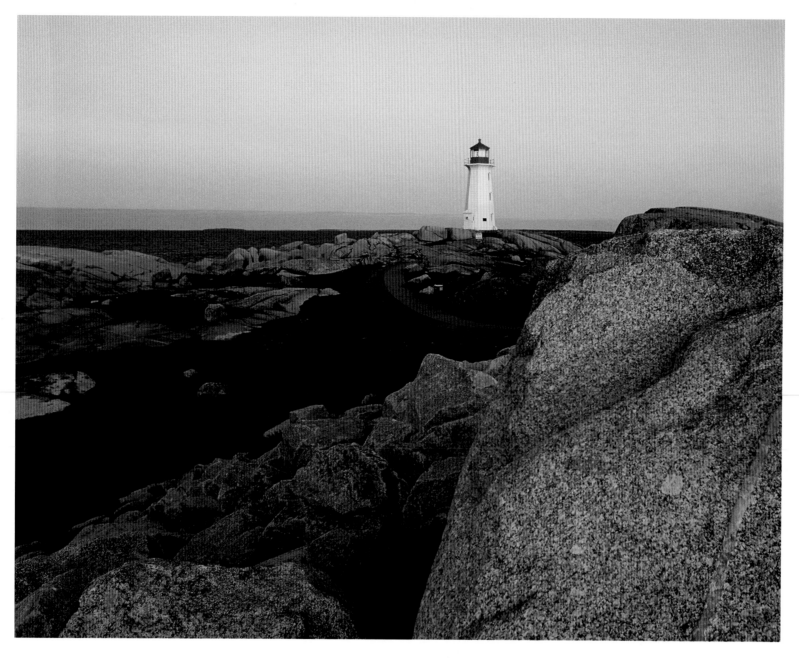

Four-hundred-million-year-old granite boulders complement the lighthouse at Peggy's Cove, which is a post office during the summer.

Overleaf pages 4 and 5: Mahone Bay, 100 kilometres west of Halifax, is a popular tourist destination famous for its gingerbread houses and antique and craft shops.

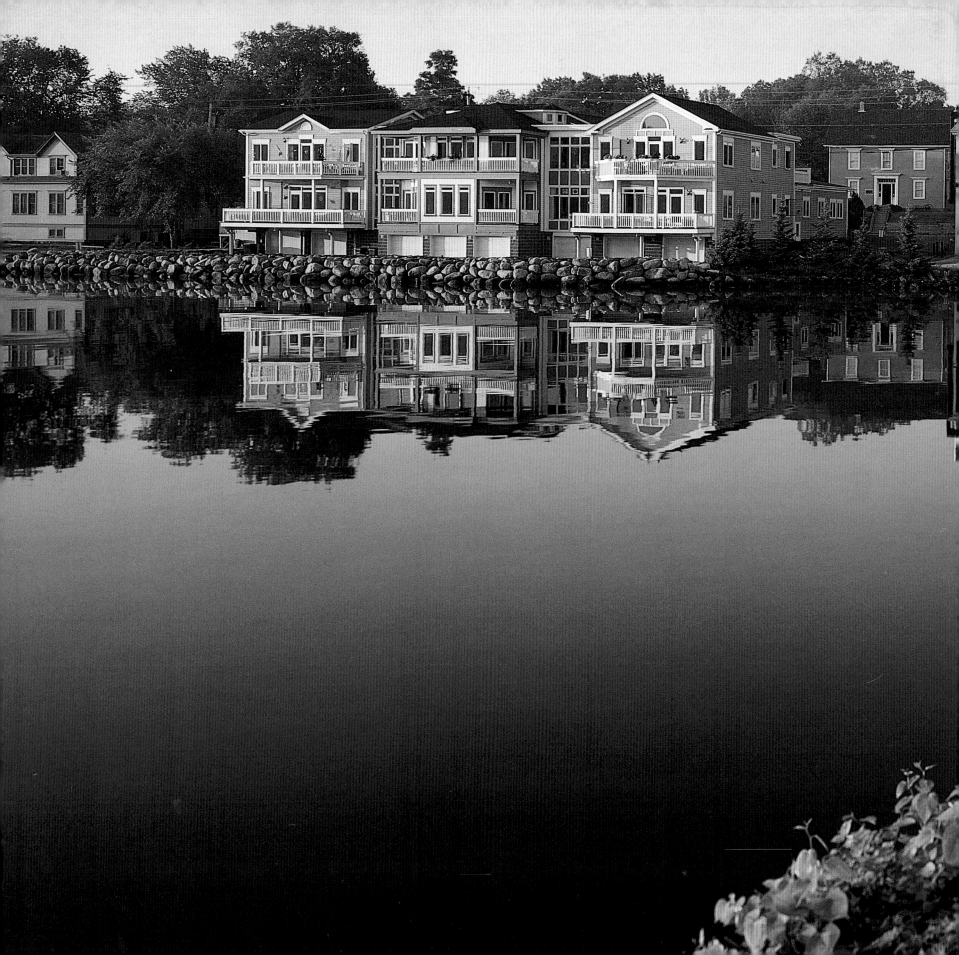

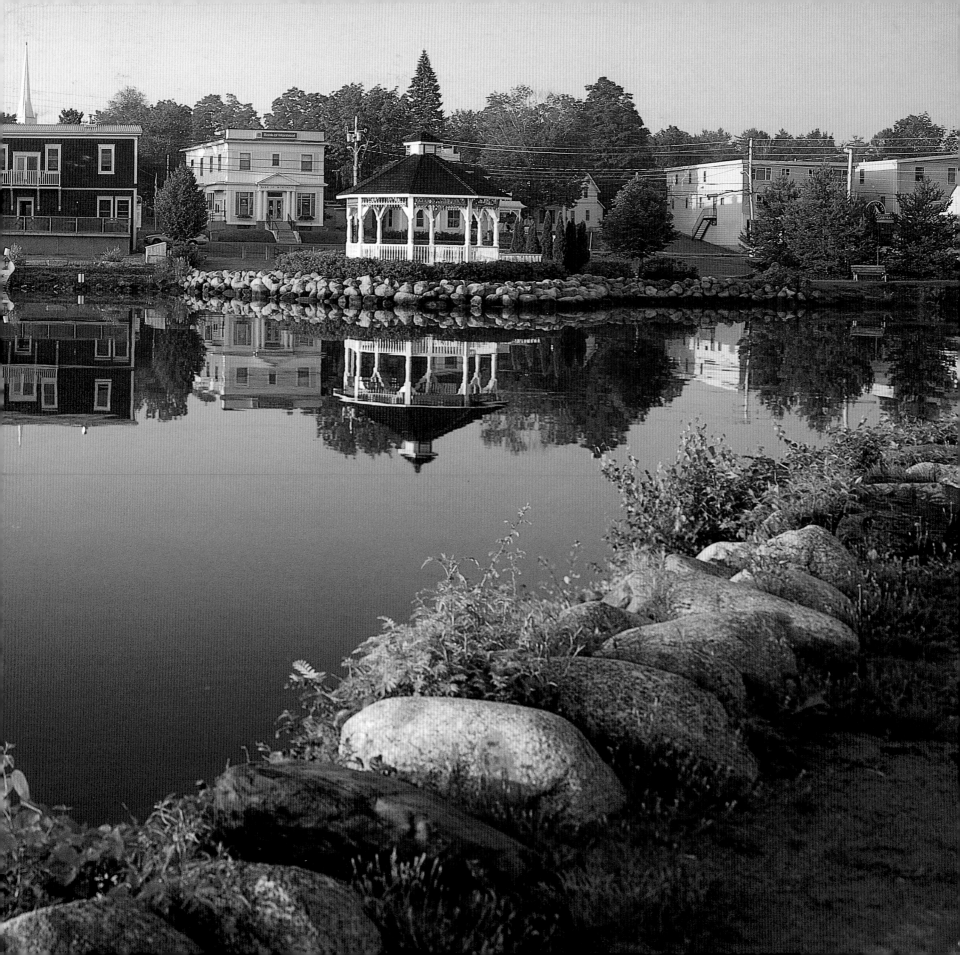

Blowing in the wind: this resident at Westport, on Brier Island, knows the most energy-efficent way to dry his laundry.

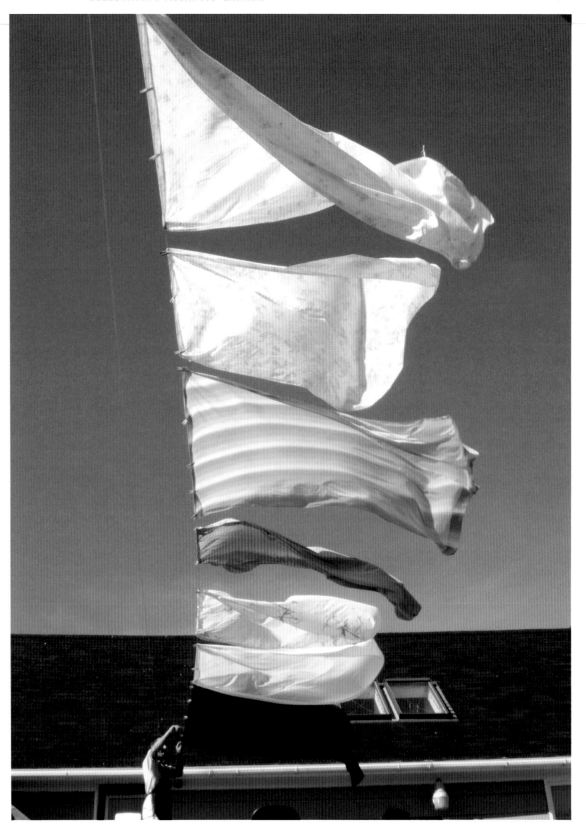

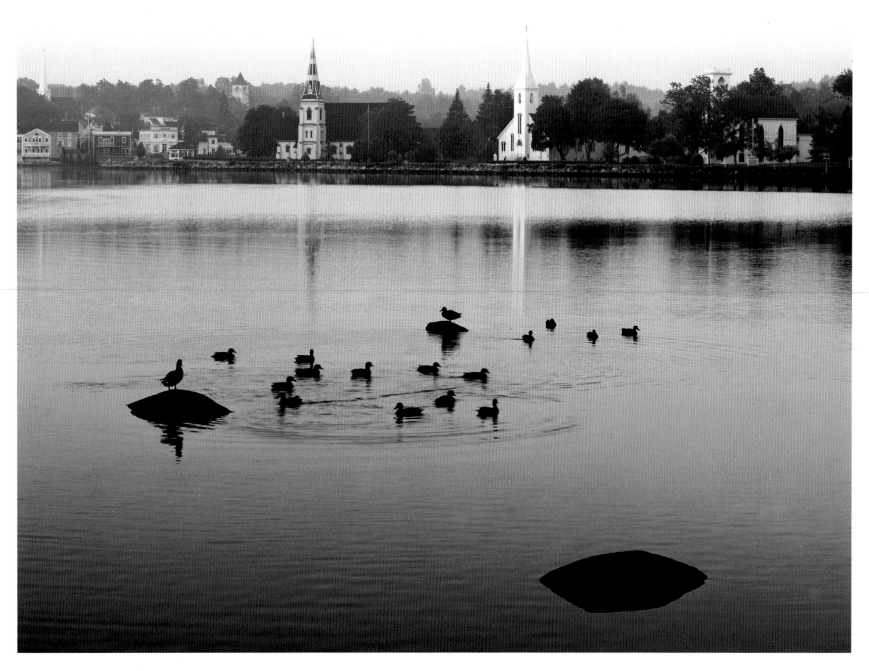

These 19th-century pointed church spires are the
signatures of Mahone Bay, a tourist town of 1,100 people.

A Coast Guard ship patrols the waters off
Brier Island in western Nova Scotia.

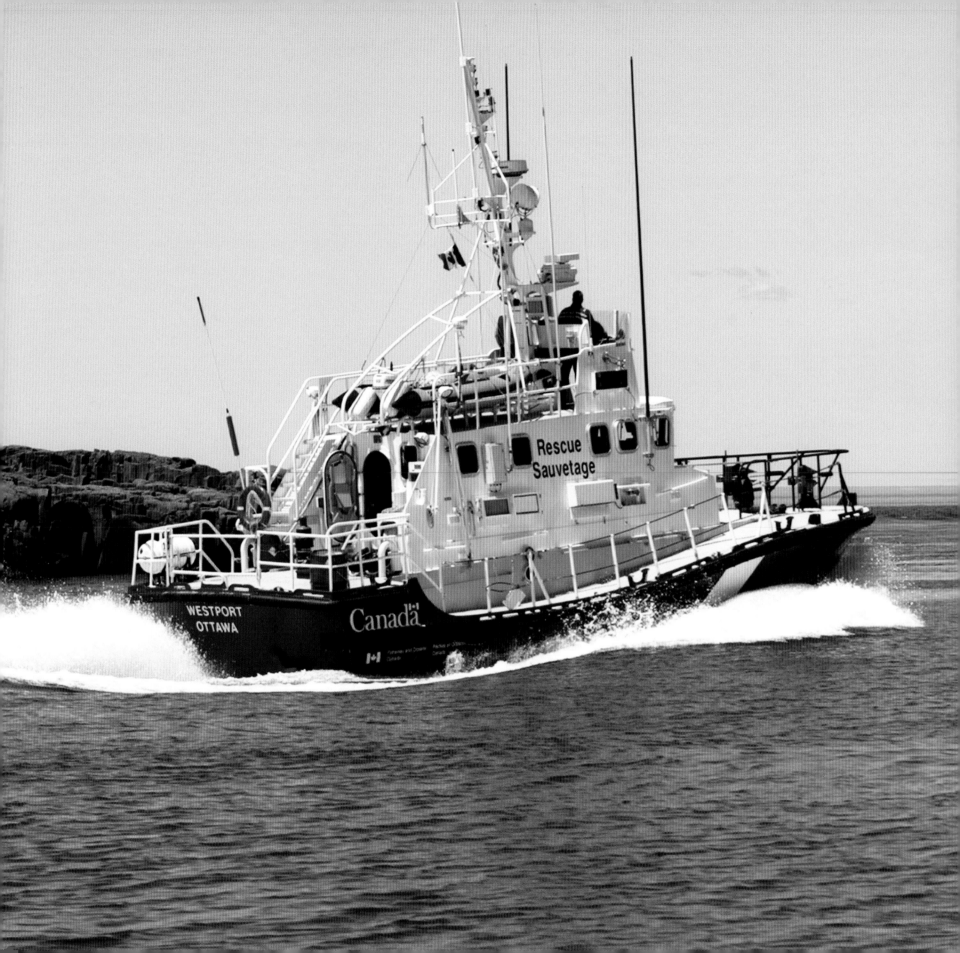

Digby, situated at the Bay of Fundy, experiences an average tidal range of about eight metres (26.4 feet).

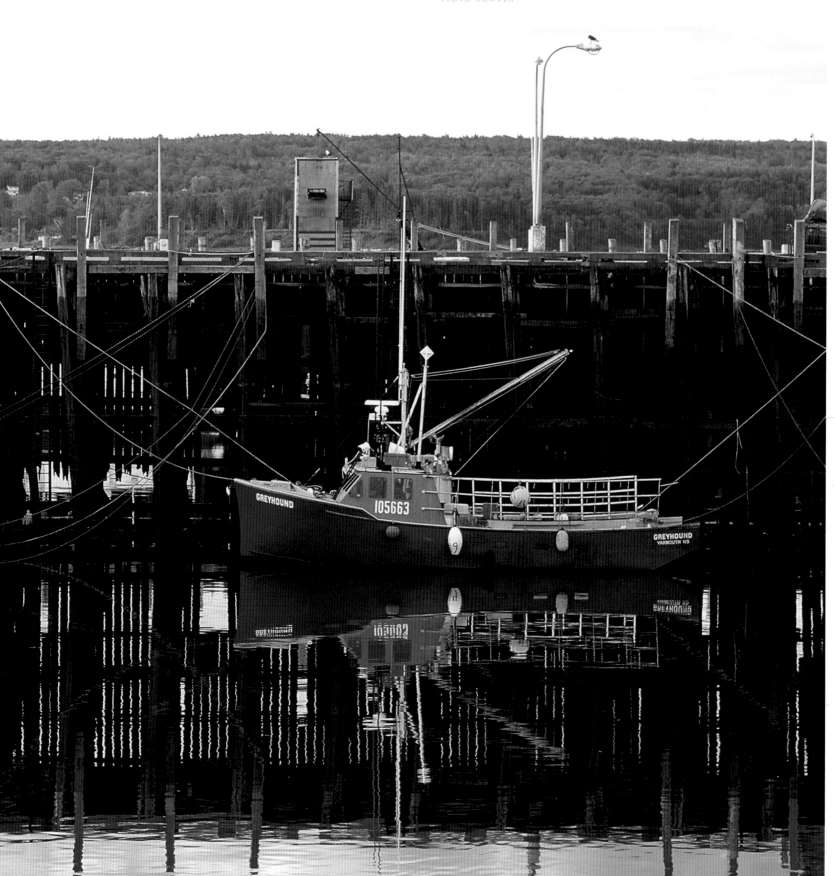

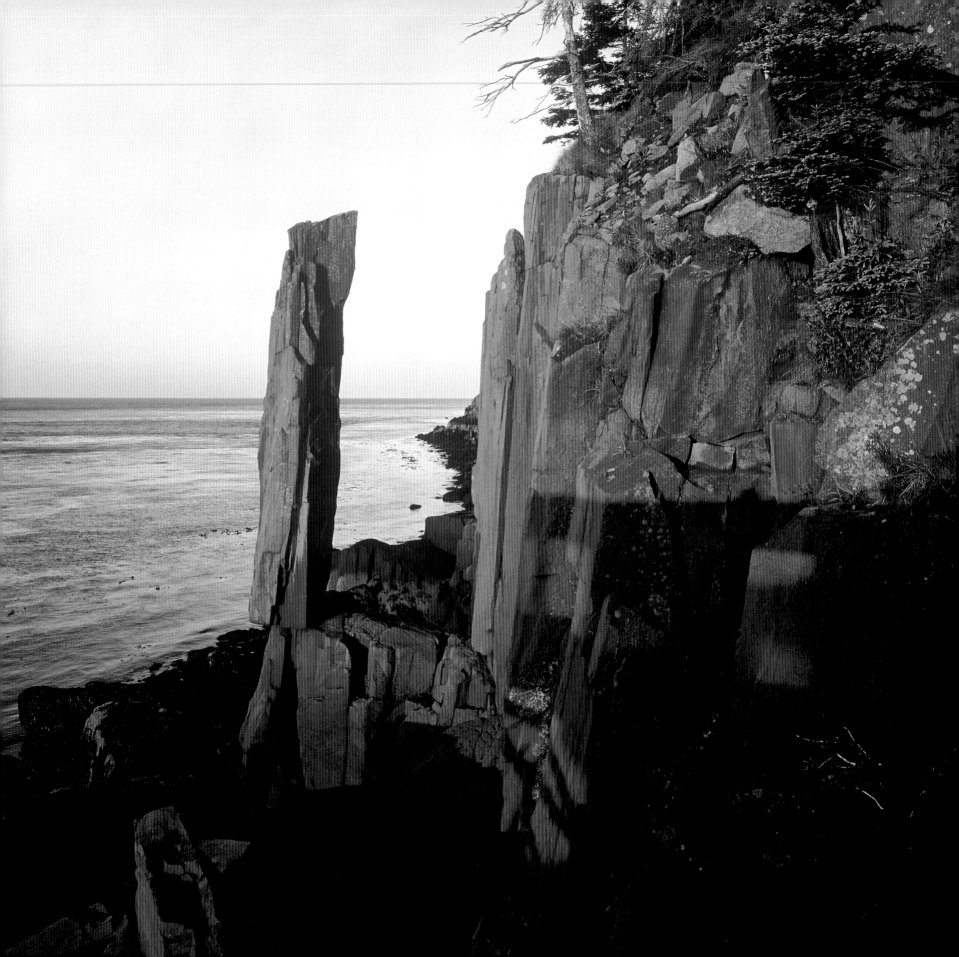

Left: The Balancing Rock at Tiverton is a geological wonder: a seven-metre basalt rock that sits precariously at the ledge over the shore.

Kejimkujik National Park is 381 square kilometres of pristine wilderness located in the interior of western Nova Scotia.

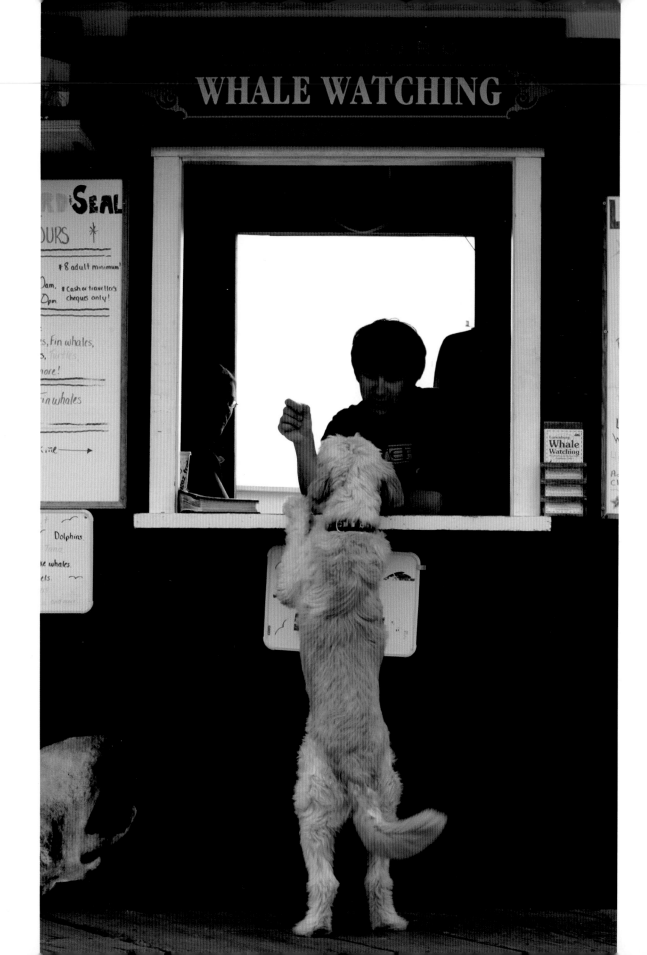

Everybody knows Lunenburg,
a historic shipbuilding town,
is a great place for whale-watching.

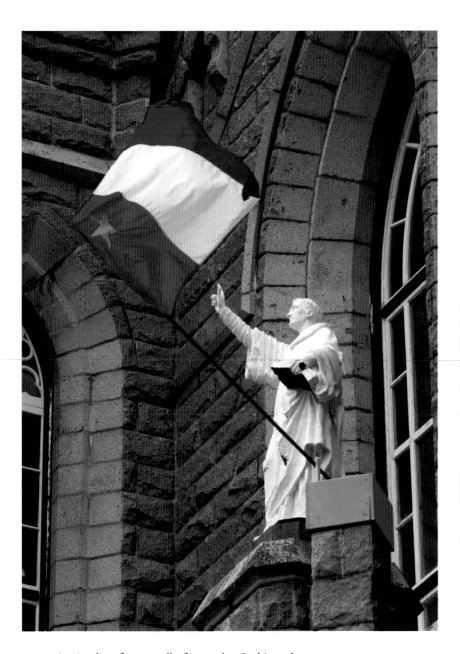

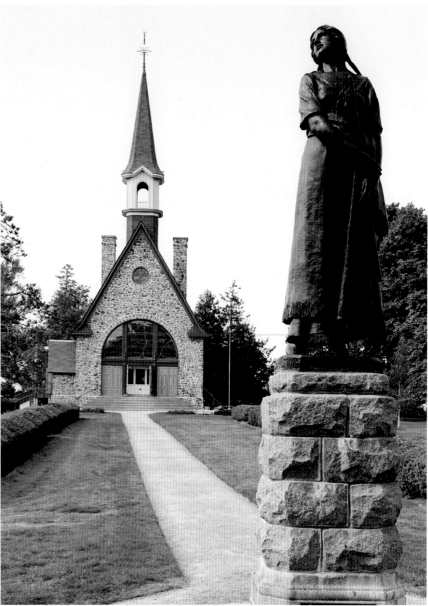

An Acadian flag proudly flies at the Gothic-style St. Bernard Church, which took 32 years to build — from 1910 through 1942.

The statue of Evangeline, the fictional heroine in Longfellow's poem, stands tall in front of the Commemorative Church at Grand Pré, once the largest Acadian settlement before the 1755 Deportation.

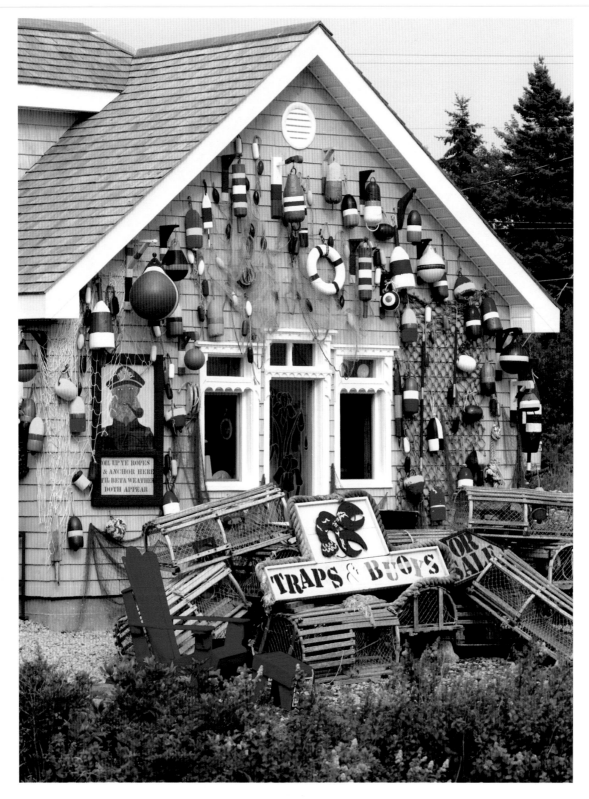

The seafaring heritage of Nova Scotia is on display
at this house in Blue Rocks, just east of Lunenburg.

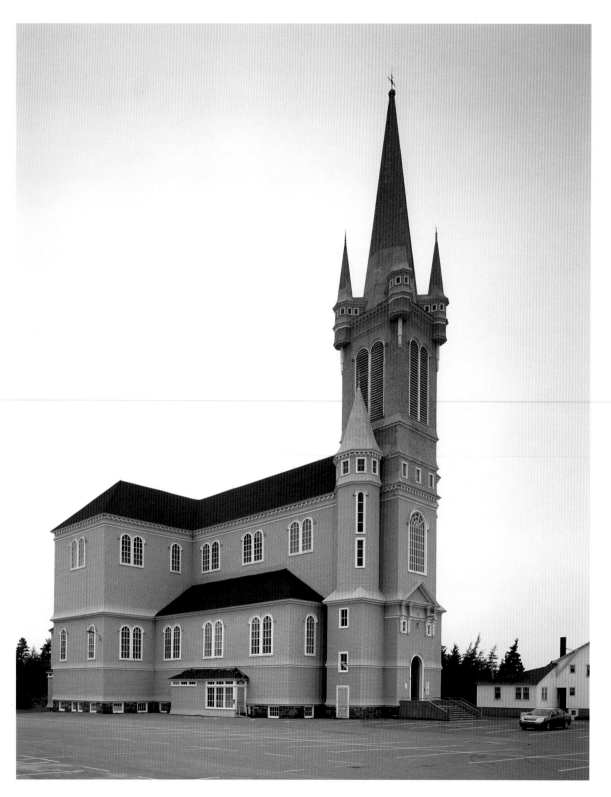

The spire of St. Mary's Church at Church Point rises to
56 metres (185 feet). It was built between 1903 and 1905.

This Swissair Memorial
near Peggy's Cove
commemorates the
229 people who died
aboard a Swissair jetliner
that crashed off the coast
on September 2, 1998.

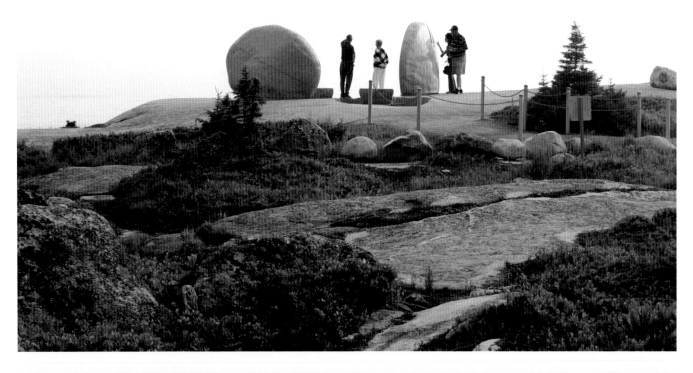

Sea caves like this are
the key attraction at
Ovens Natural Park,
just south of Lunenburg.

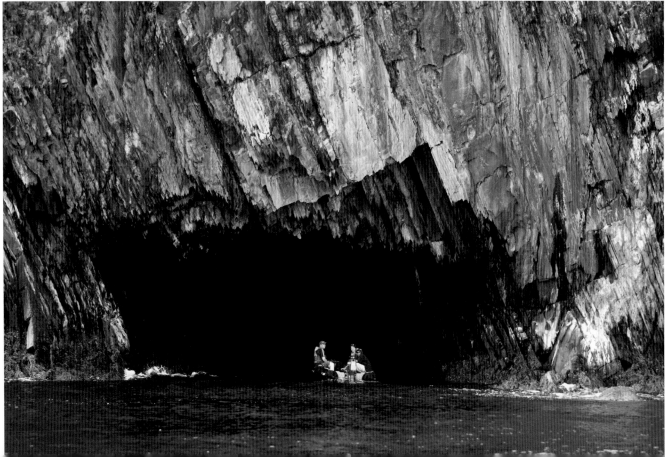

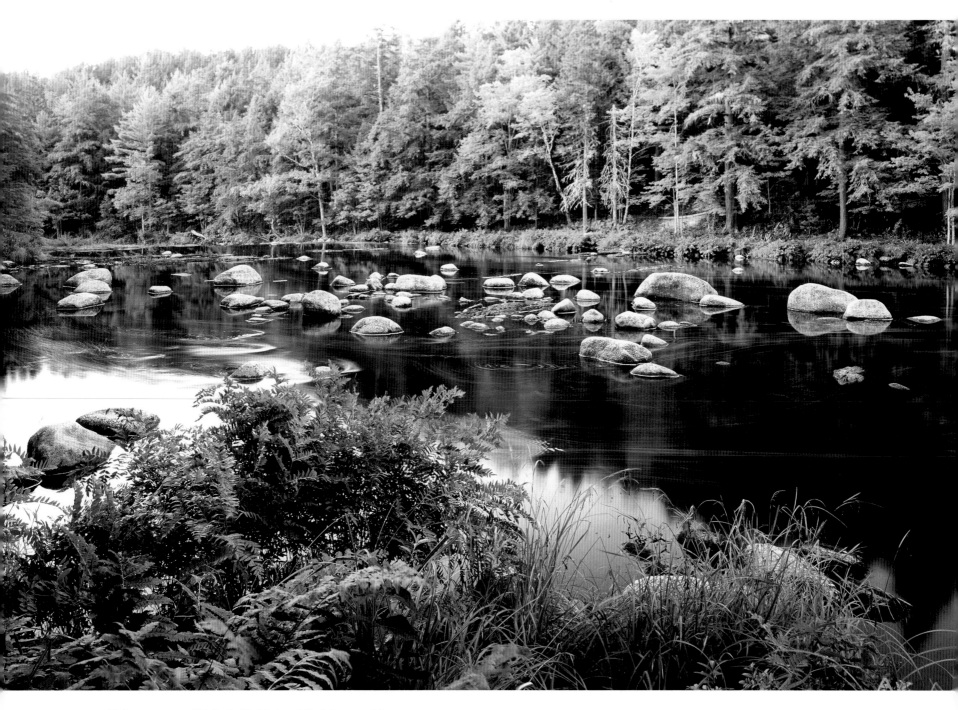

Eighty percent of Kejimkujik National Park is accessible
only by foot or canoe. The 381-square-kilometre park is
located in the interior of western Nova Scotia.

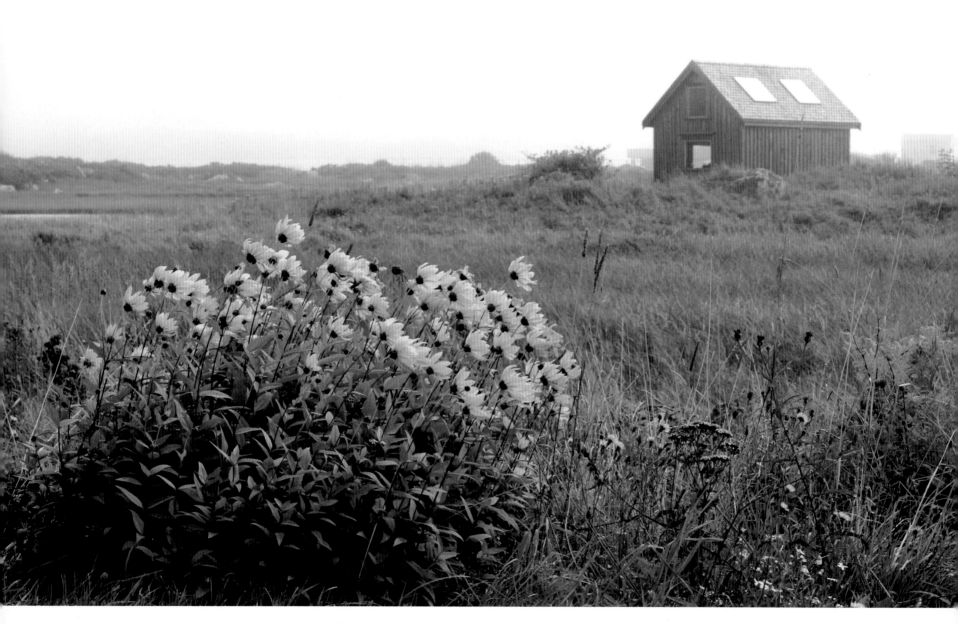

Even in the rain, Prospect, located some 30 kilometres
southwest of Halifax, is a scenic spot.

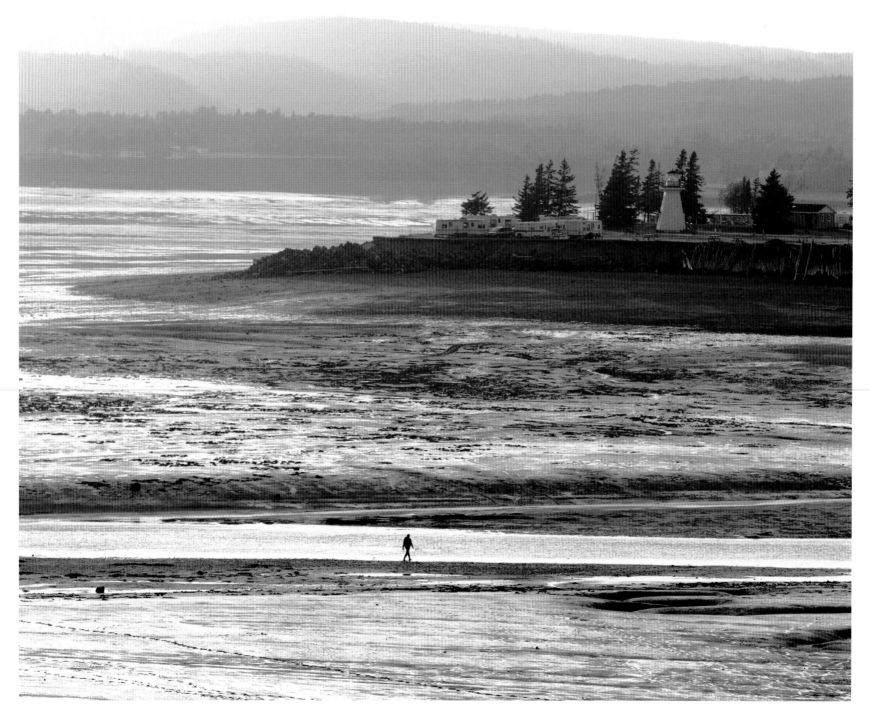

At low tide, the tidal flats at Five Islands Provincial Park
is good for clam-digging — or walking.

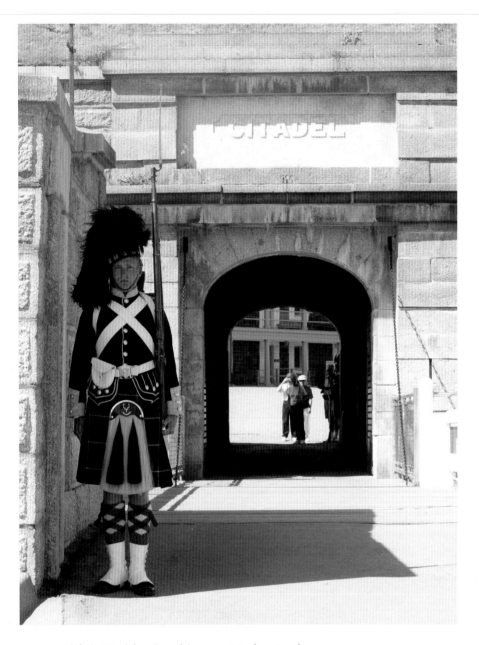

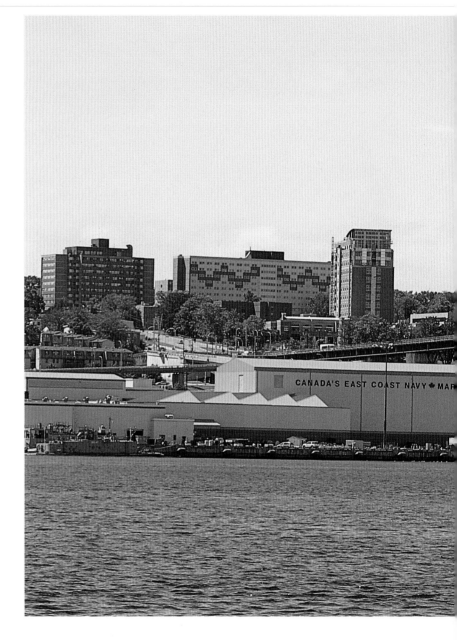

Halifax's Citadel is Canada's most visited national historic site. During the summer, costumed re-enactors demonstrate 19th-century military drills.

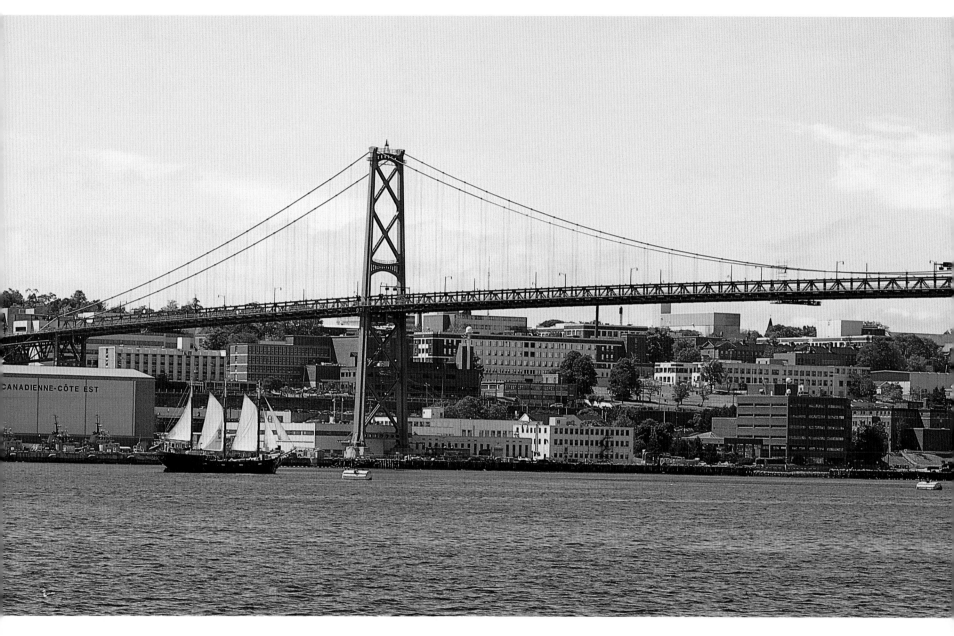

The Macdonald Bridge connects Halifax and its sister city, Dartmouth.
The command centre of Canada's East Coast Navy is at left.

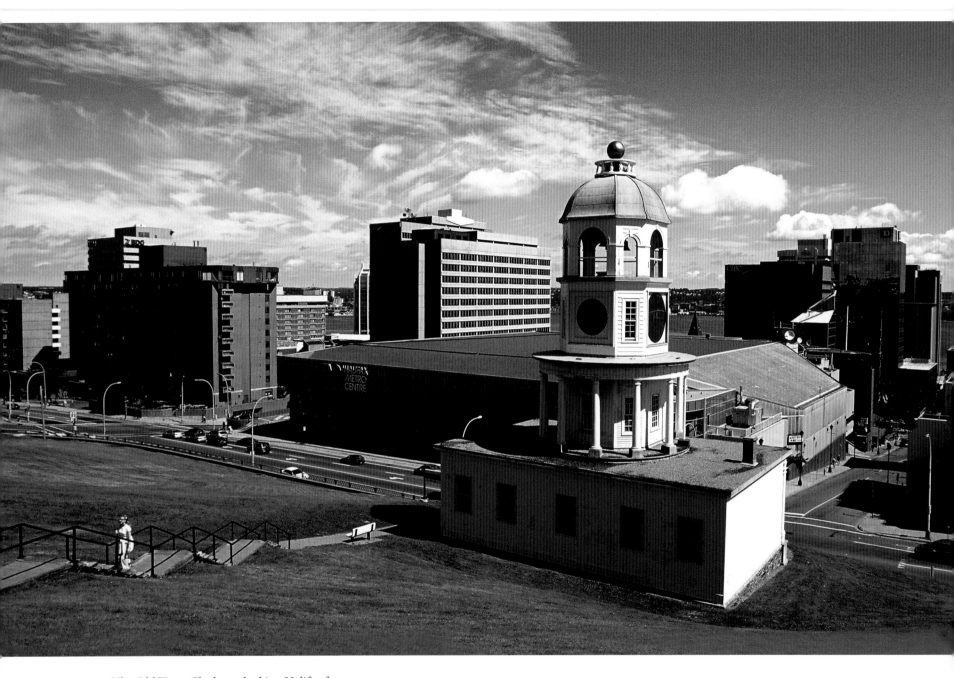

The Old Town Clock overlooking Halifax from
Citadel Hill was completed in 1803.

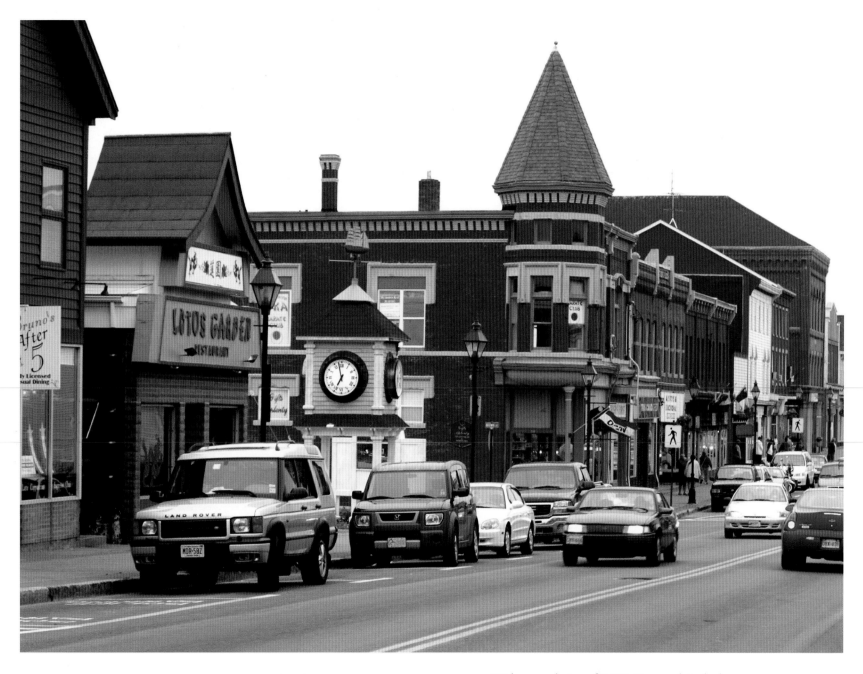

With a population of 8,000, Yarmouth is the largest town
and the largest seaport in western Nova Scotia. Its downtown
is lined with many historic 19th-century buildings.

Le Village Historique Acadien and La Musée Acadien in West Pubnico celebrate the area's rich Acadian heritage.

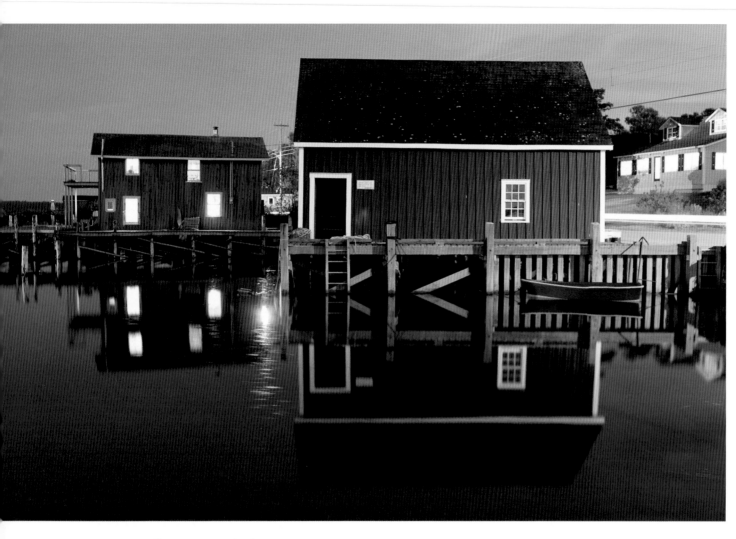

Westport village on Brier Island is a
popular destination for whale-watching.

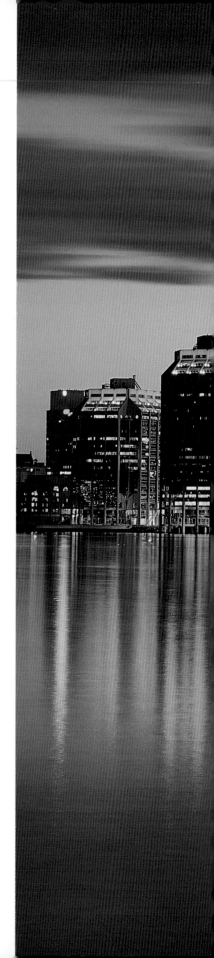

Right: Halifax, with a population of more than 110,000, is the
capital of Nova Scotia. It has the busiest port in Atlantic Canada.

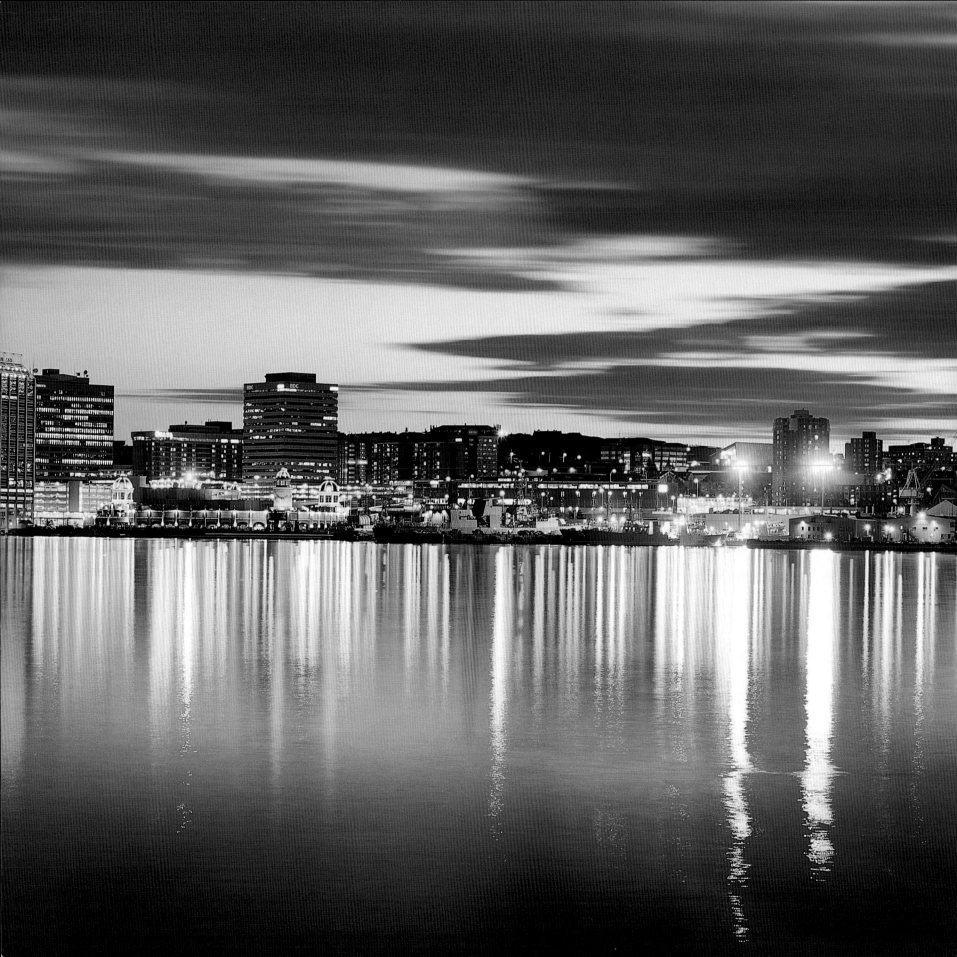

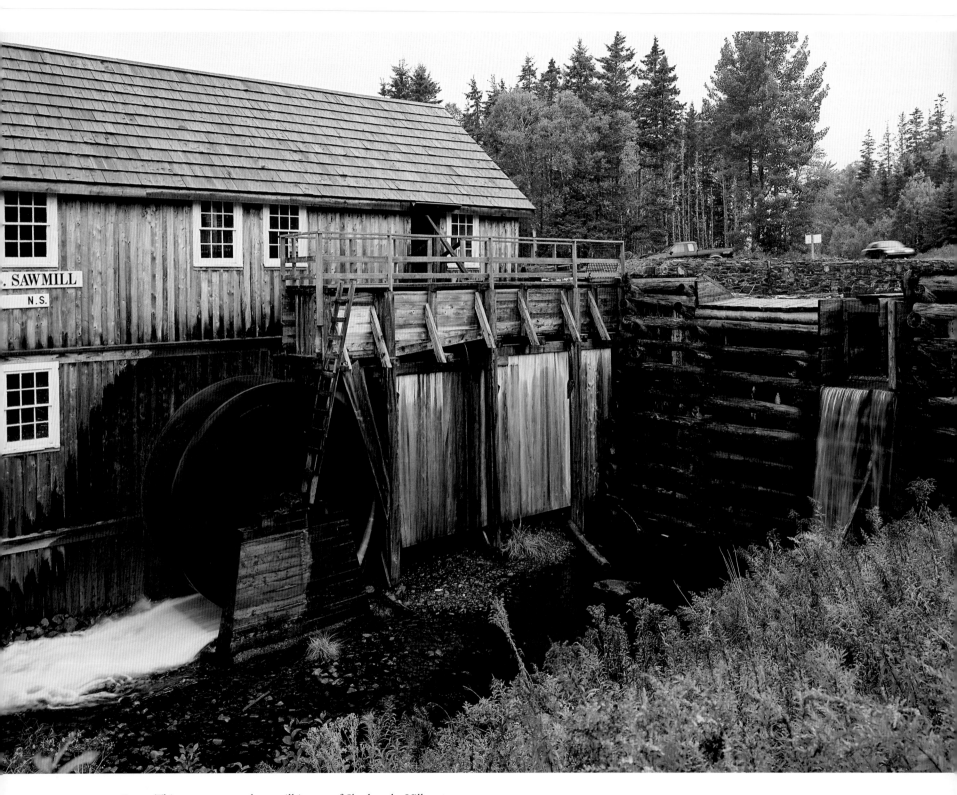

Above: This water-powered sawmill is part of Sherbrooke Village in Sherbrooke, which features more than two dozen refurbished buildings from the gold-mining days in the mid-1800s.

Right: The south shore of Nova Scotia does not attract a lot of tourists, but its scenery is no less attractive than in the rest of the province.

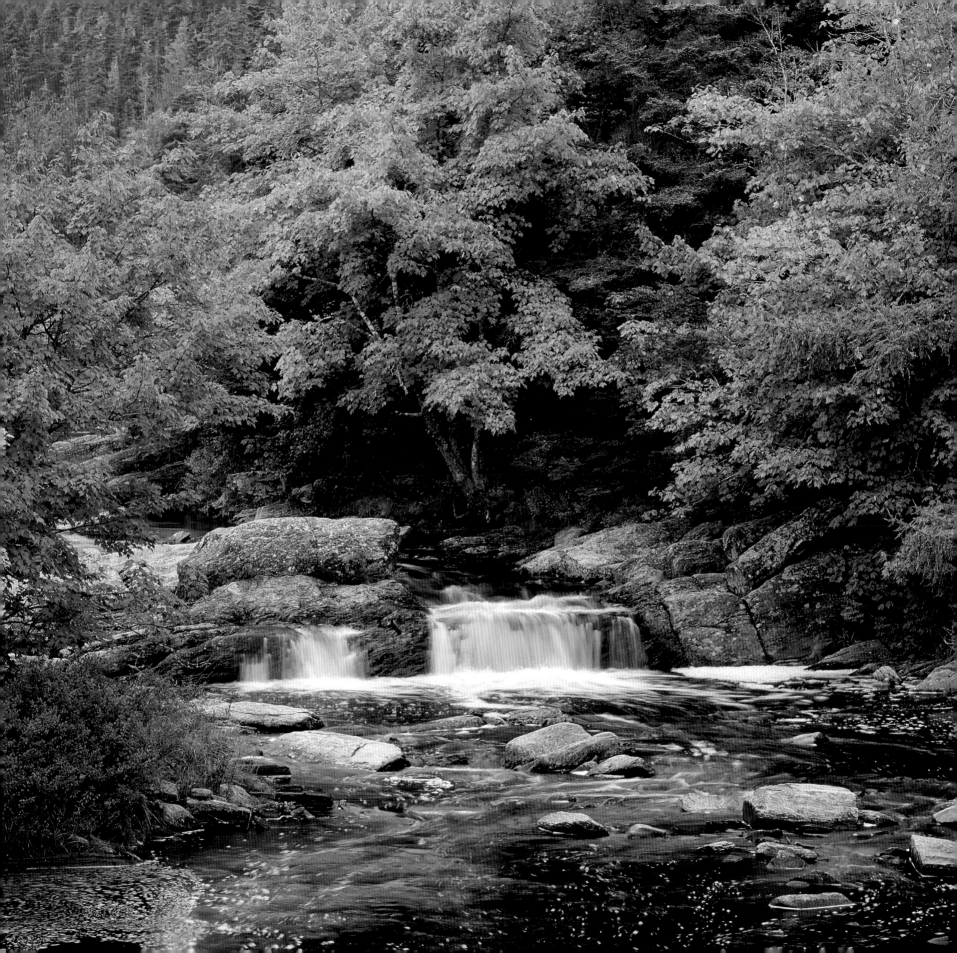

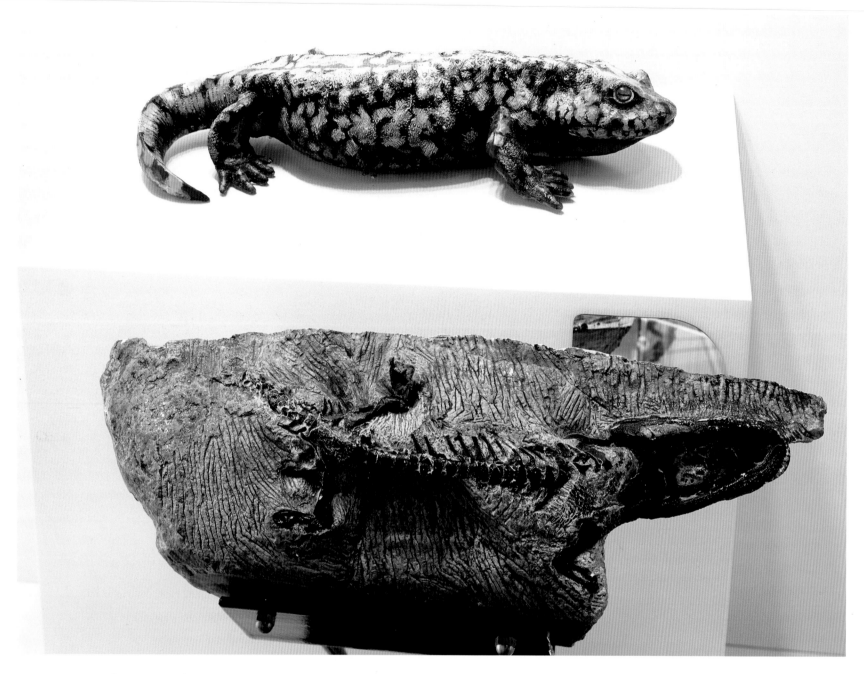

A 300-million-year-old fossil skeleton of an amphibian called
Dendrerpeton is on display at the Fundy Geological Museum,
part of the Nova Scotia Museum. Since the 1970s, more than
100,000 fossilized bones have been found in the Parrsboro area.

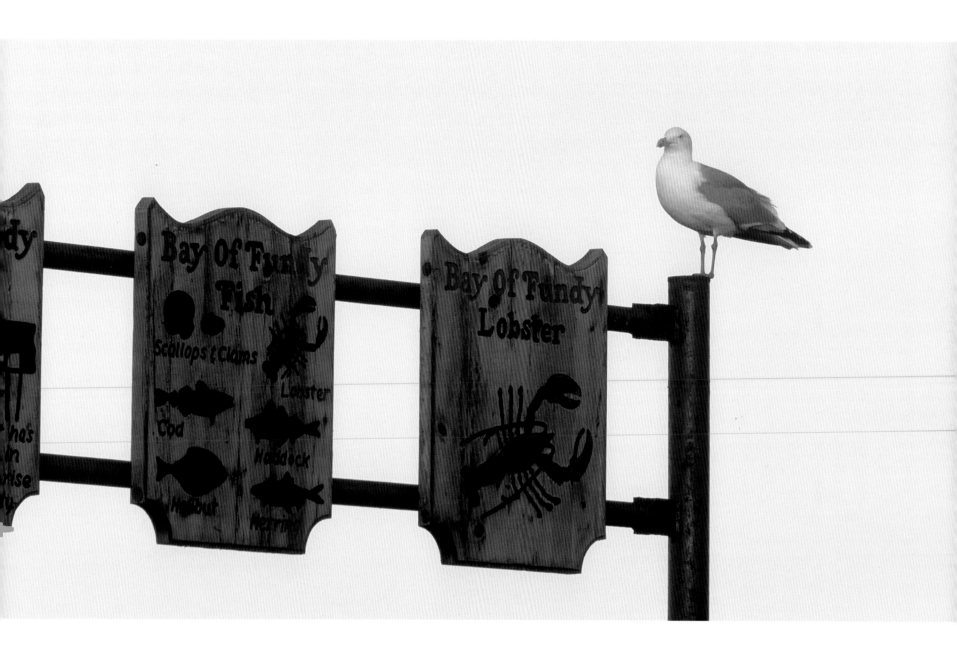

A seagull takes a break at a sign post in Pictou in eastern Nova Scotia.

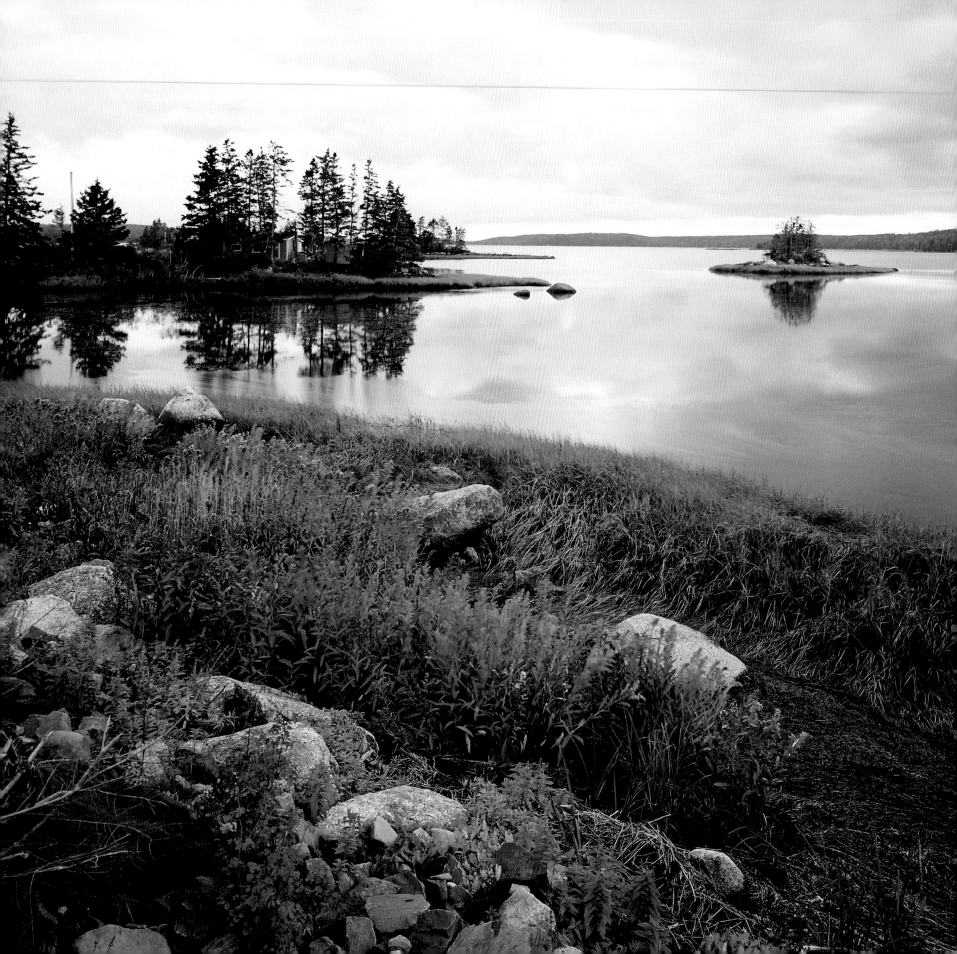

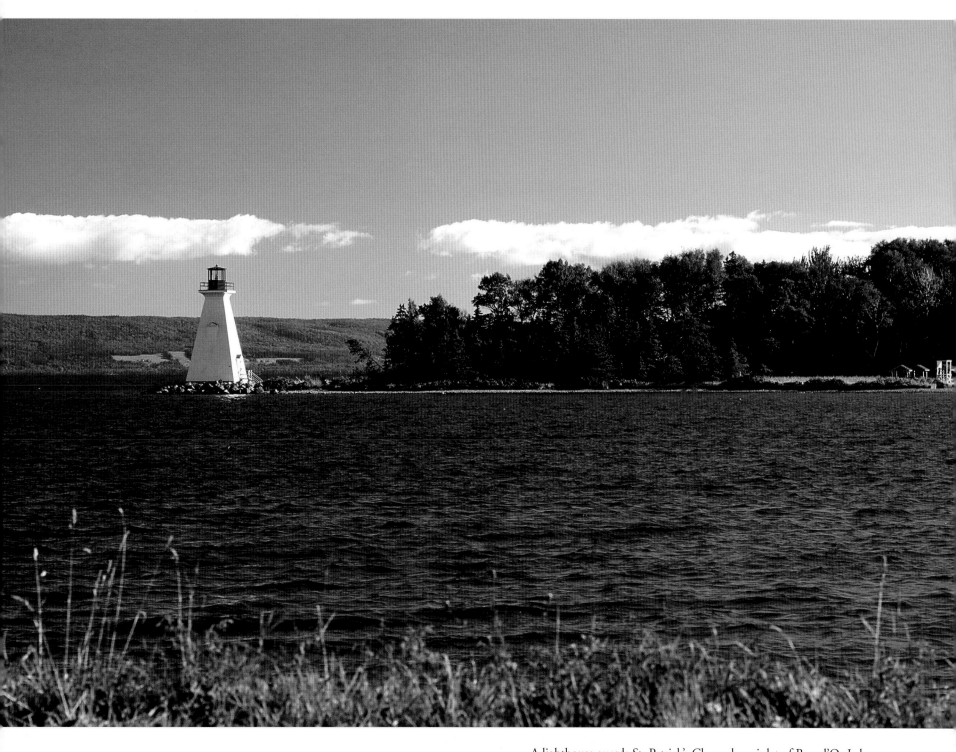

A lighthouse guards St. Patrick's Channel, an inlet of Bras d'Or Lakes. This view is from the Alexander Graham Bell National Historic Site at Baddeck. Bell did numerous experiments in the area.

Left: Such a tranquil scene is common along the south shore between Dartmouth and Canso.

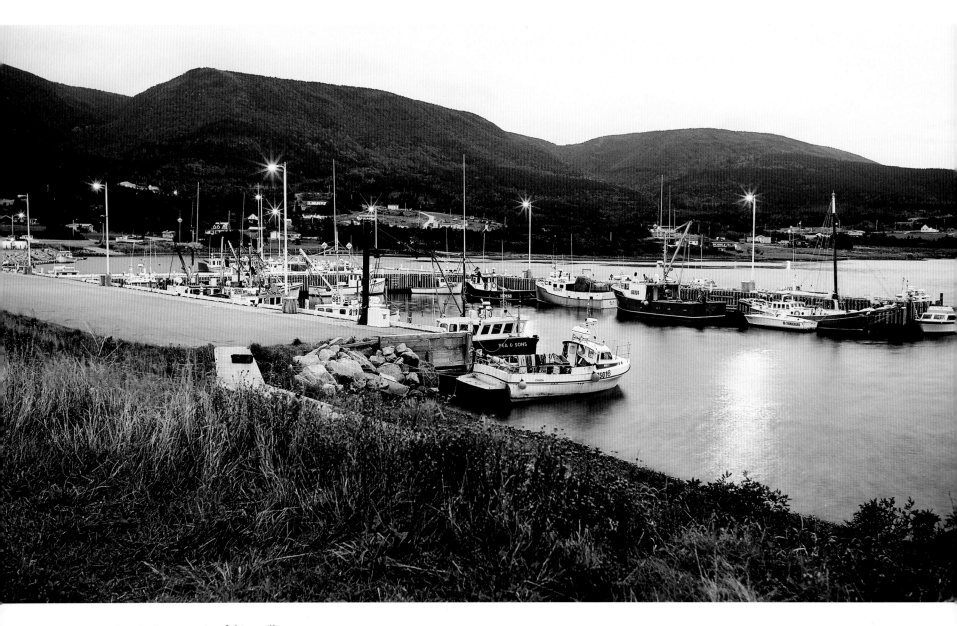

Bay St. Lawrence is a fishing village
just south of Cape North, the northern tip
of Cape Breton.

Right: Boats jam the harbour at Chéticamp,
an Acadian fishing village and a tourist centre
five kilometres south of Cape Breton Highlands
National Park.

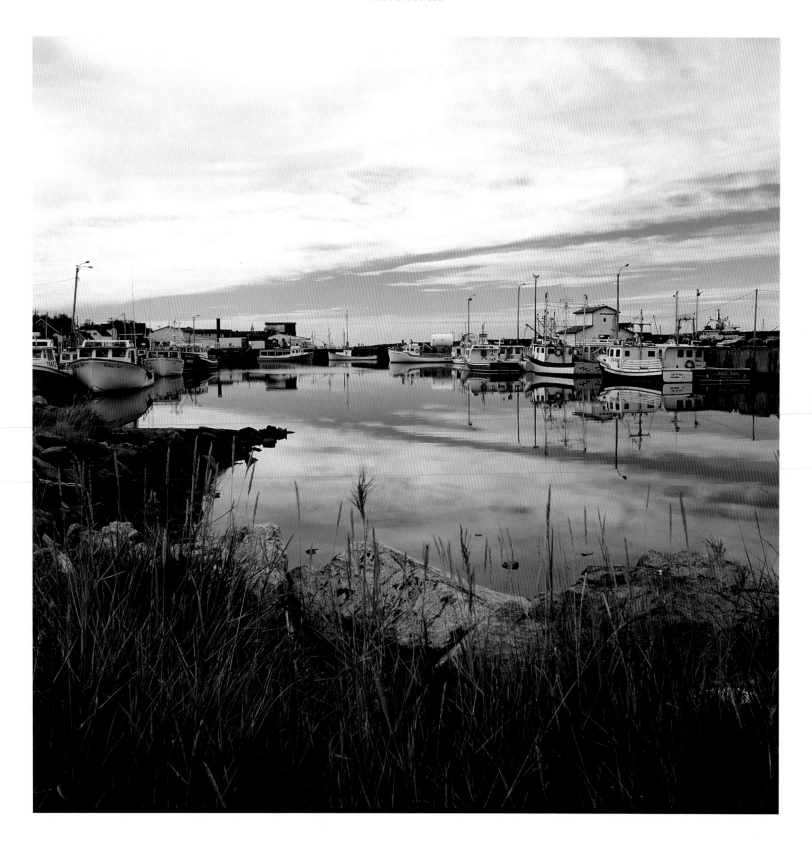

The Waterfront Park in Wolfville is a good place
to see the unusual tidal mud flats of the Minas Basin
during low tide.

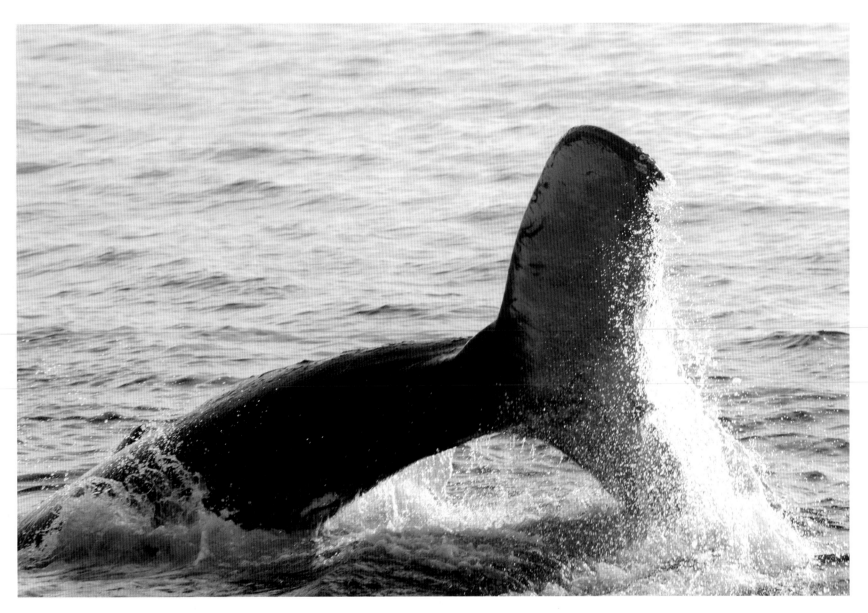

A humpback whale thrills spectators with acrobatics.

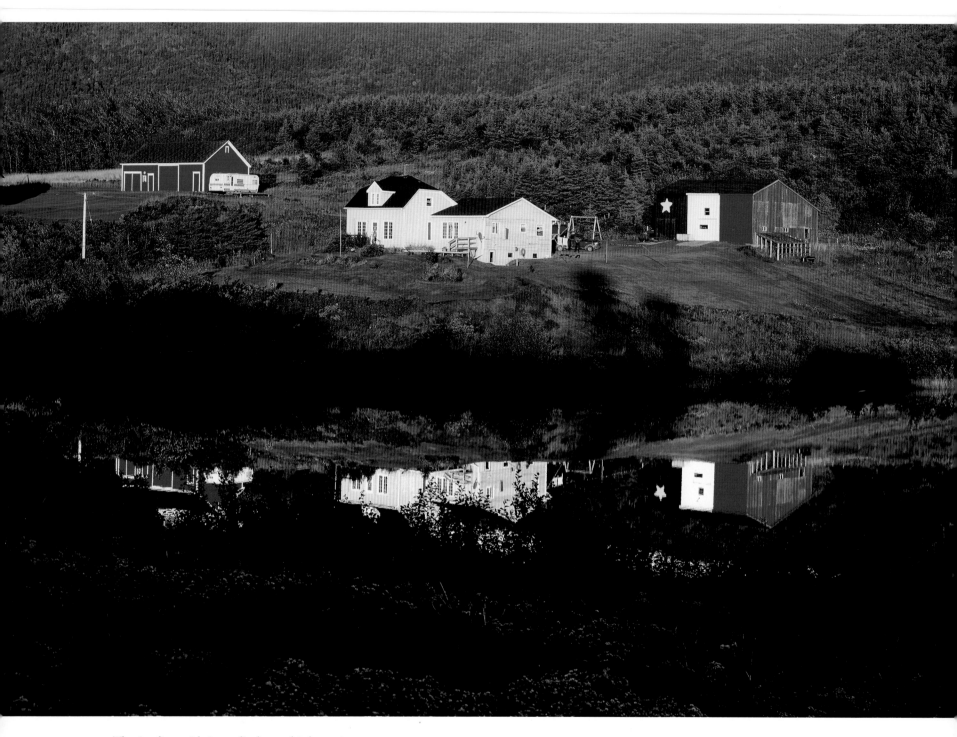

The Acadian pride is on display at this house in
Cape Breton, where some Acadians settled following
their expulsion from the mainland.

St. Pierre Catholic Church, built in 1893, towers over
Chéticamp, a village of 1,000 people.

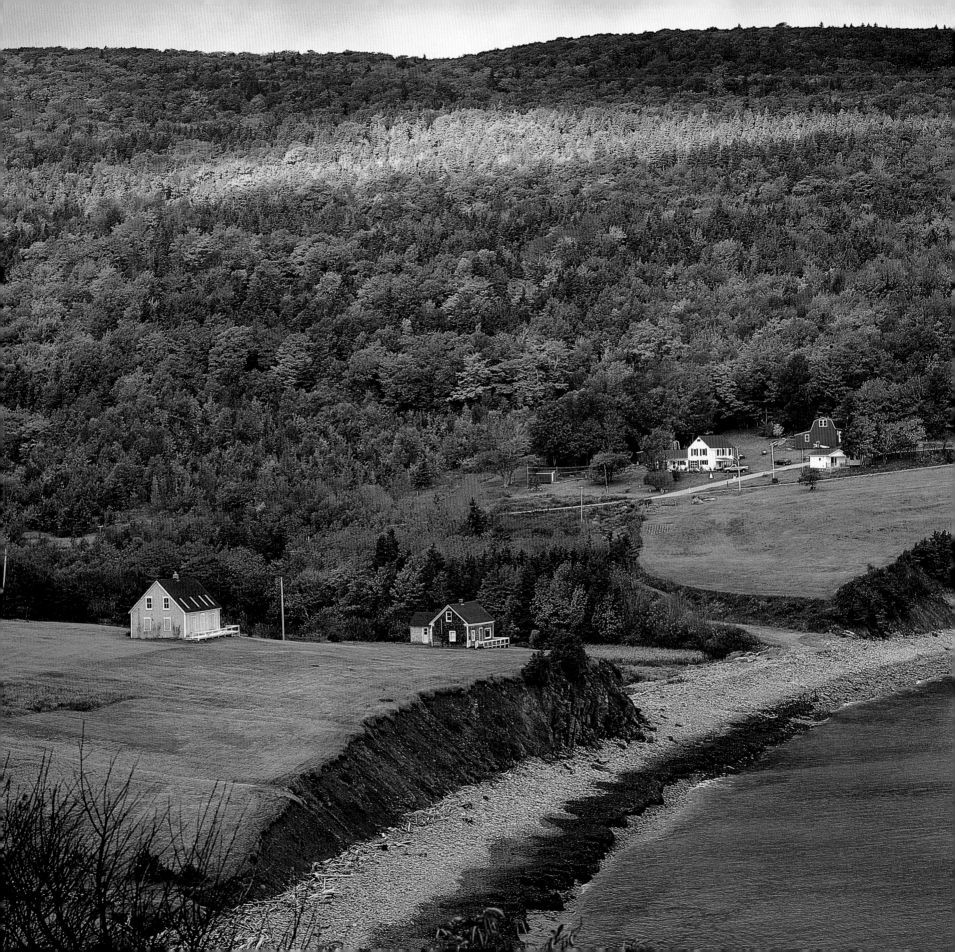

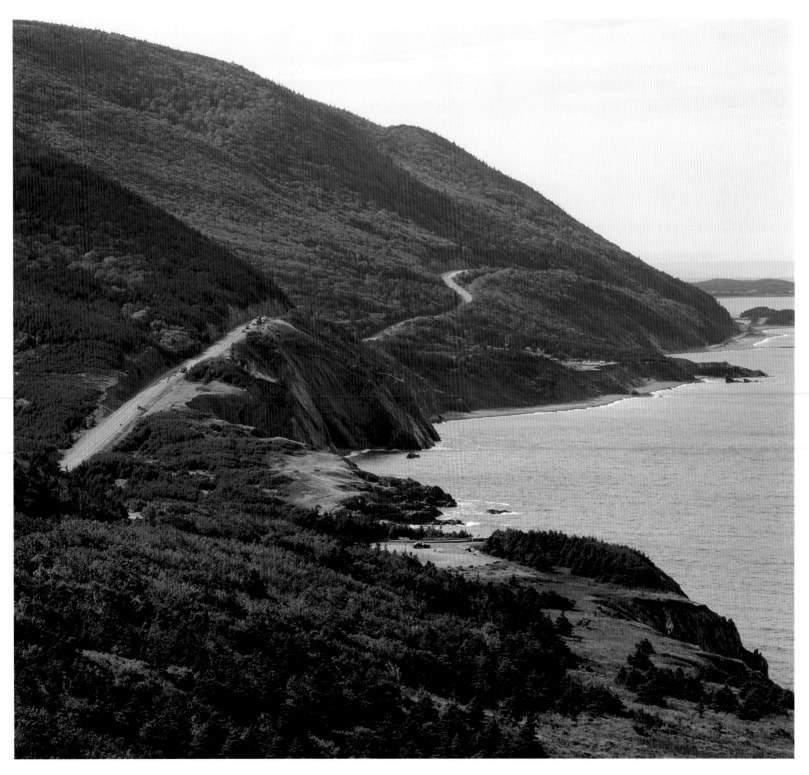

The breathtaking Cabot Trail winds through some of Canada's best scenic spots.

Left: Fall colours brighten Capstick at the northern tip of Cape Breton.

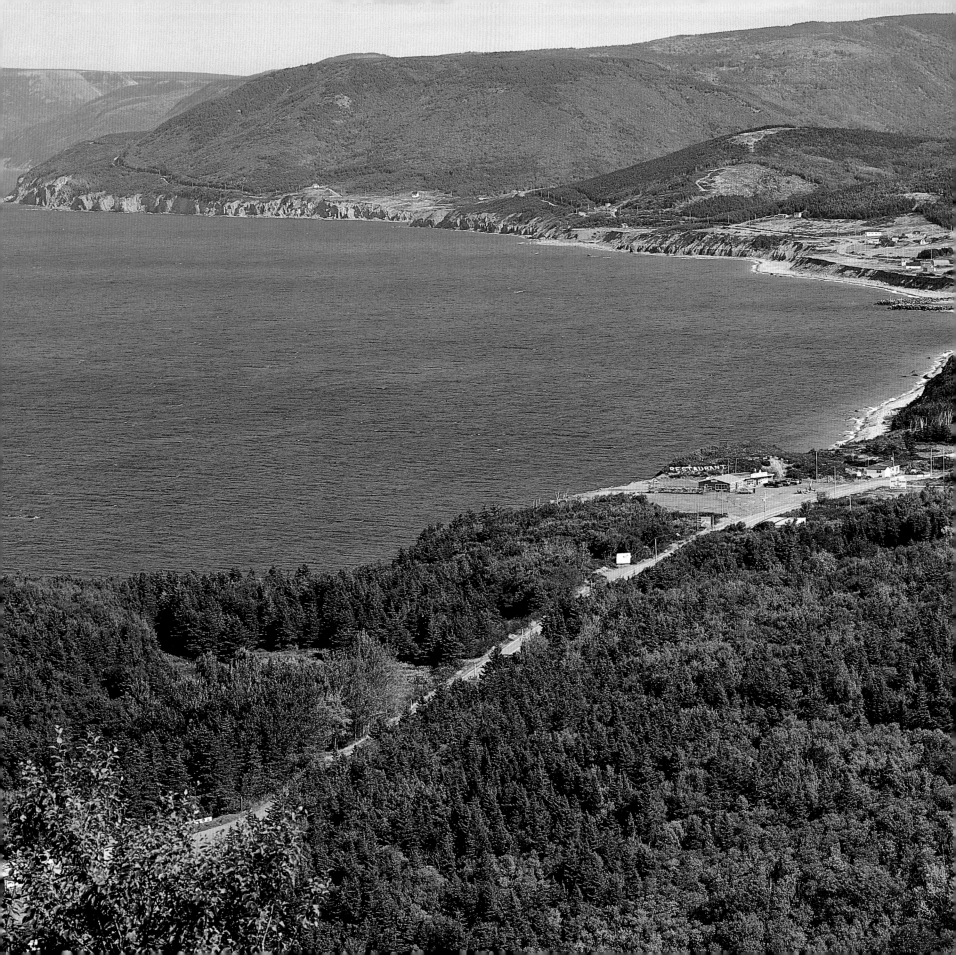

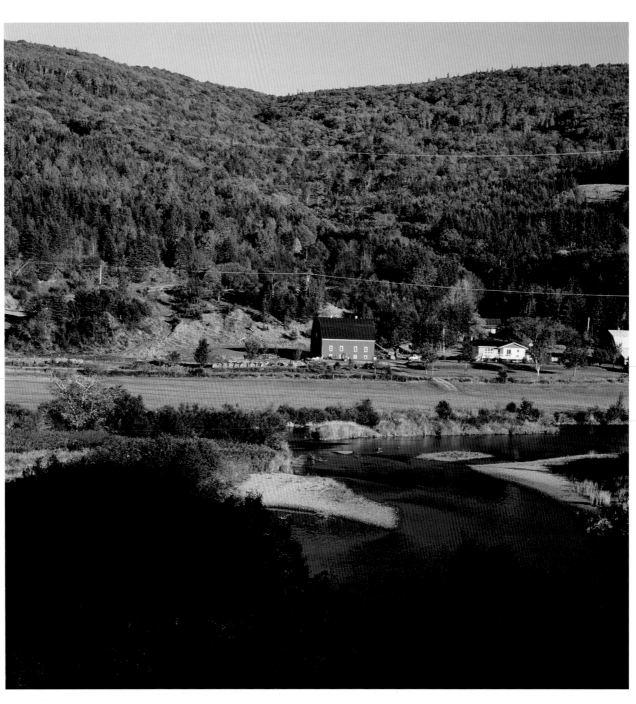

The scenic Margaree River Valley is in northwestern Cape Breton, on the 294-kilometre Cabot Trail.

Left: Seaside cliffs and winding roads characterize Pleasant Bay.

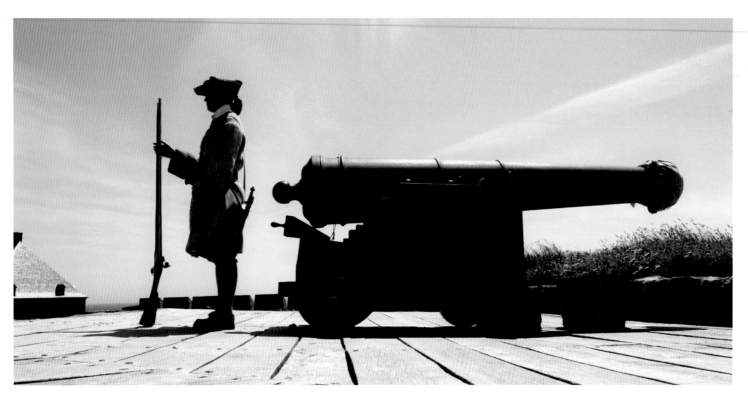

Fortress Louisbourg depicts French life in Canada during the 1700s. After the closures of many coal mines in the area, the federal government began a make-work project to reconstruct 50 of the original 80 buildings.

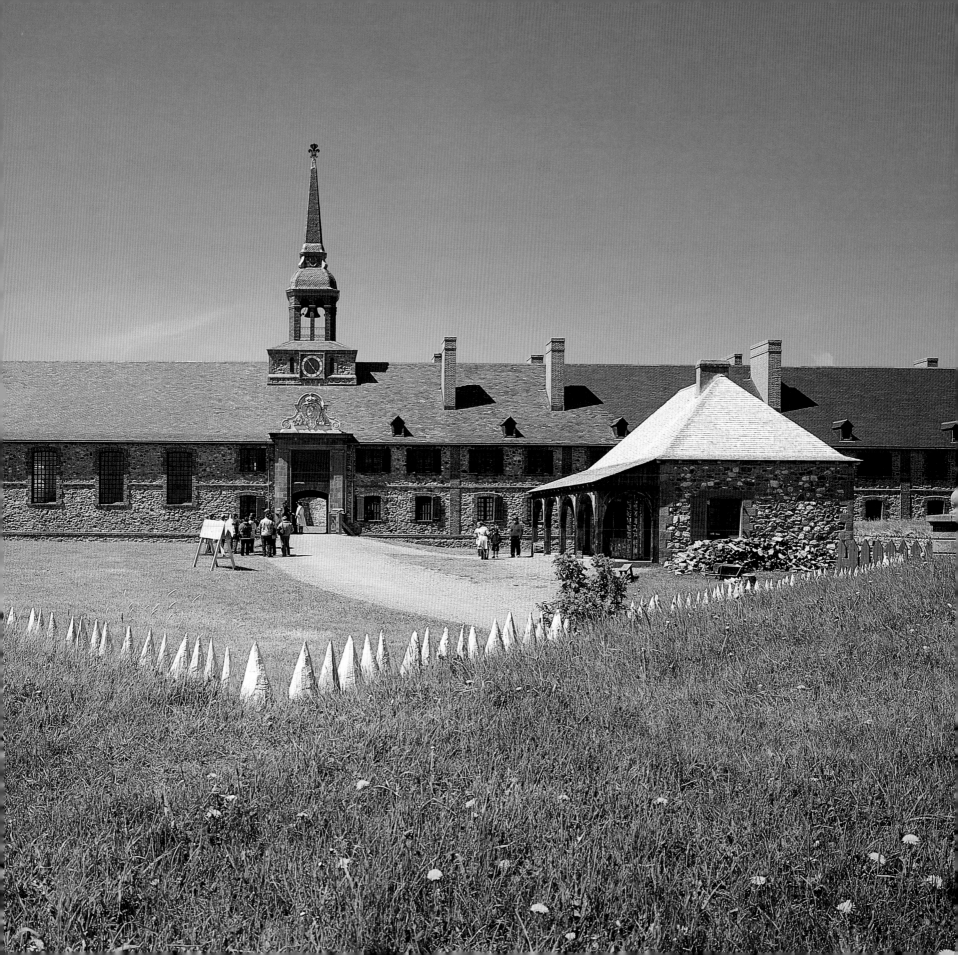

The Louisbourg Fortress, first built in 1719, was destroyed by the British in 1760. In the 1960s, the federal government reconstructed it after it sat empty for 200 years.

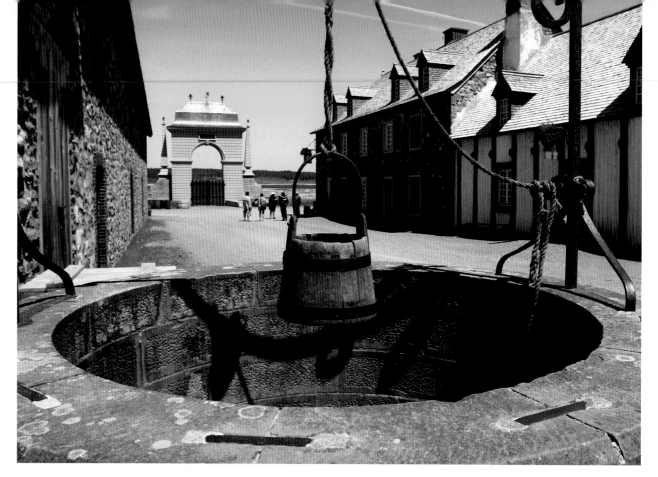

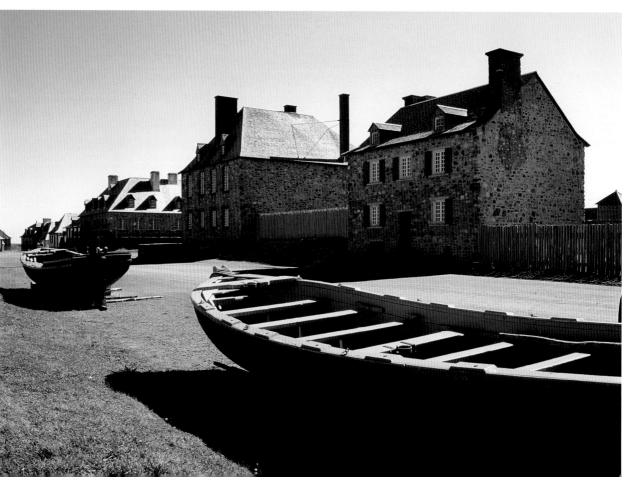

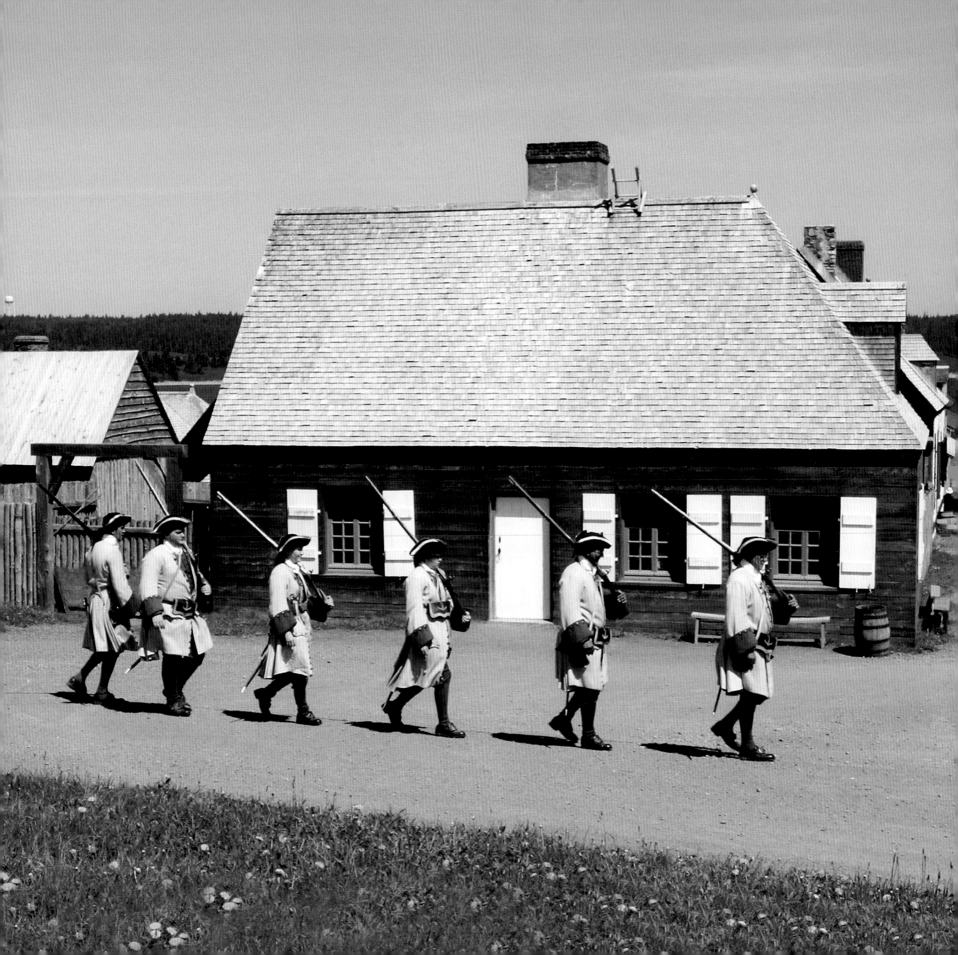

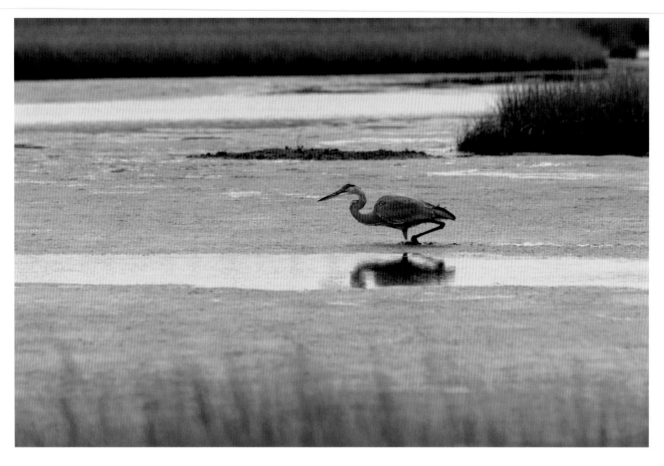

A heron patiently searches for food at
Cape St. Mary's, north of Yarmouth.

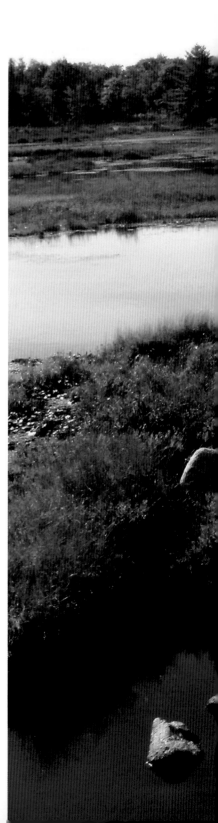

Right: Milford is a scenic site midway between
Annapolis Royal and Kejimkujik National Park.

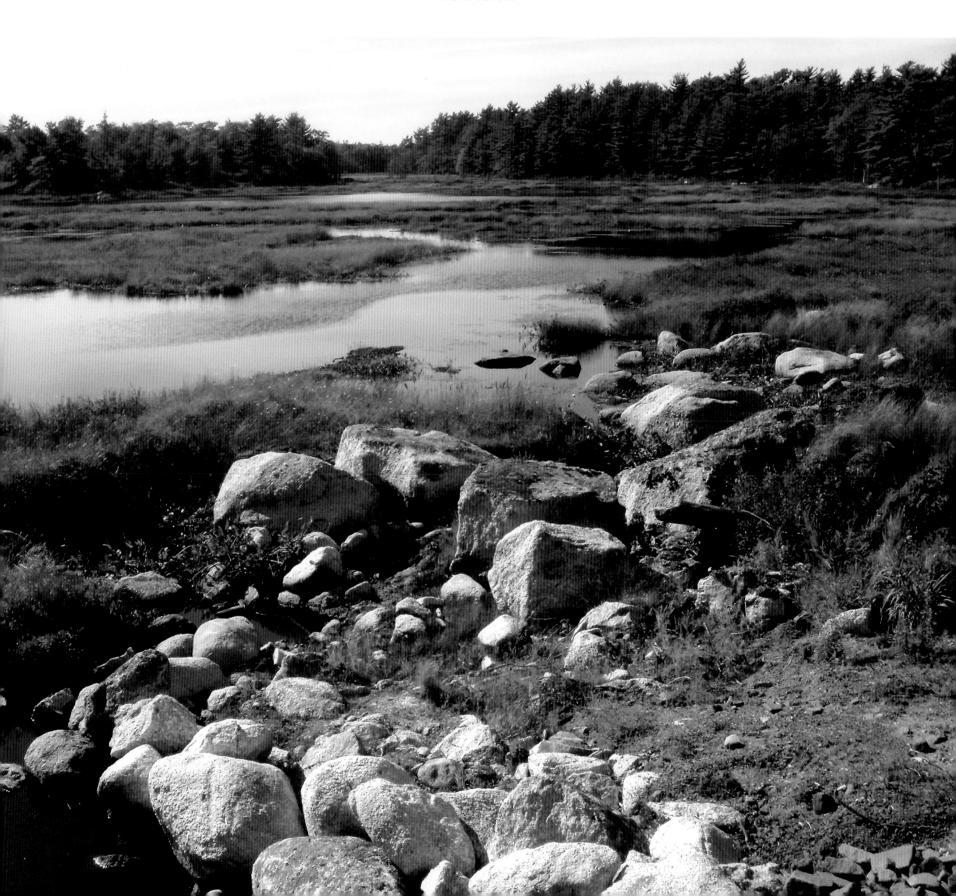

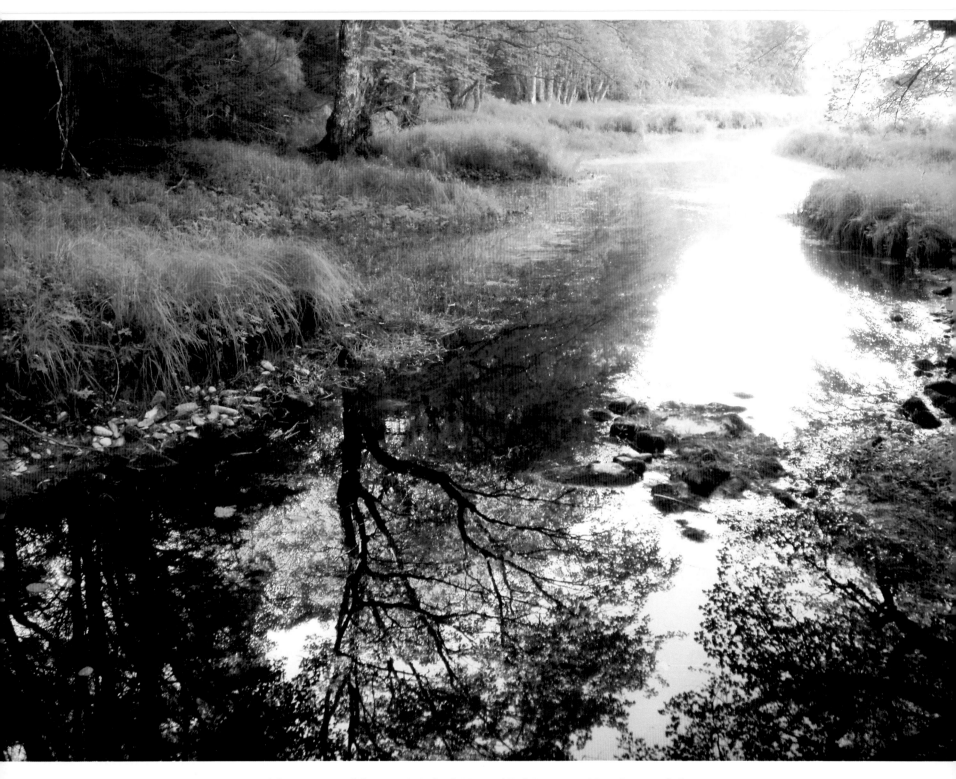

The 381-square-kilometre Kejimkujik National Park in western Nova Scotia includes
numerous lakes. In fact, 12 percent of the park is covered by water.

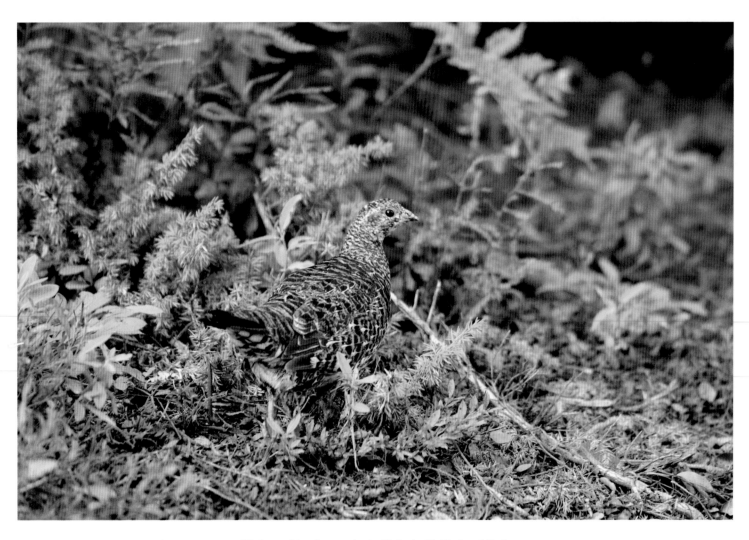

Bird-watching is popular in Kejimkujik National Park
because of the large variety of birds there.

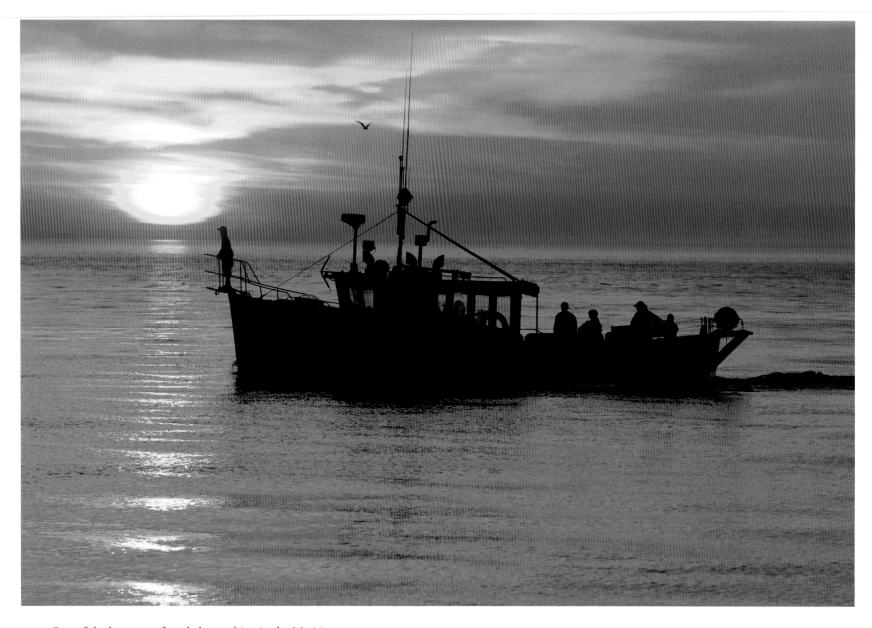

One of the best spots for whale-watching in the Maritimes
is at Brier Island. Humpback, minke and finback whales congregate
here from June through September.

Celebrating
NEW BRUNSWICK

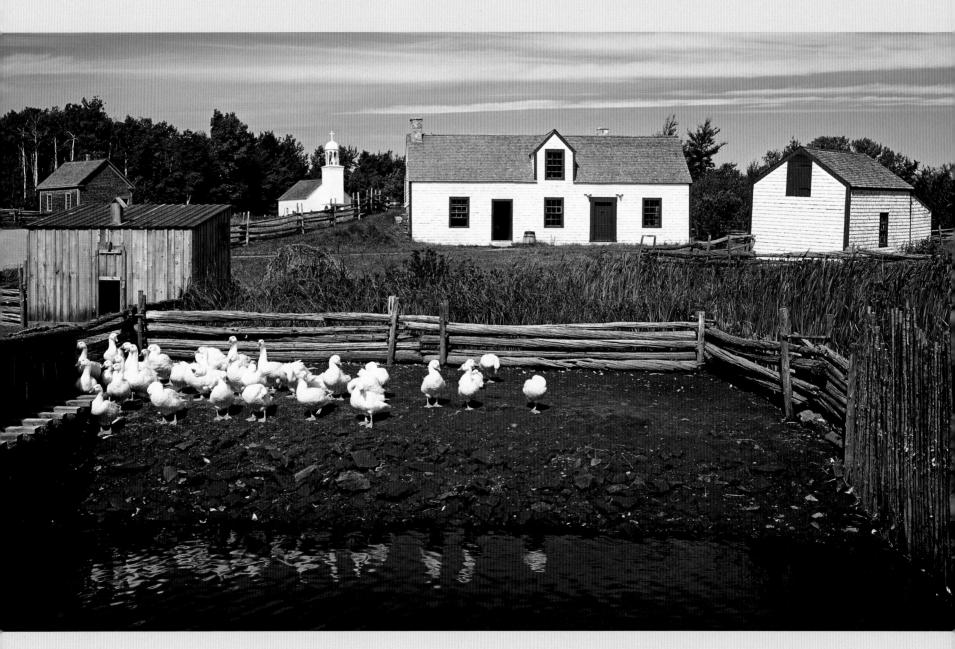

The Acadian Historical Village west of Caraquet portrays
Acadian life of the post-expulsion period between 1780 and 1890.

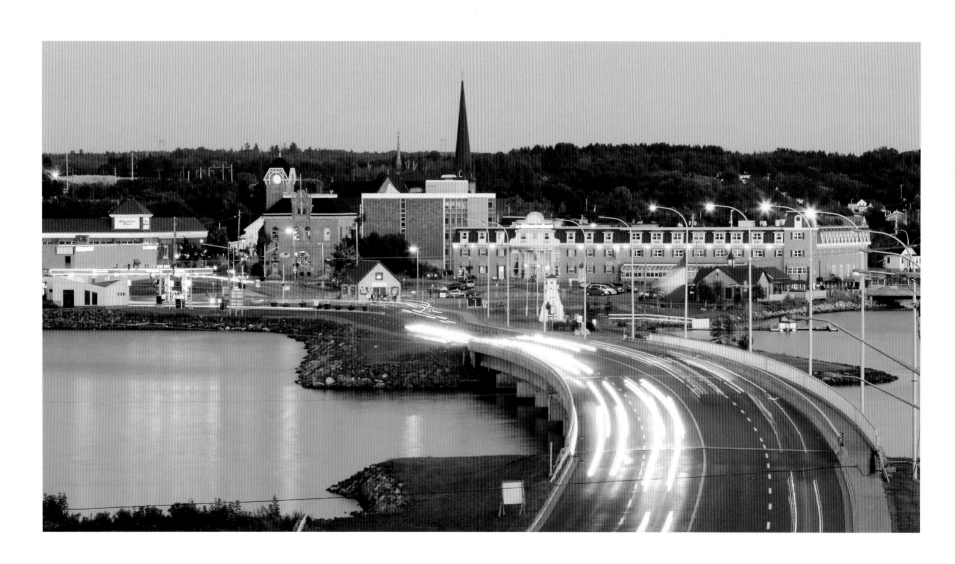

Bathurst, a town at Nepisiguit Bay with a population of 13,000,
is a mining centre for zinc and lead.

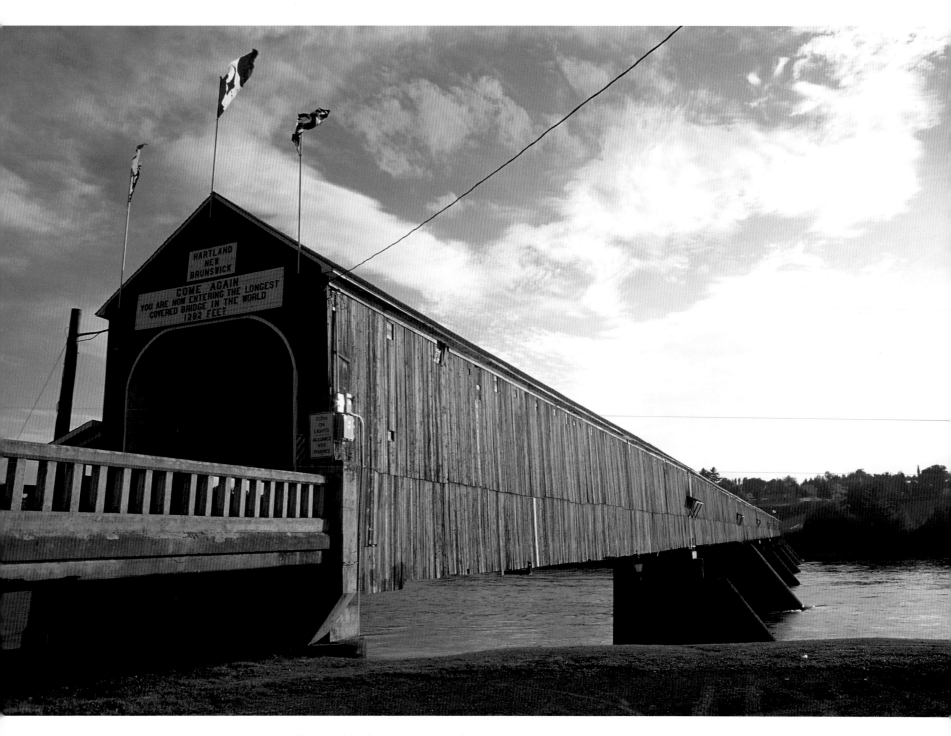

Hartland's covered bridge is the longest of New Brunswick's 74 wooden covered bridges.
The cover protects the timber and prolongs the life of the bridge.

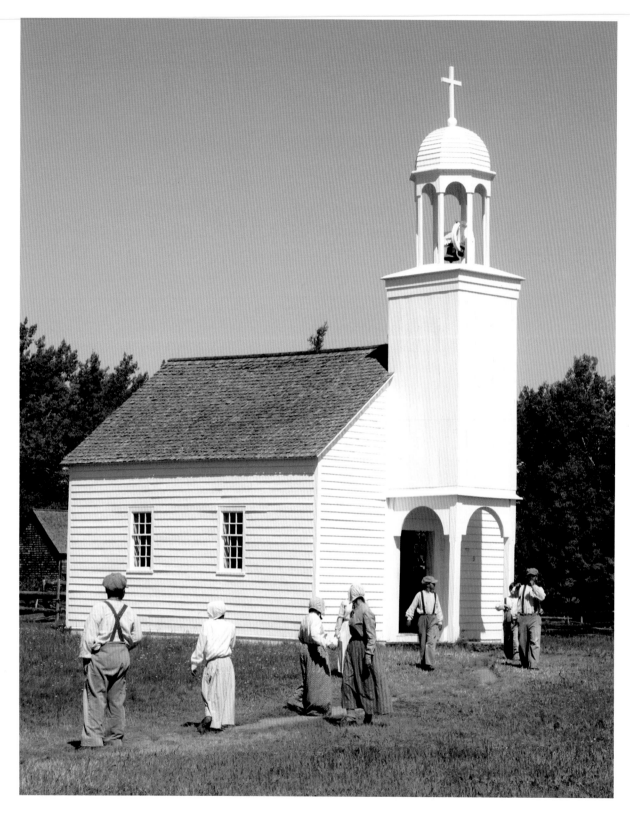

Costumed staff and volunteers at the Acadian Historical Village west of Caraquet attend a Sunday church service.

The Acadian Historical Village sits on a 1,133-hectare site with 40 restored buildings to depict Acadian life from 1780 through 1890.

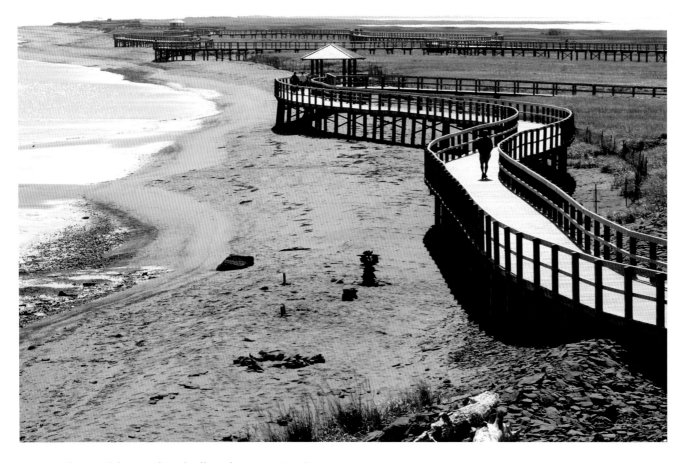

The two-kilometre boardwalk at the Irving Eco Centre north of Bouctouche allows visitors to enjoy the dunes without endangering the ecosystem.

Right: The gristmill in the Acadian Historical Village.

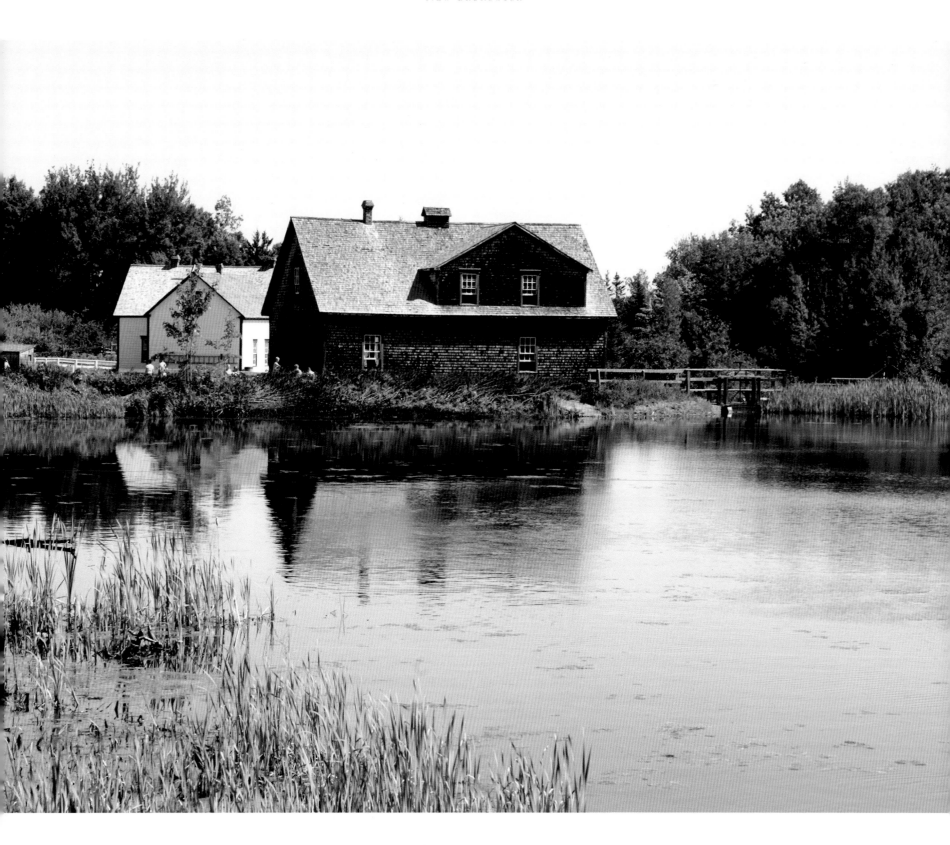

Appalachian forests cover 90 percent of
New Brunswick's 73,440 square kilometres.

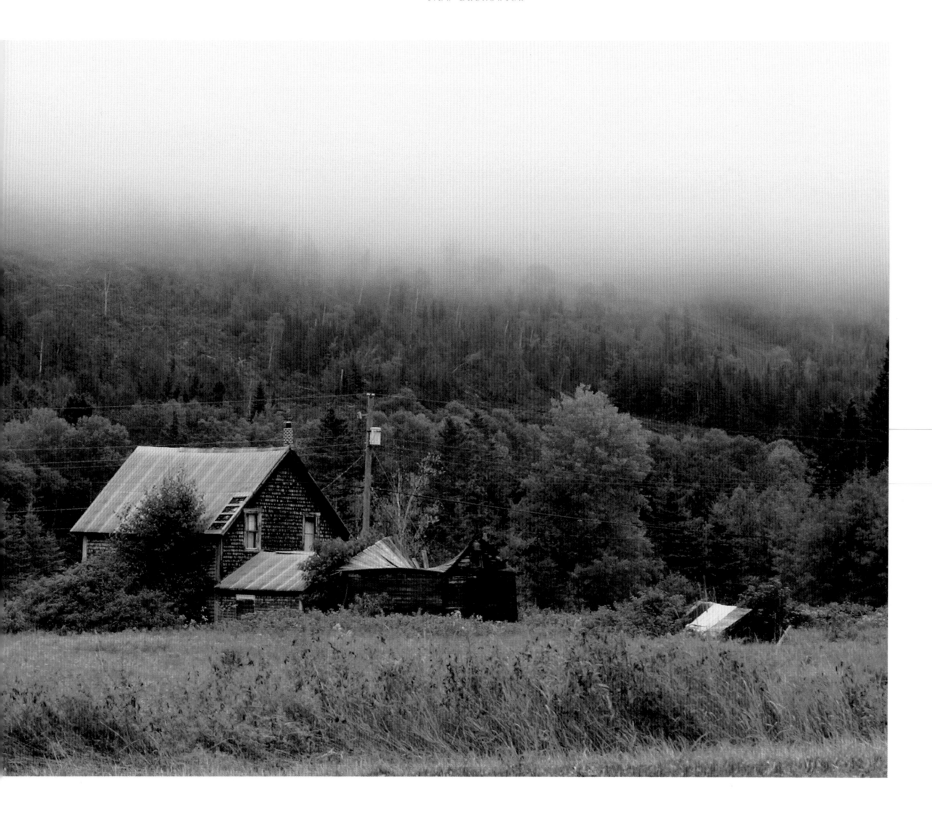

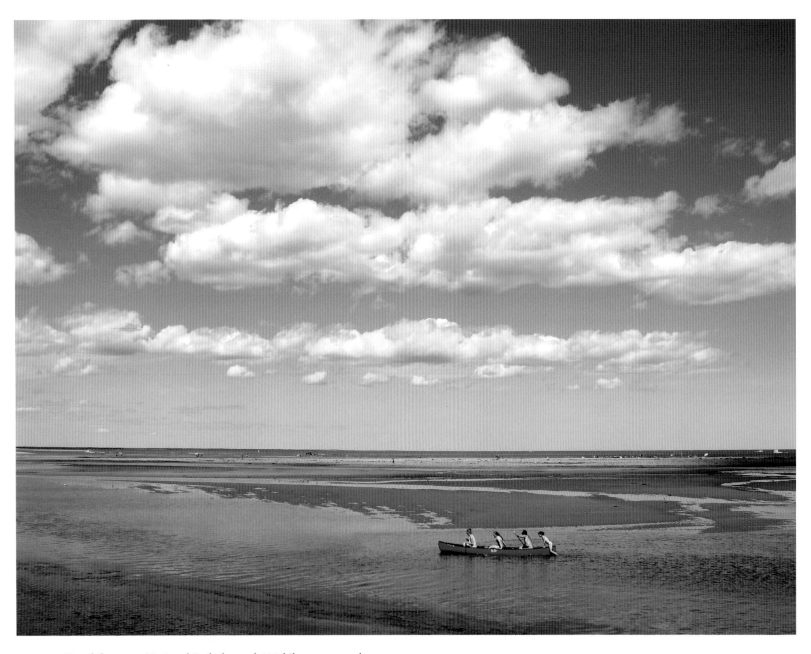

Kouchibouguac National Park, located 100 kilometres north
of Moncton, is famous for its beaches, sand dunes and lagoons.
Kouchibouguac is a Mi'kmaq word for "river of long tides."

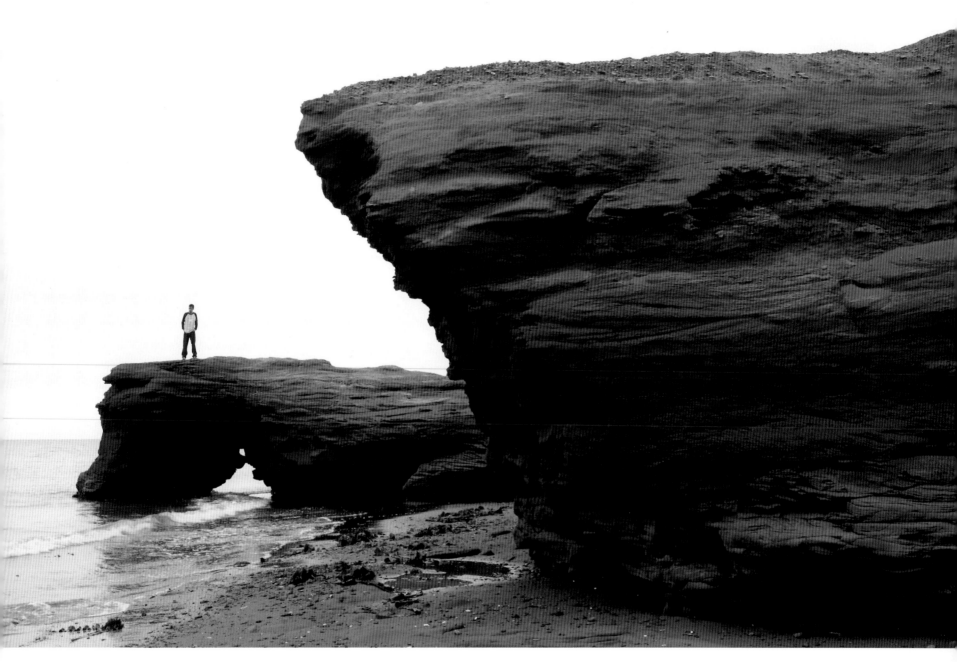

The eroded stones at Cap-Bateau are in the less travelled Acadian Peninsula region.

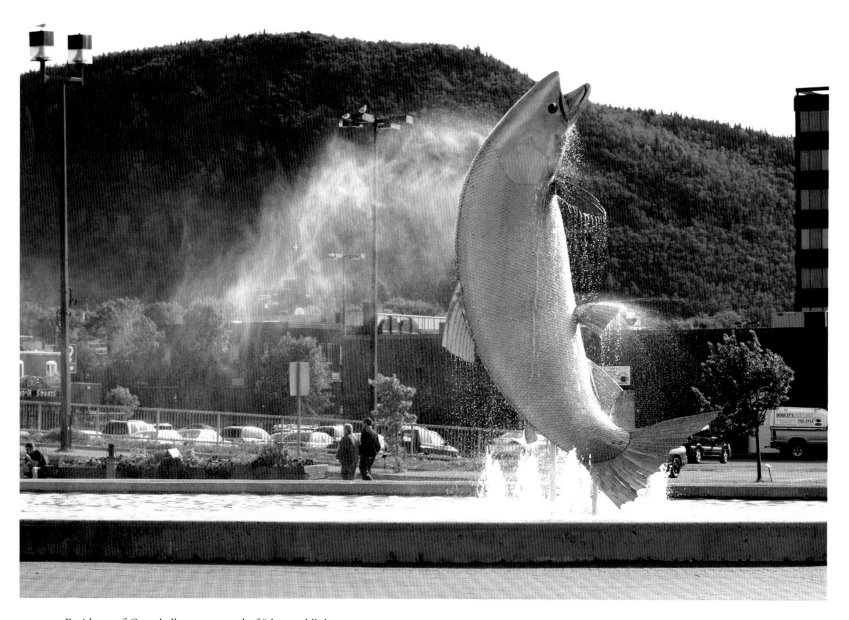

Residents of Campbellton are proud of "the world's largest salmon," which stands at 8.5 metres (28 feet) tall. They call this stainless steel sculpture Restigouche Sam.

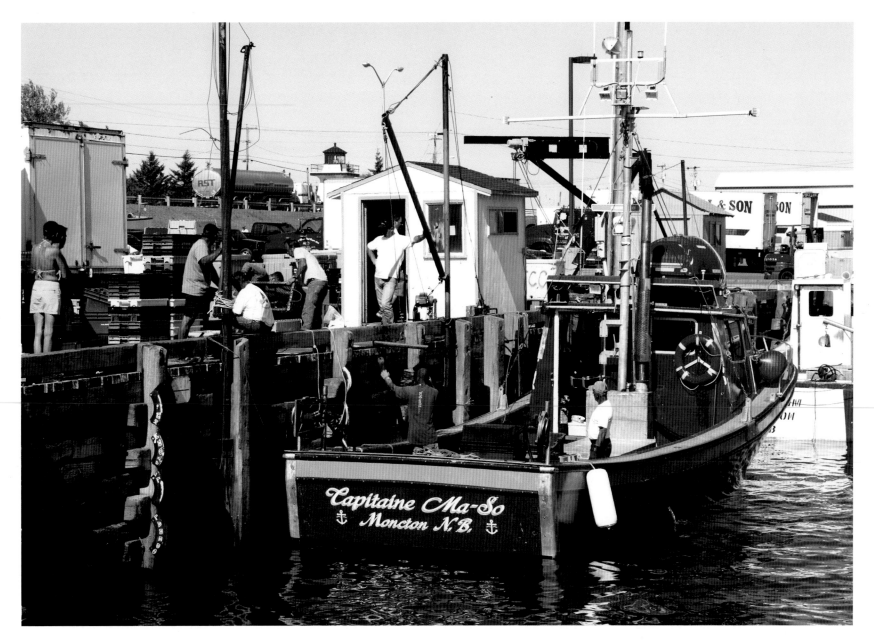

Fishers unload their catches at Pointe-Sapin at Kouchibouguac Bay just north of Kouchibouguac National Park.

There are 62 kilometres of trails at Mount Carleton Provincial
Park, which covers 17,427 hectares of wilderness. At 820 metres,
Mount Carleton is the highest peak in the Maritimes.

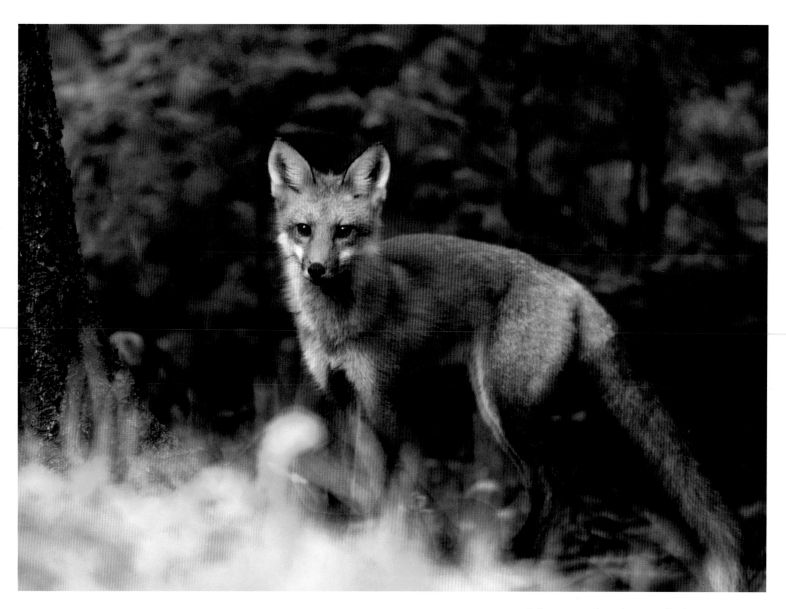

A fox gets ready to hunt its food at
Sugarloaf Provincial Park in Campbellton.

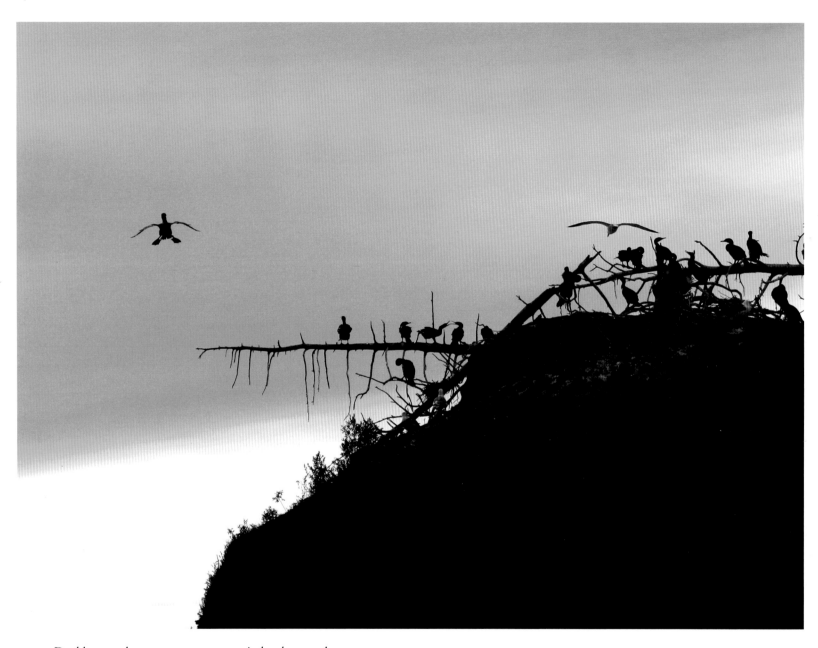

Double-crested cormorants nest on an isolated sea-stack
at Pokeshaw Community Park near Grande-Anse.

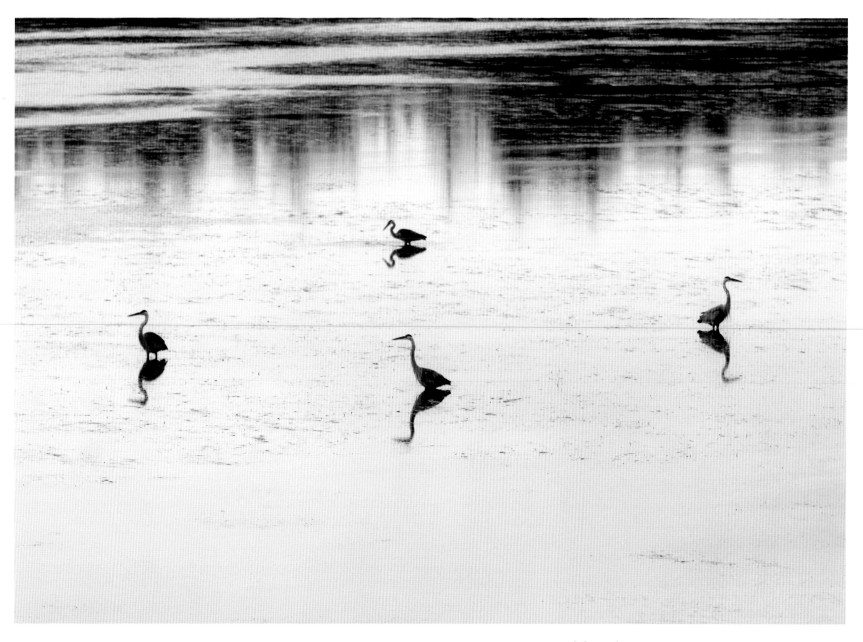

Each heron has its own space as it waits patiently
for the next meal at the Ecological Park of Acadian
Peninsula in Lamèque.

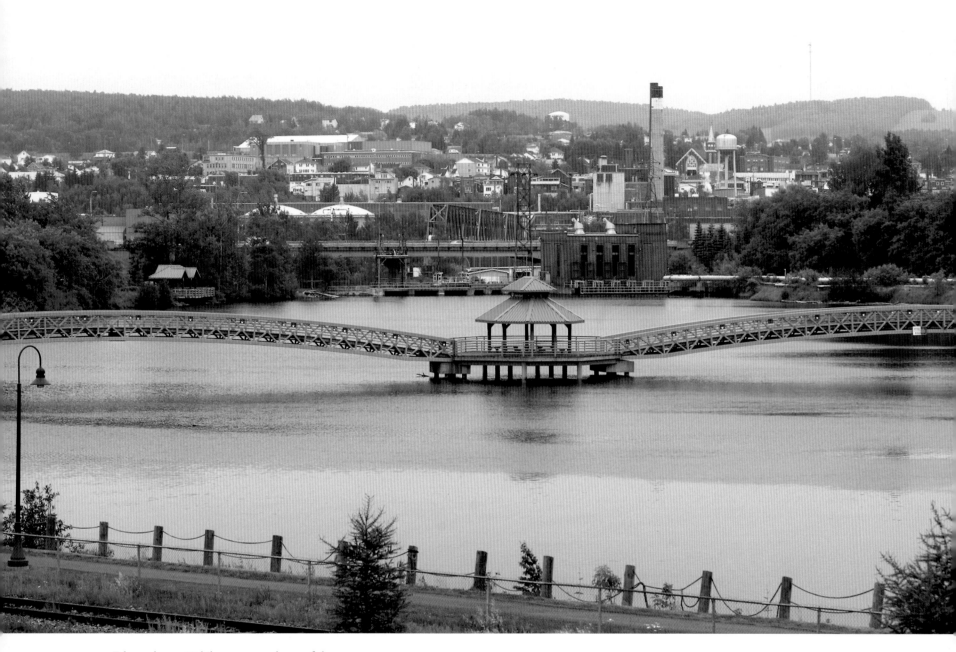

Edmundston, 20 kilometres southeast of the
Quebec border, is usually the first stop for visitors
coming through Ontario and Quebec.

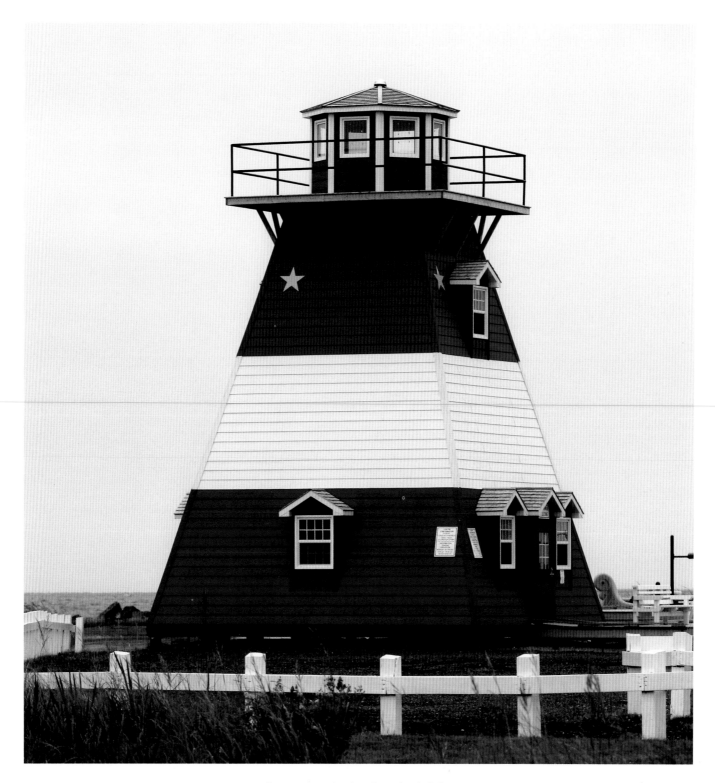

Acadian pride is displayed on this lighthouse
in Neguac, just northeast of Miramichi.

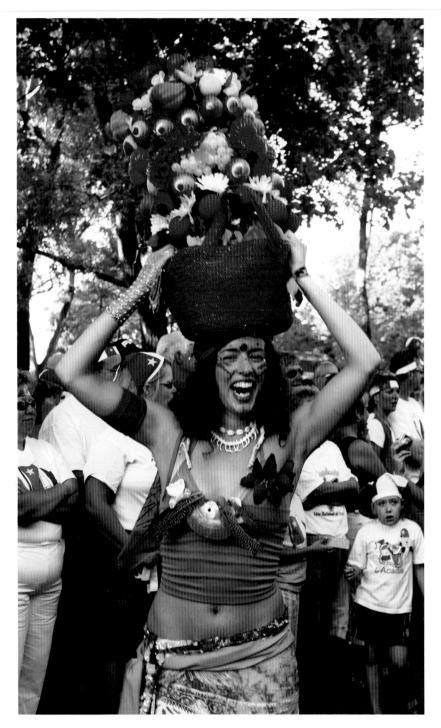

The Festival acadien de Caraquet is one of the largest events in
New Brunswick. The finale, the Tintamarre, or noisy commotion,
is attended by between 10,000 and 20,000 people each year.

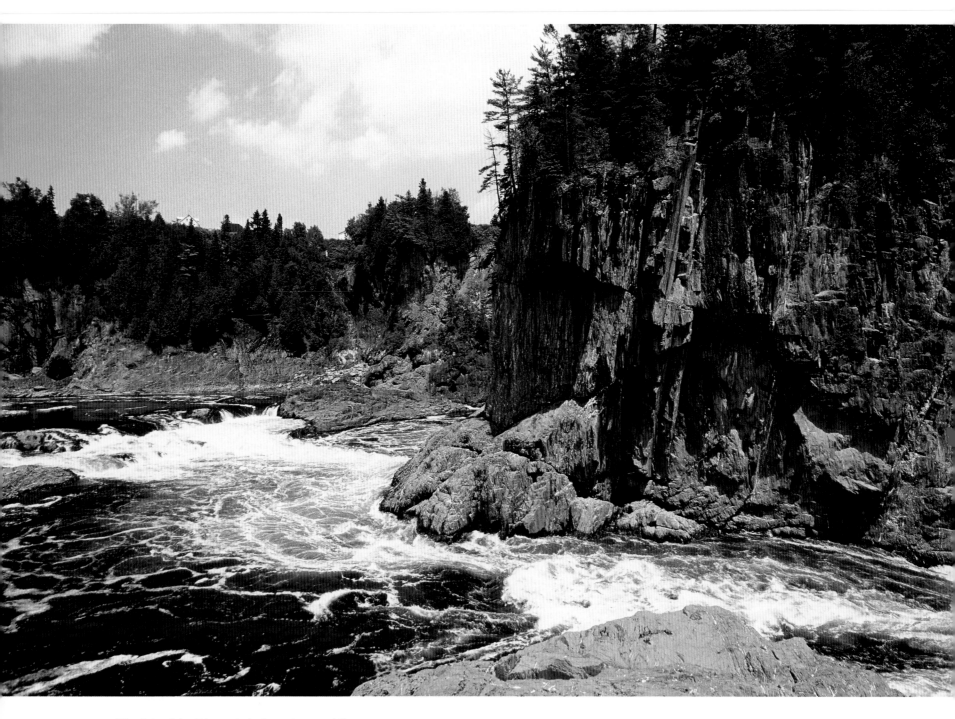

The Saint John River winds through a two-kilometre gorge at Grand Falls. Visitors can descend to the bottom of the falls via a staircase.

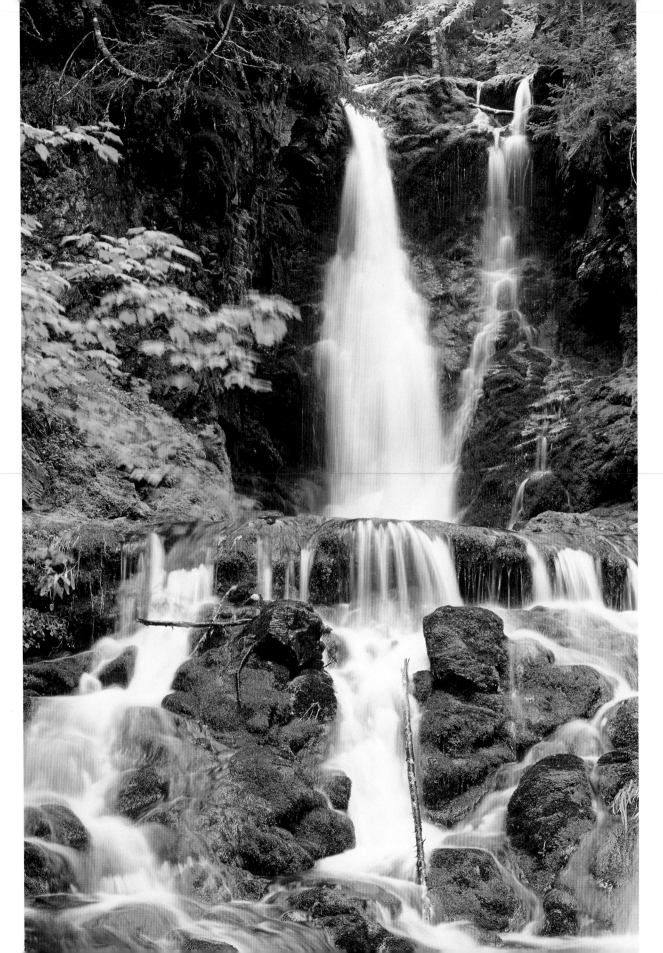

Fundy National Park is one of Atlantic Canada's most magnificent parks. It encompasses 206-square kilometres of rivers and waterfalls, highlands and valleys, sandstone cliffs and beaches and, of course, the world's highest tides.

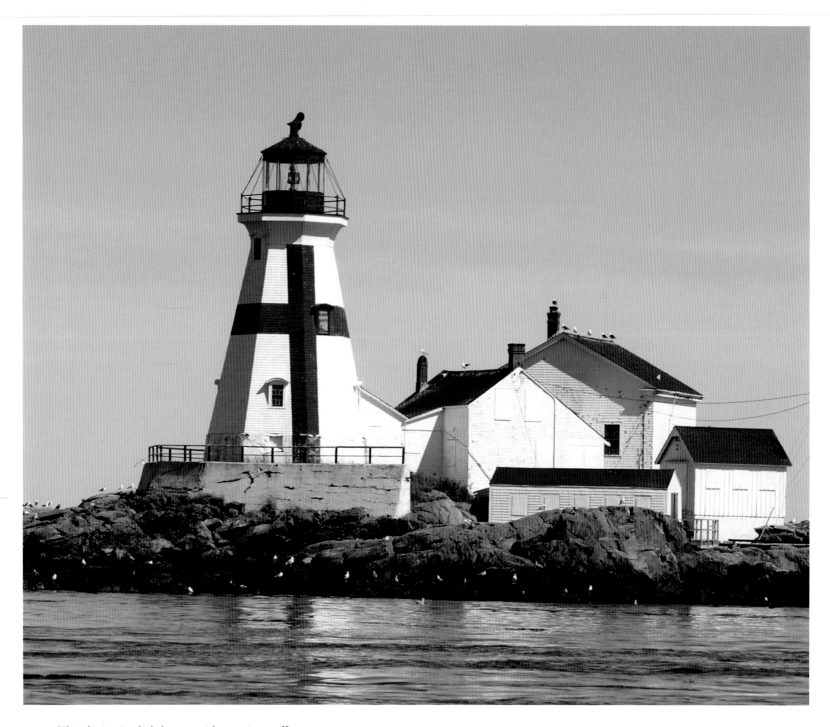

This distinctive lighthouse guides marine traffic
to Campobello Island, once a popular summer resort
for affluent Americans.

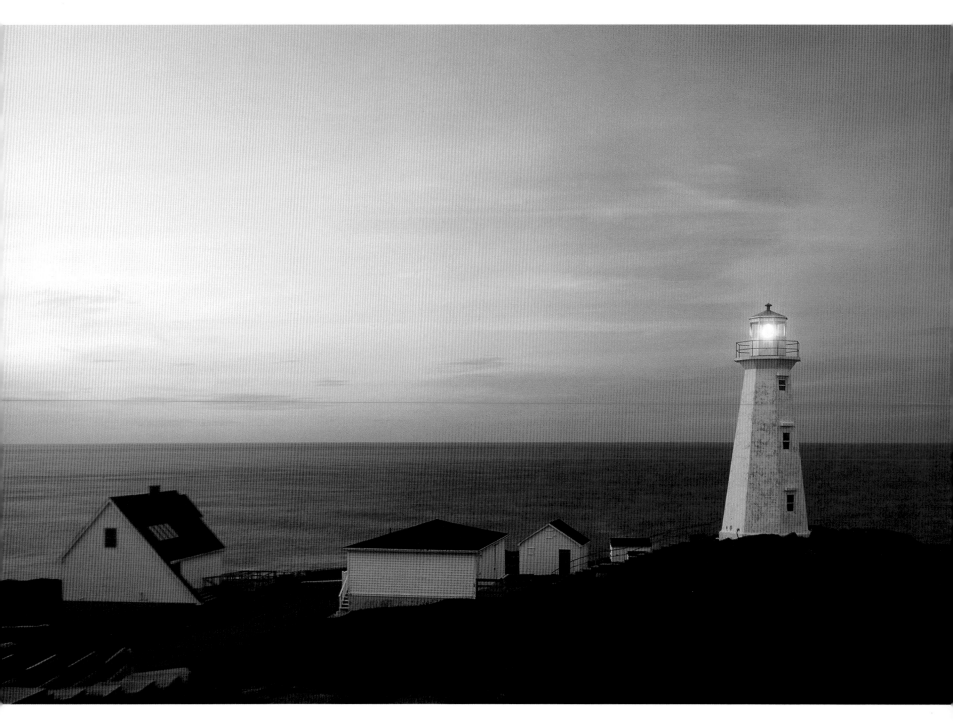

Grand Manan is the largest of the Fundy Isles. It's a long
journey from the mainland, but the trip is worth it
because the island is an excellent place for hiking, bird-
watching and whale-watching.

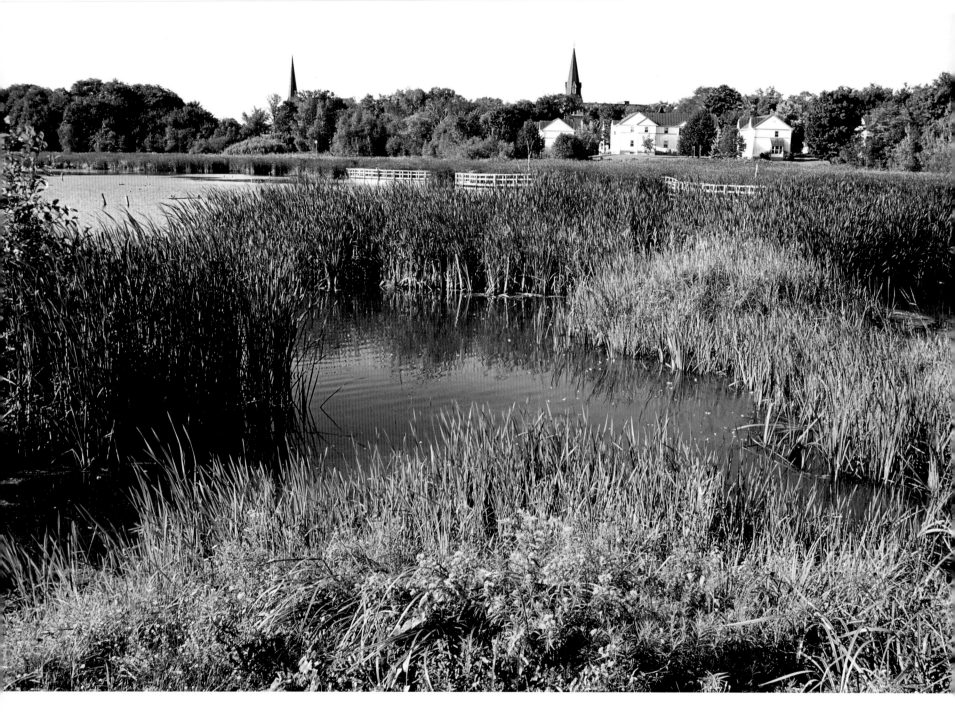

The Sackville Waterfowl Park is a 22-hectare refuge
of marshes which are home to a variety of birds.

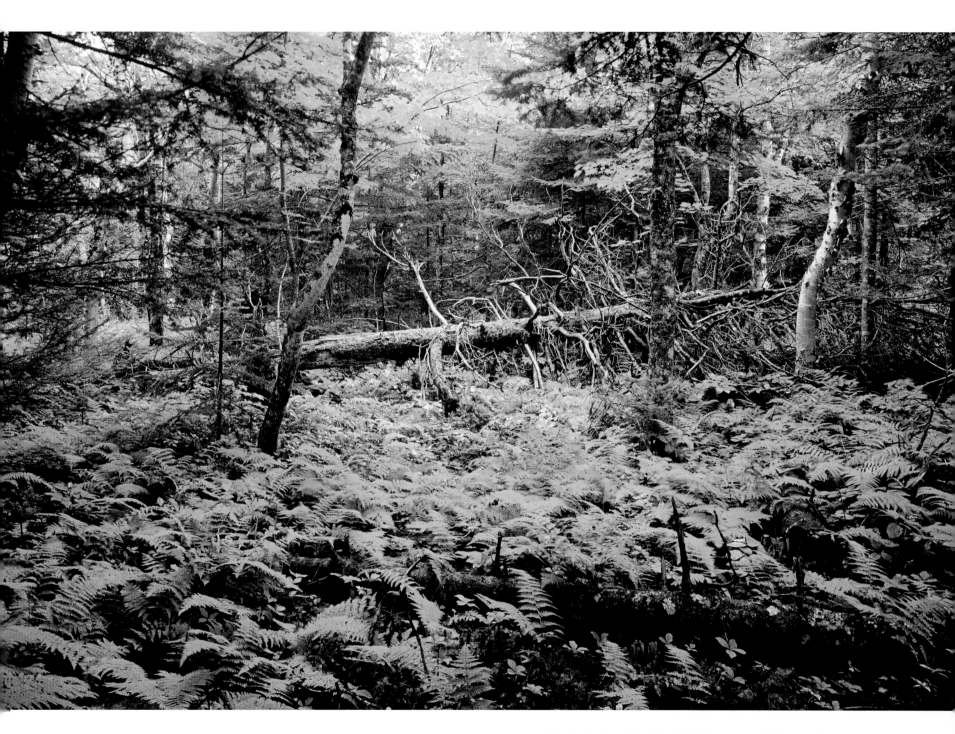

Fundy National Park has 120 kilometres of hiking trails —
some of which wind through dense forests.

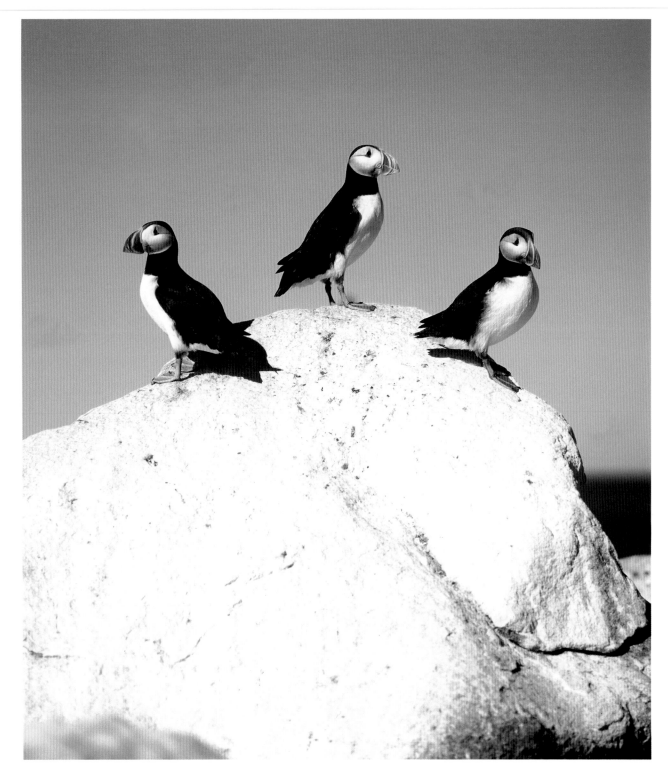

Puffins are the main attraction on Michias Seal Island, a bird sanctuary
16 kilometres south of Grand Manan. Only a limited number of visitors
is permitted to go there each day.

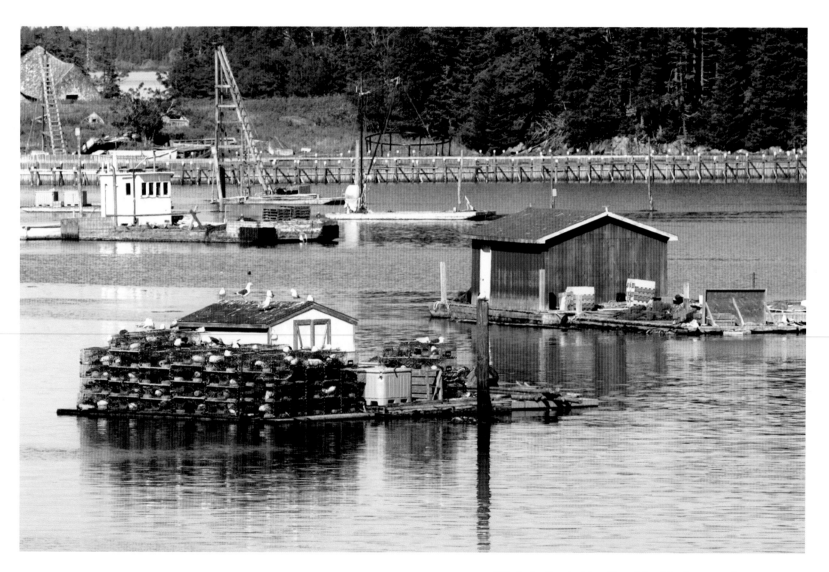

Of all the Fundy Isles, Deer Island is closest to the mainland. Lobster is the main catch for local fishers.

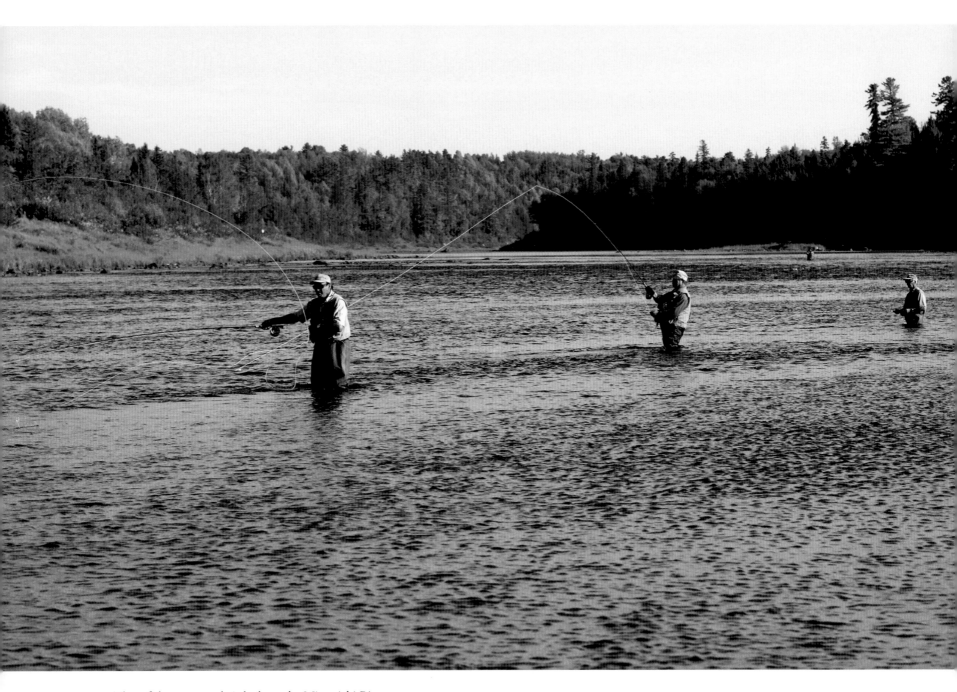

These fishermen try their luck on the Miramichi River,
one of the world's best places for Atlantic salmon fishing.

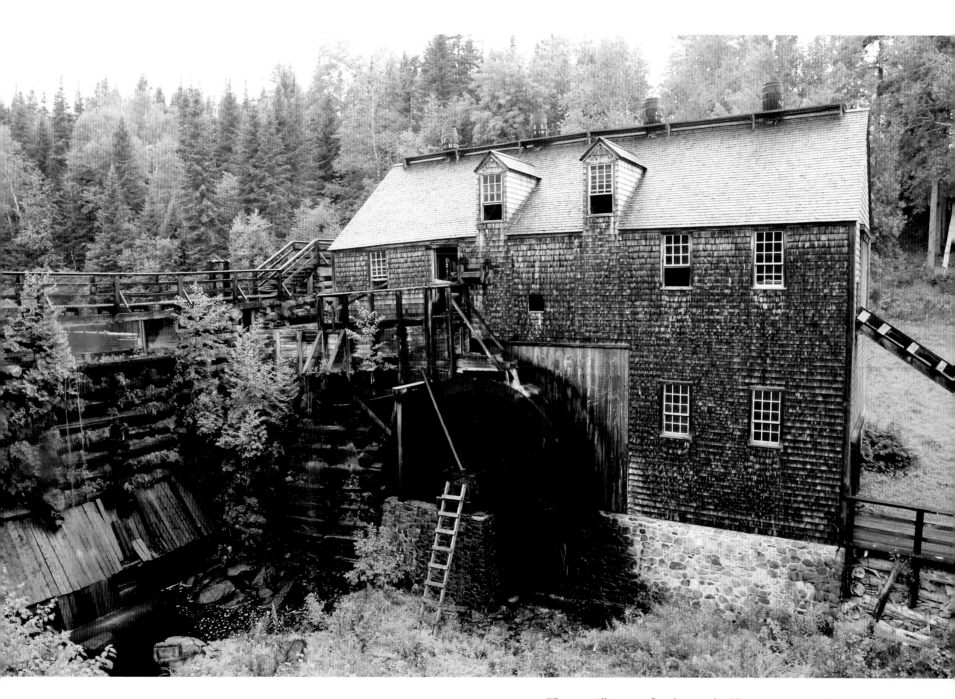

The sawmill is one of 70 historic buildings at Kings Landing
Historical Settlement, which depicts life in a typical English-
speaking, 19th-century settlement.

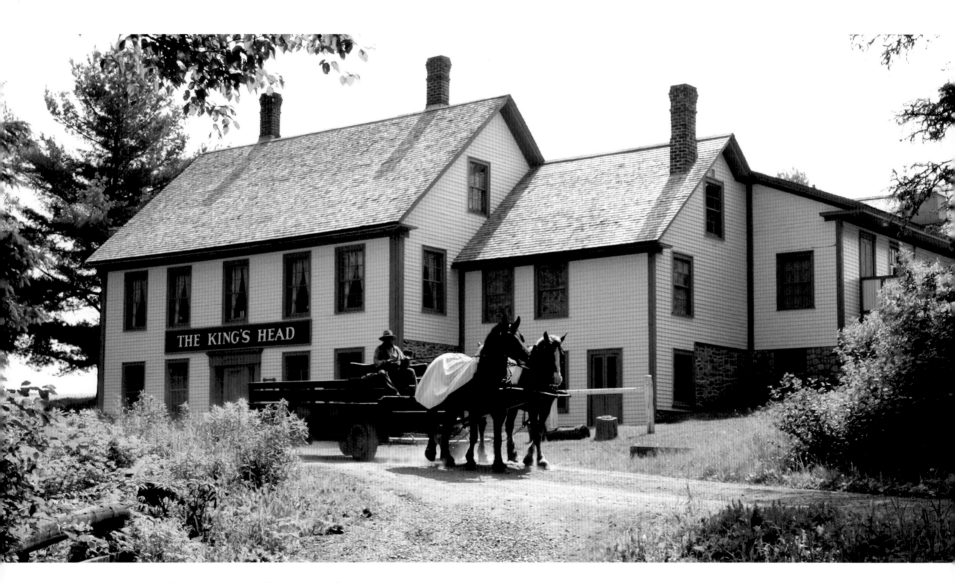

King's Head Inn at Kings Landing serves 19th-century
meals giving visitors a taste of what life was like during
colonial times.

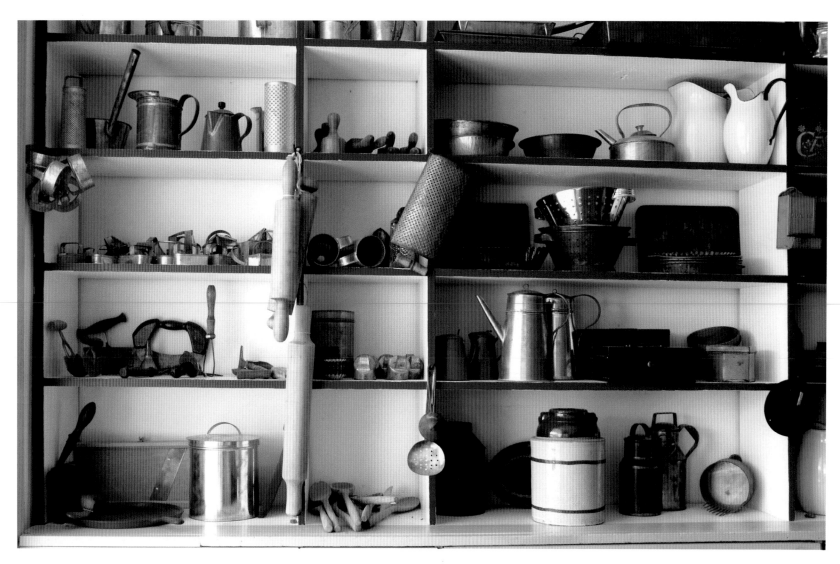

The attention to details is evident in this showcase
of utensils. The recreated Kings Landing settlement
depicts lives of the Loyalists from the 1780s.

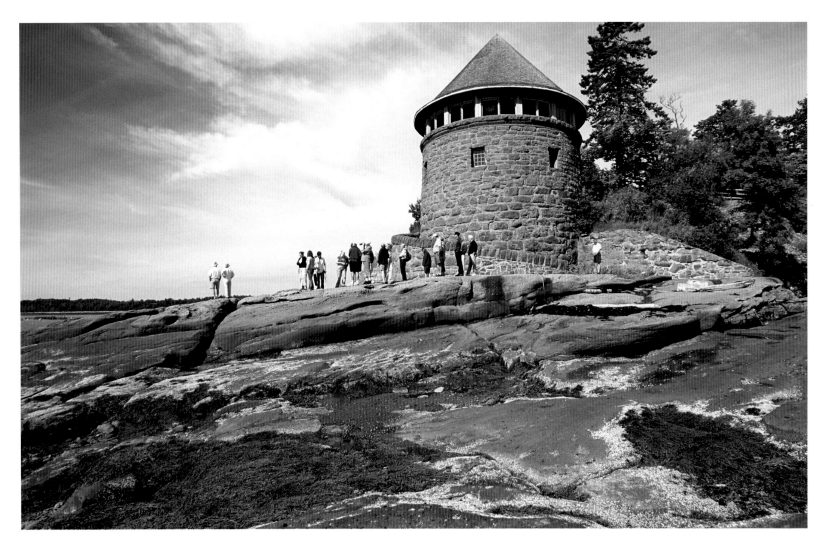

Visitors admire the former summer retreat of William Van Horne
on Minister's Island north of St. Andrews.

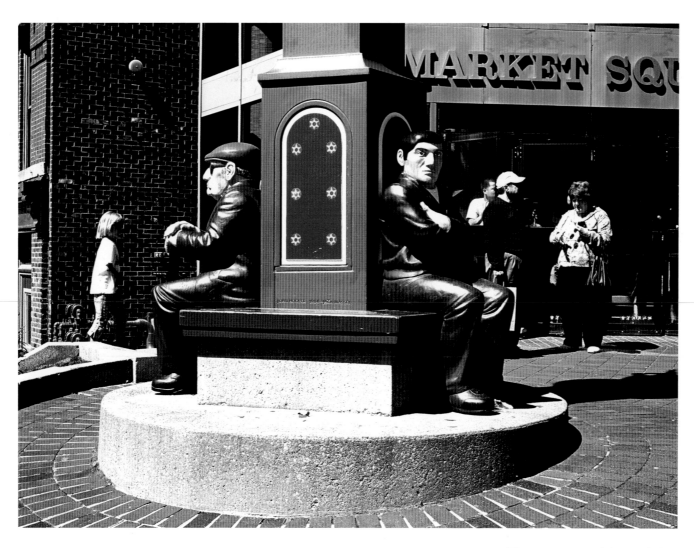

Above and overleaf: These statues guard Saint John's impressive Old City Market, which spans a city block and is stocked with all kinds of crafts, baked goods, fresh produce and meat.

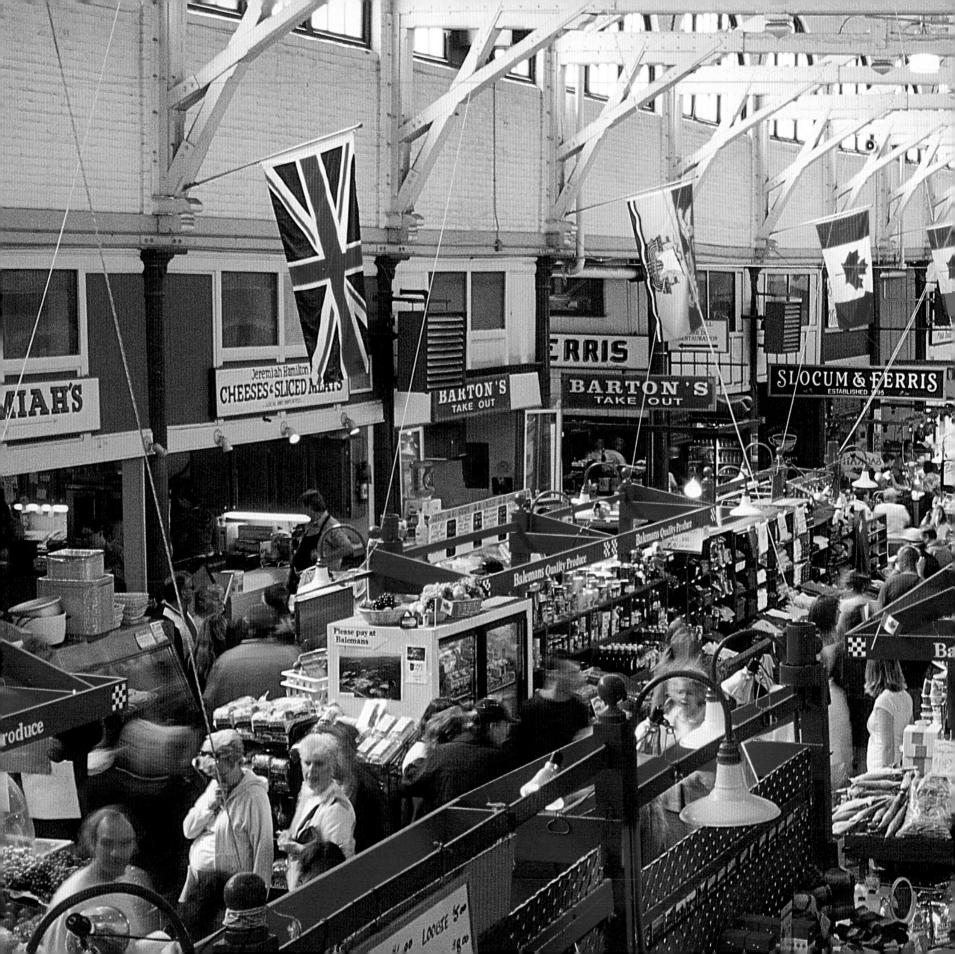

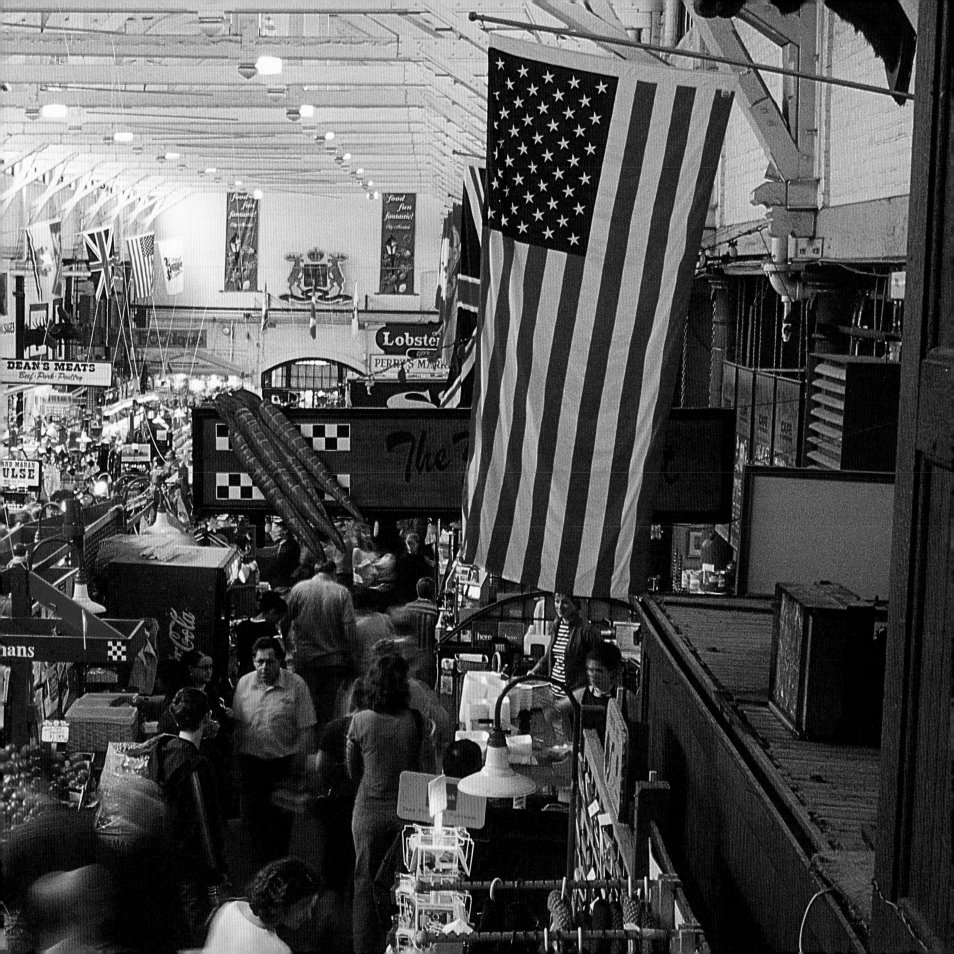

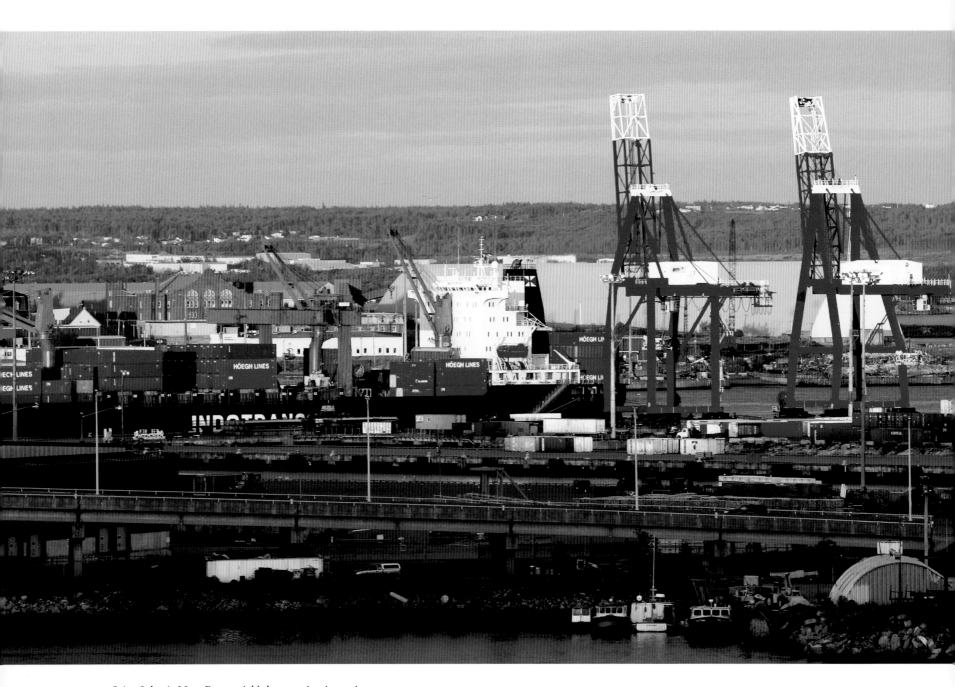

Saint John is New Brunswick's largest city, its main
industrial centre and its major port. The drydock above
is one of the world's largest.

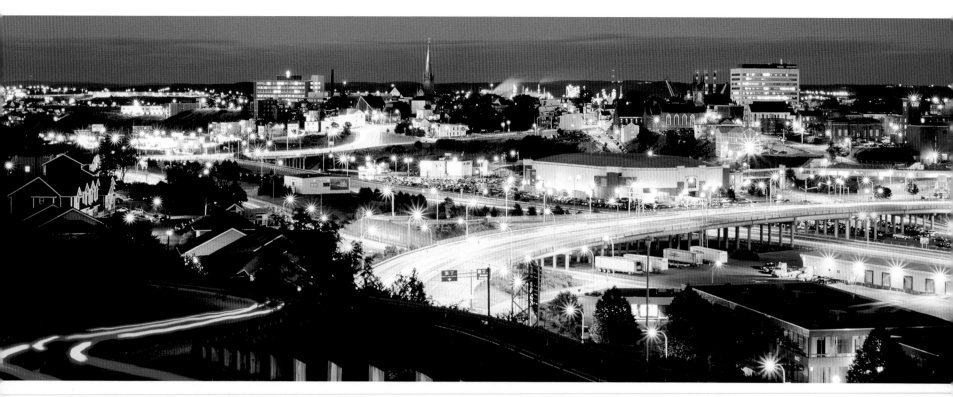

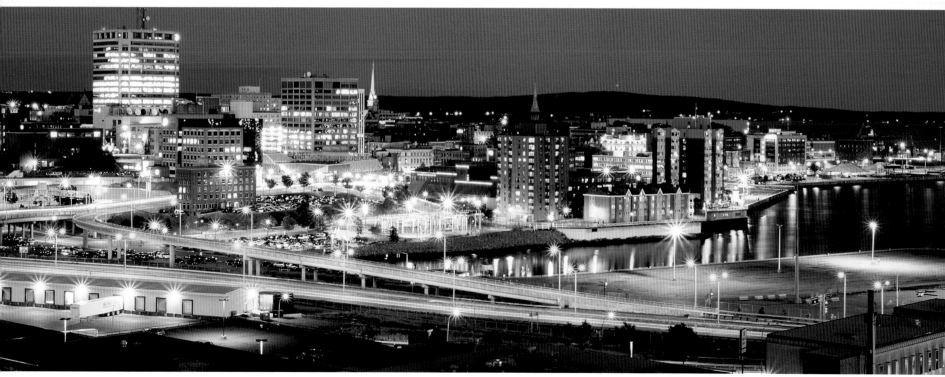

The panoramic views of Saint John from Fort Howe
National Historical Site on Magazine Street are spectacular.

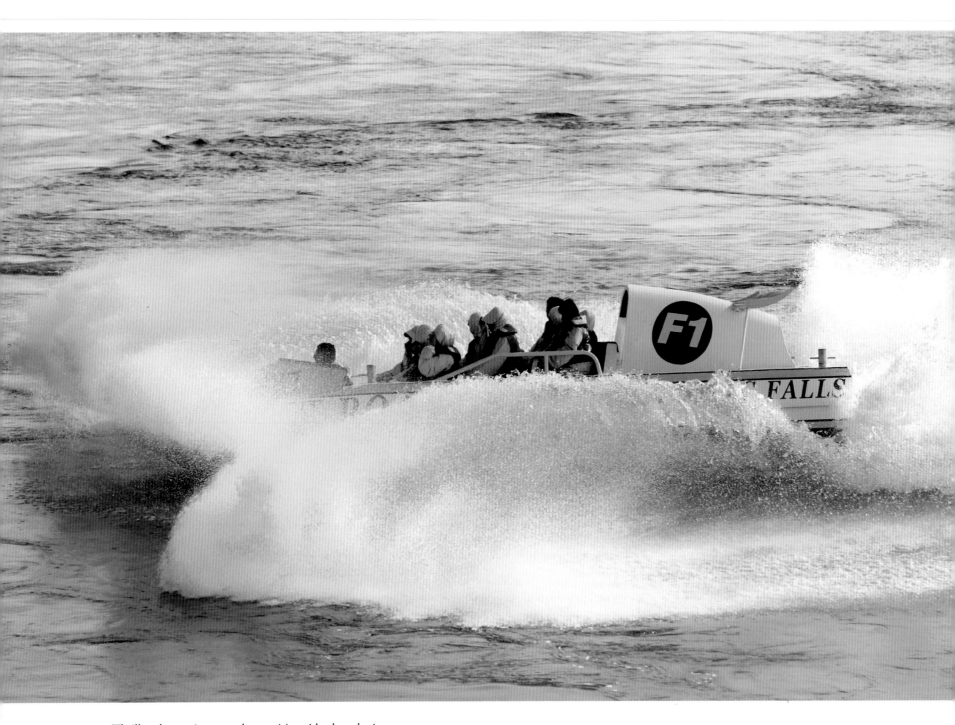

Thrill-seekers enjoy a wet but exciting ride aboard a jet boat at the Reversing Falls, where rising Fundy tides flow up against the sea-bound Saint John River.

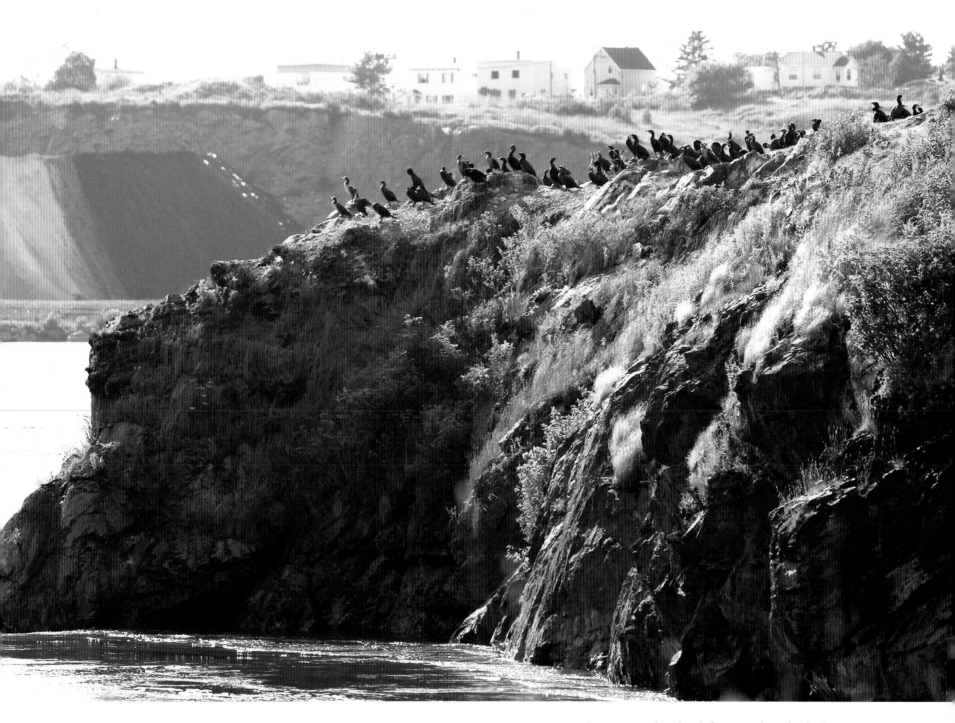

Cormorants take a break from searching for food
on the Saint John River at the Reversing Falls.

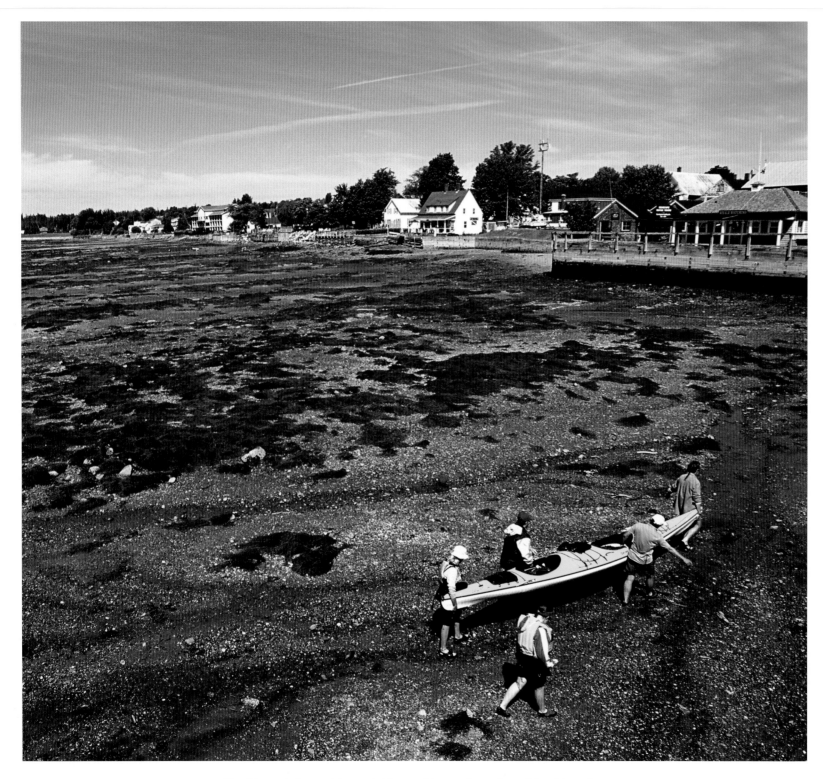

Kayaking, whale-watching and tide-watching are just a few of the things that
tourists can do at St. Andrews, a picturesque and historic seaside resort town.

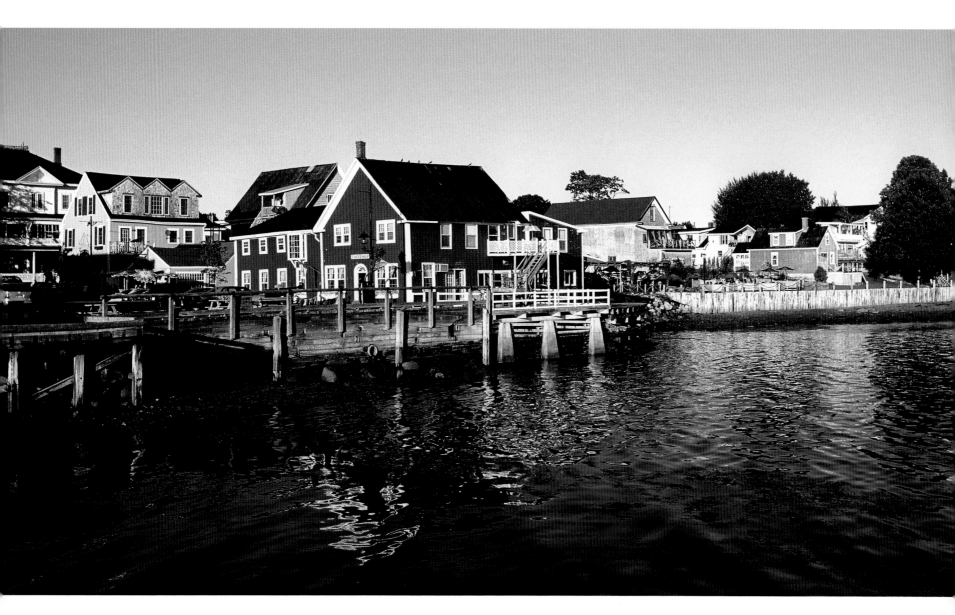

St. Andrews has long been one of New Brunswick's premier tourist destinations.

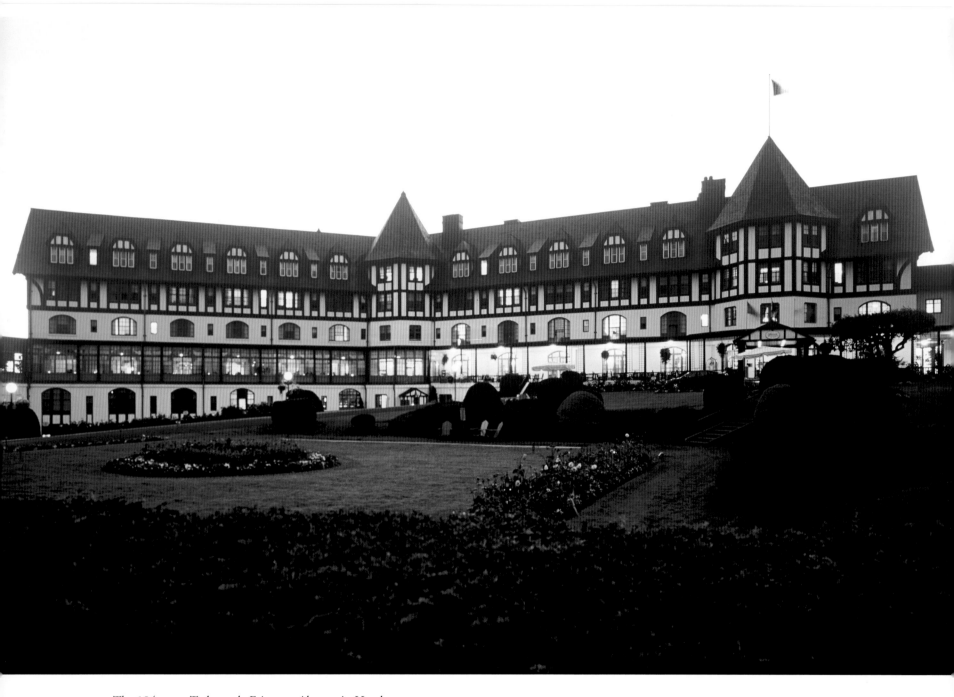

The 184-room Tudor-style Fairmont Algonquin Hotel
is one of the many historic buildings in St. Andrews.

The village of Alma, located just east of Fundy National
Park, has many facilities that cater to tourists.

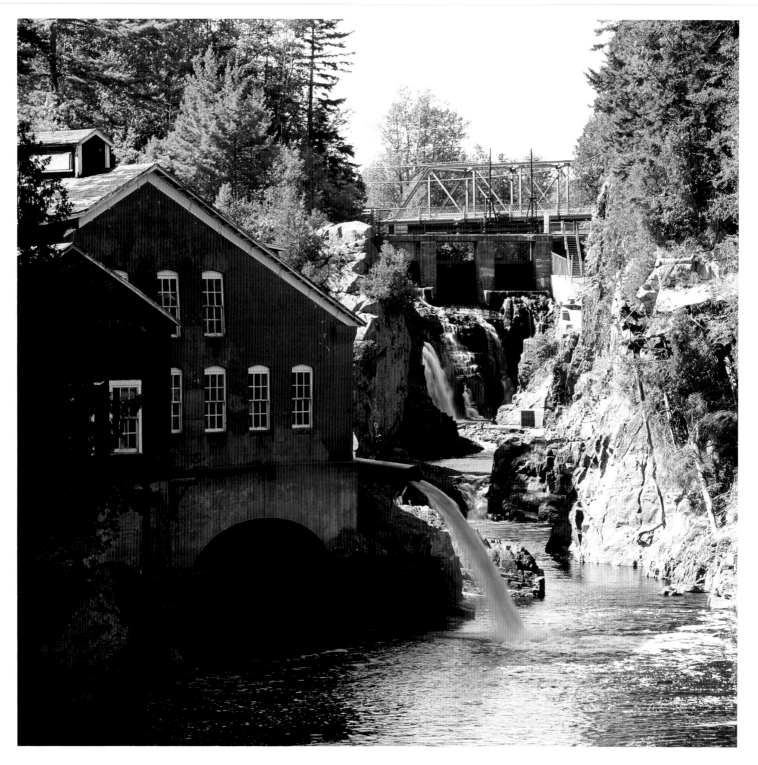

St. George is famous for its waterfalls and gorge
on the Magaguadavic River.

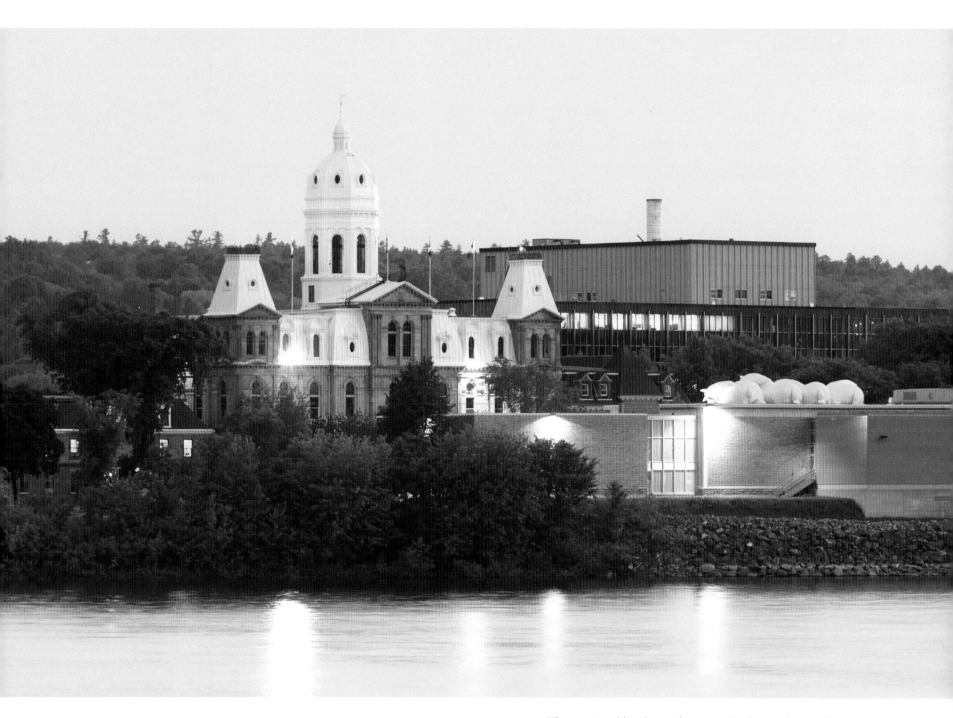

The provincial legislature dominates Fredericton's waterfront.

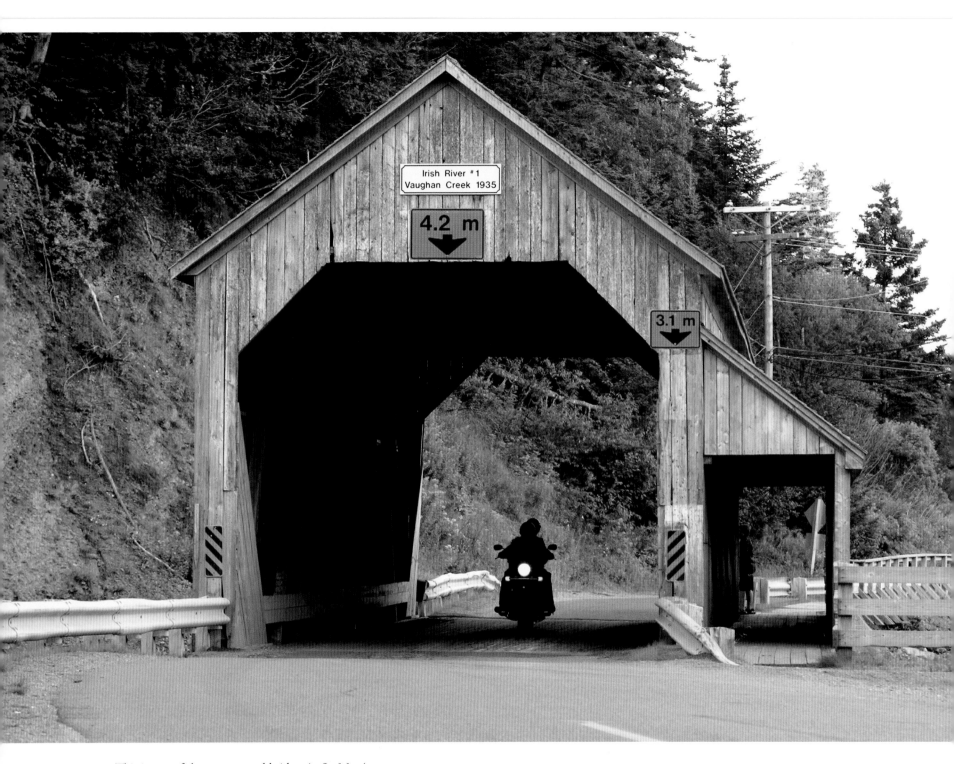

This is one of the two covered bridges in St. Martins
and one of 74 in the province.

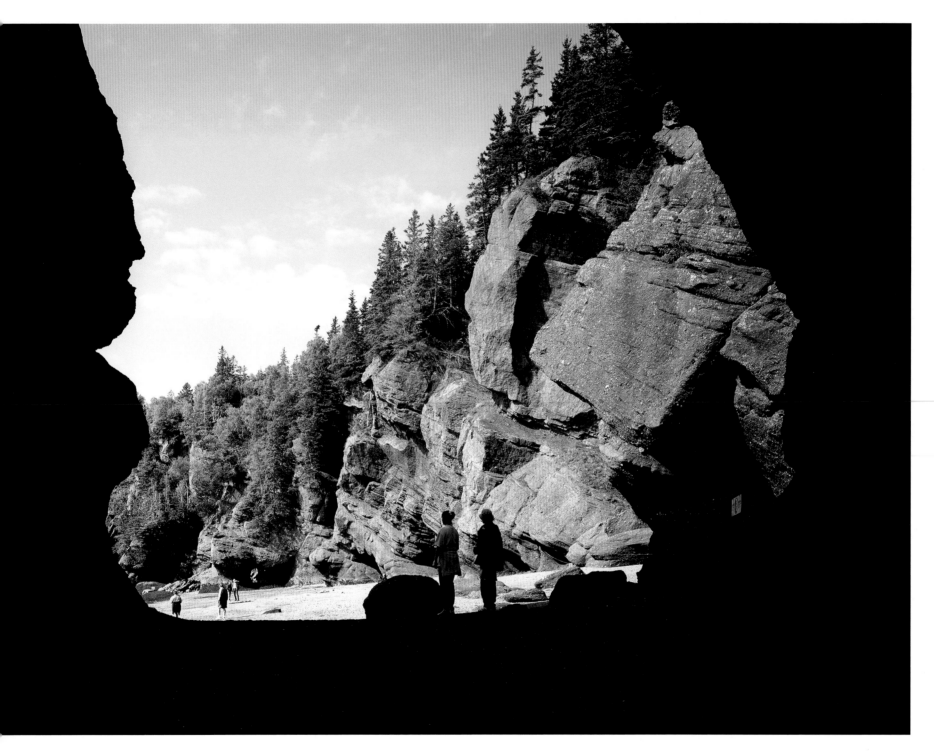

Hopewell Rocks is full of eroded sea stacks
known locally as "flowerpots."

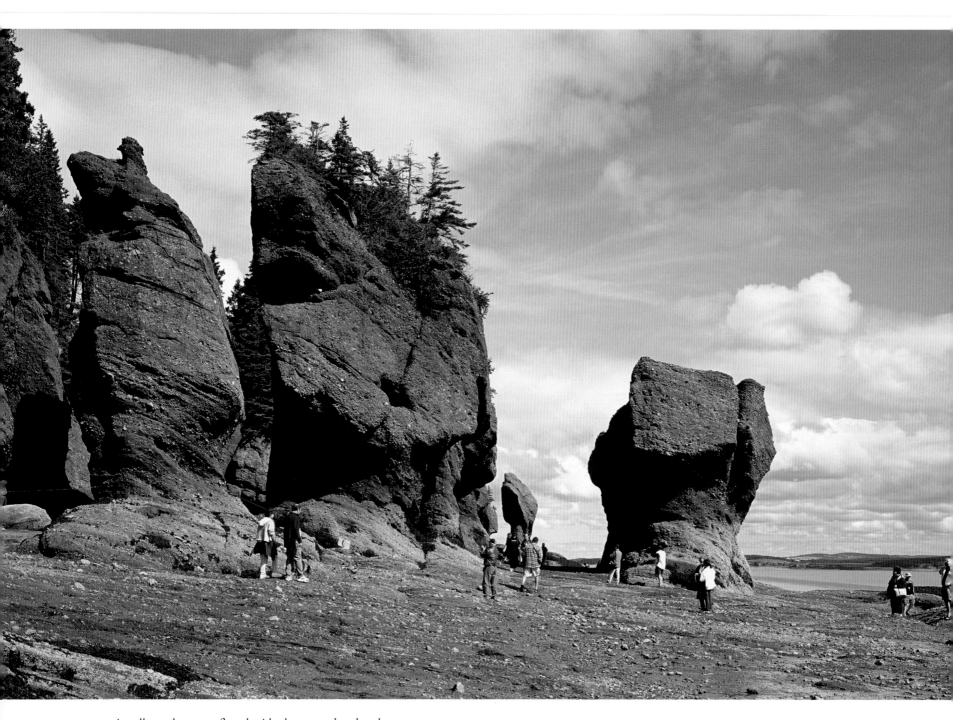

A walk on the ocean floor beside the sea-sculpted rock
formations during low tide at Hopewell Rocks is a thrill
for all visitors.

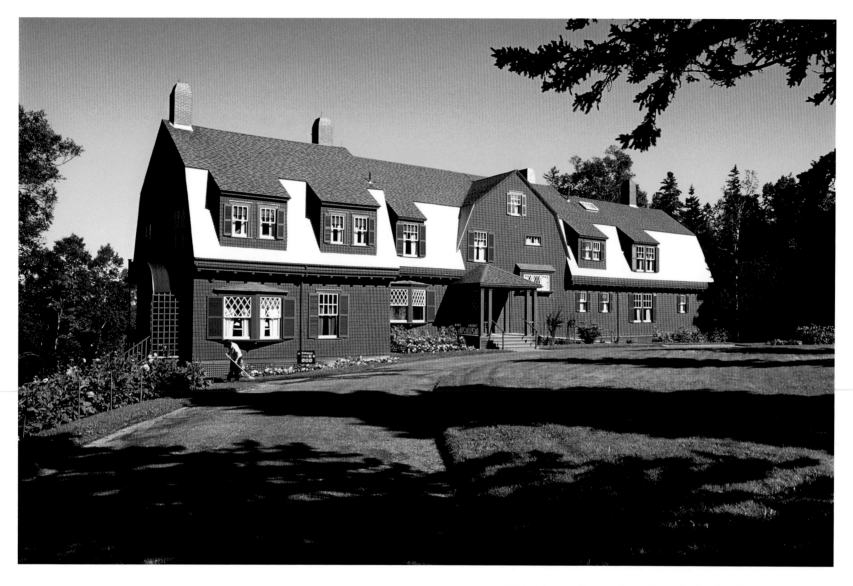

This 34-room "cottage" on Campobello Island belonged to former U.S. President Franklin D. Roosevelt. Now an international park, it is staffed by informed guides from both Canada and the U.S. during summer months.

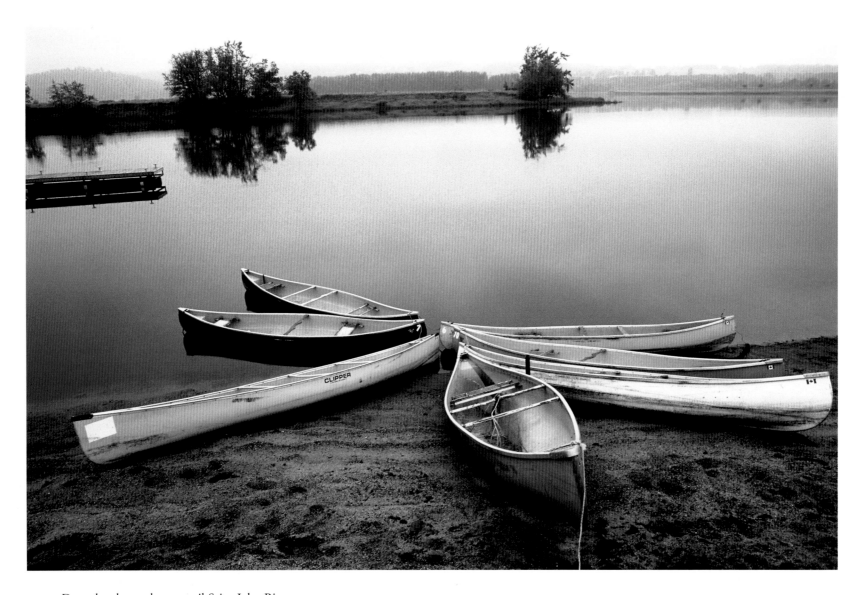

Dawn breaks on the tranquil Saint John River,
west of Fredericton.

Celebrating
PRINCE EDWARD ISLAND

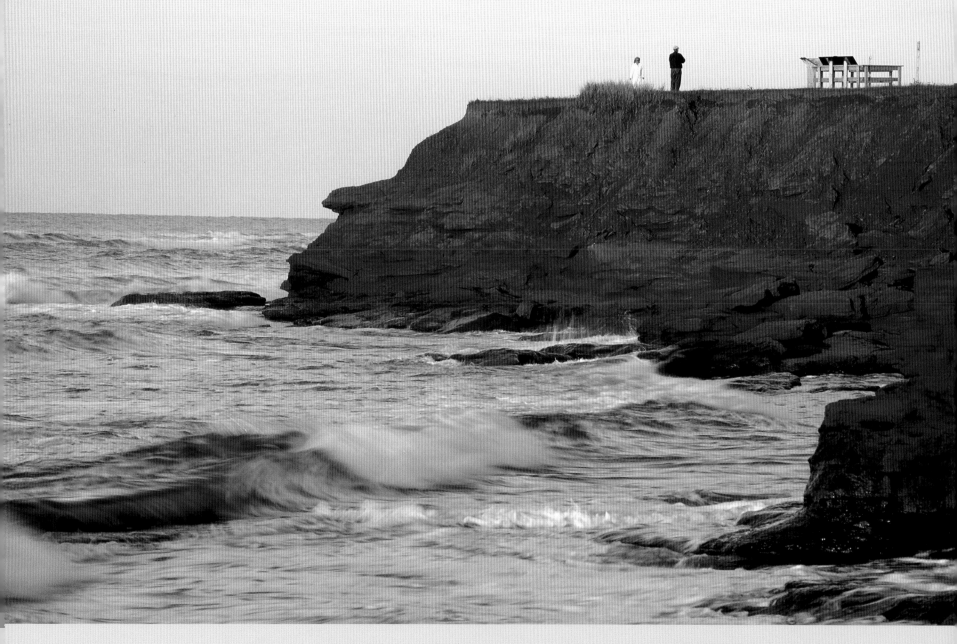

Waves pound the red sandstone cliffs
at Prince Edward Island National Park.

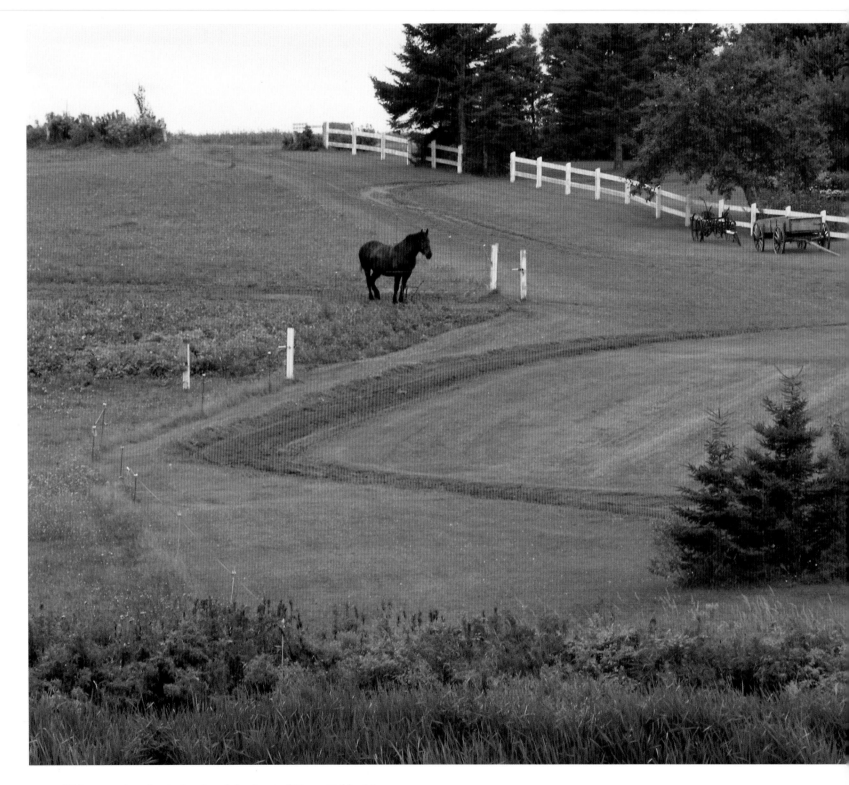

This pastoral setting is the site of the Anne of Green Gables Museum at
Park Corner, just west of Cavendish. It was here that Lucy Maud Montgomery,
author of *Anne of Green Gables*, was married in 1911.

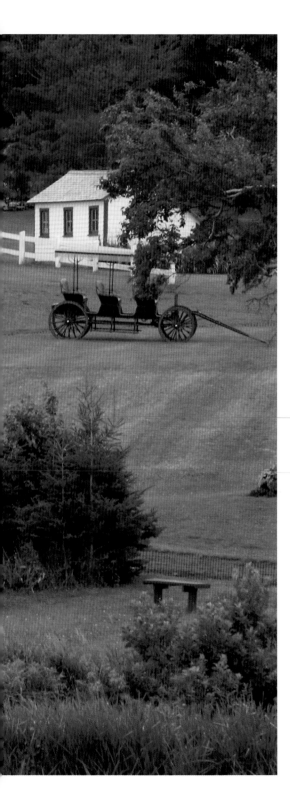

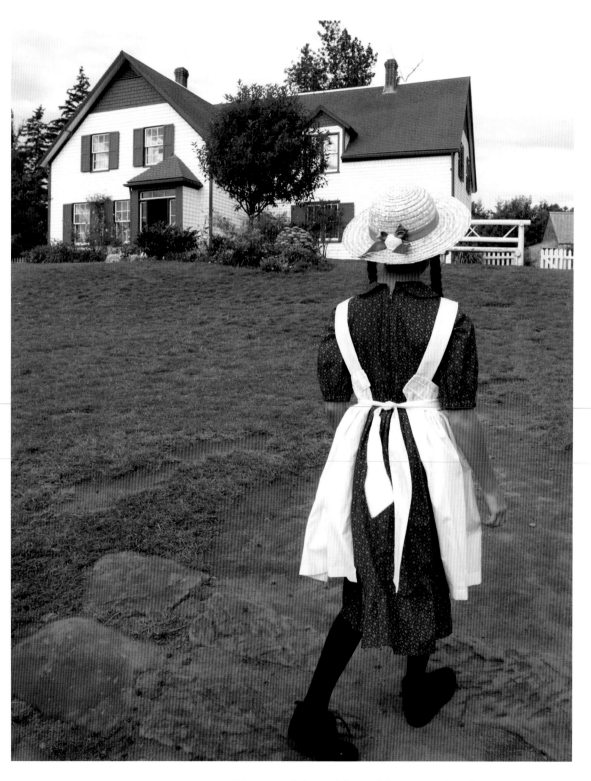

The story of *Anne of Green Gables* has captivated
the world. *The House of Green Gables* is Prince Edward
Island's most popular tourist attraction.

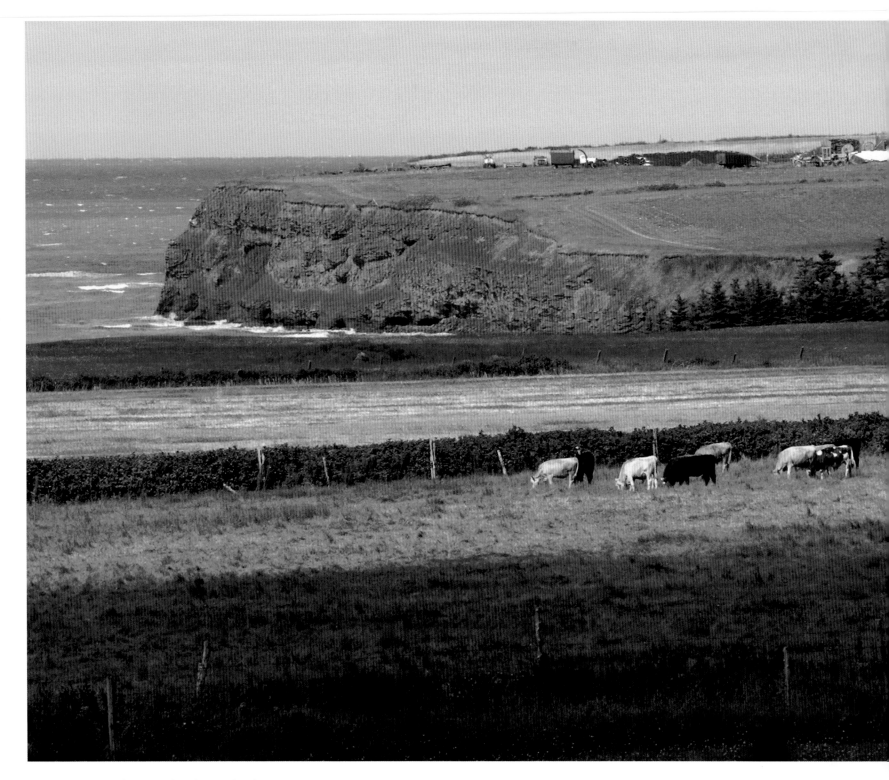

PEI is Canada's most densely populated province, yet it remains mostly rural. In fact, half the province is farmland.

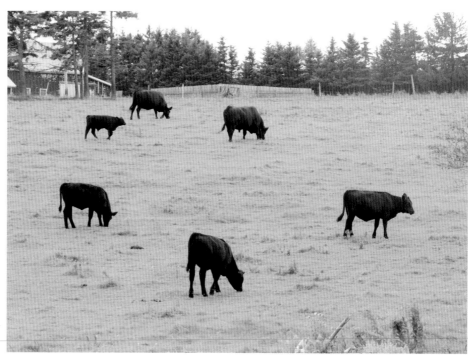

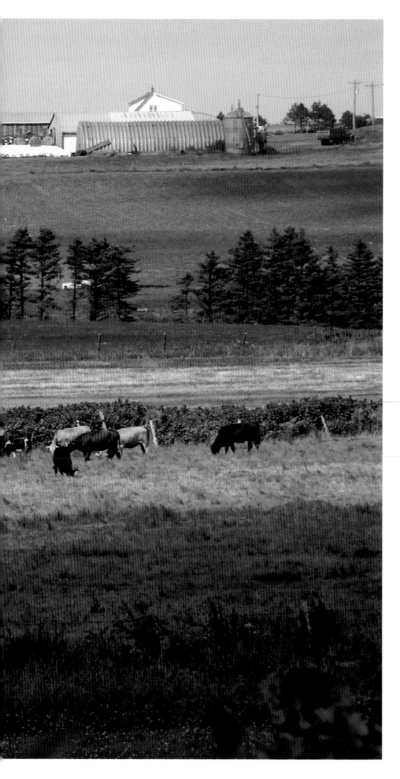

PEI is also known as Spud Island because of its prodigious potato production, but it has many cattle farms, too.

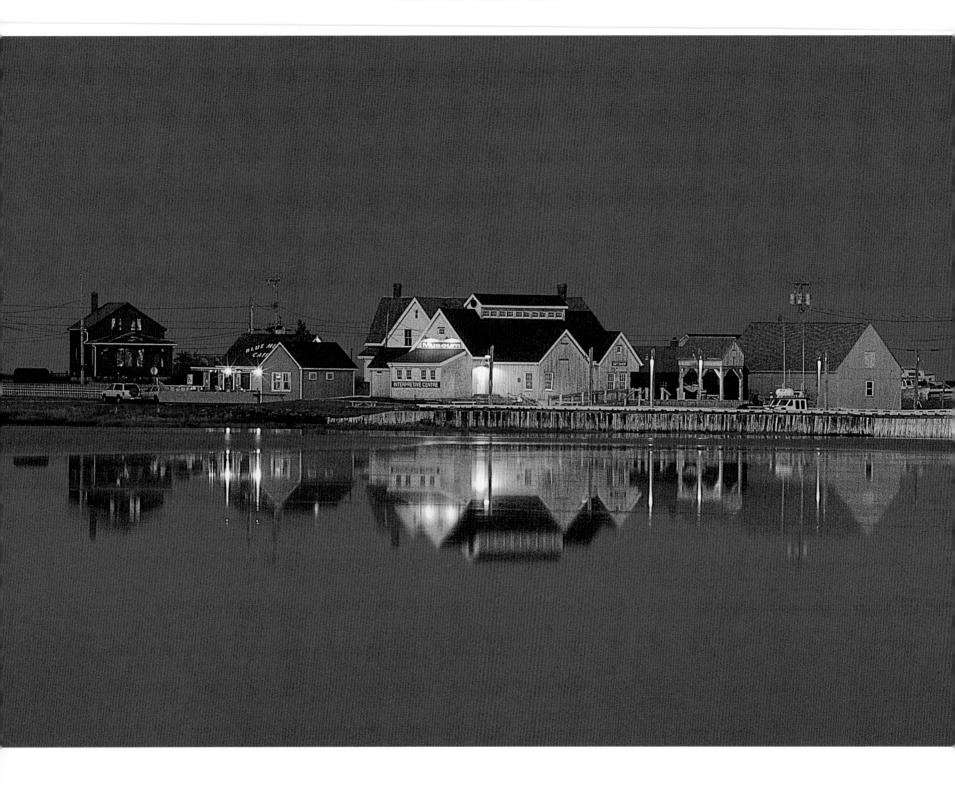

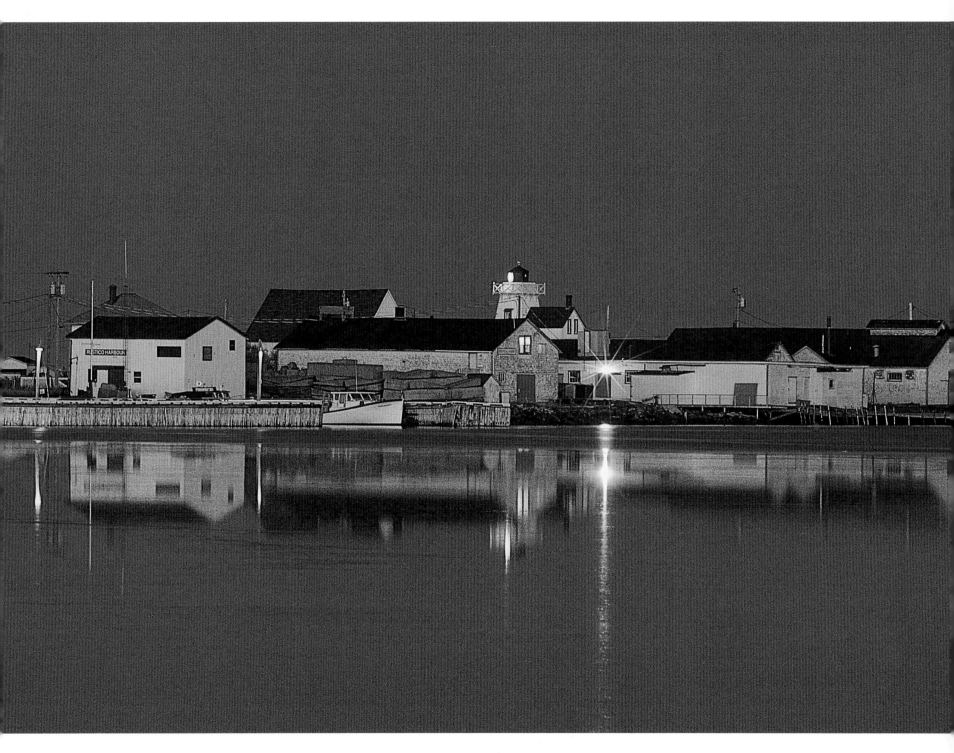

North Rustico is a picture-perfect fishing village located just west of Prince Edward Island National Park.

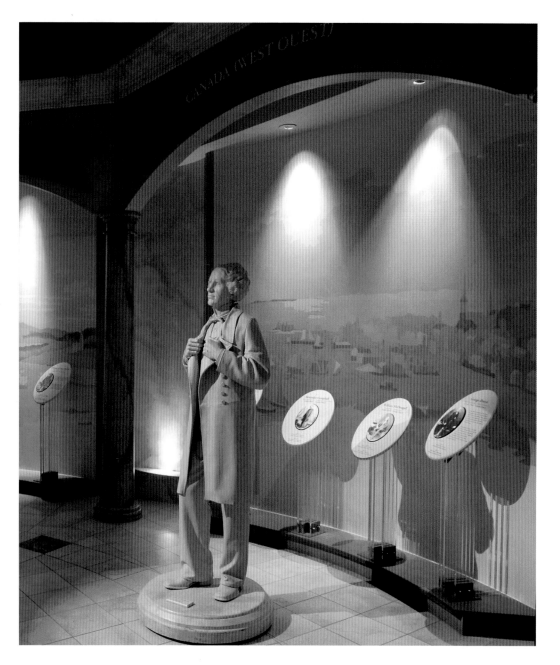

Founders Hall uses hi-tech audiovisuals to tell the story of
Canada from the 1864 Charlottetown Conference, which led
to the creation of the Dominion of Canada, to the present.

Right: A war memorial stands guard at Province House
where the Fathers of Confederation met in 1864.
The building is now the seat of the provincial legislature.

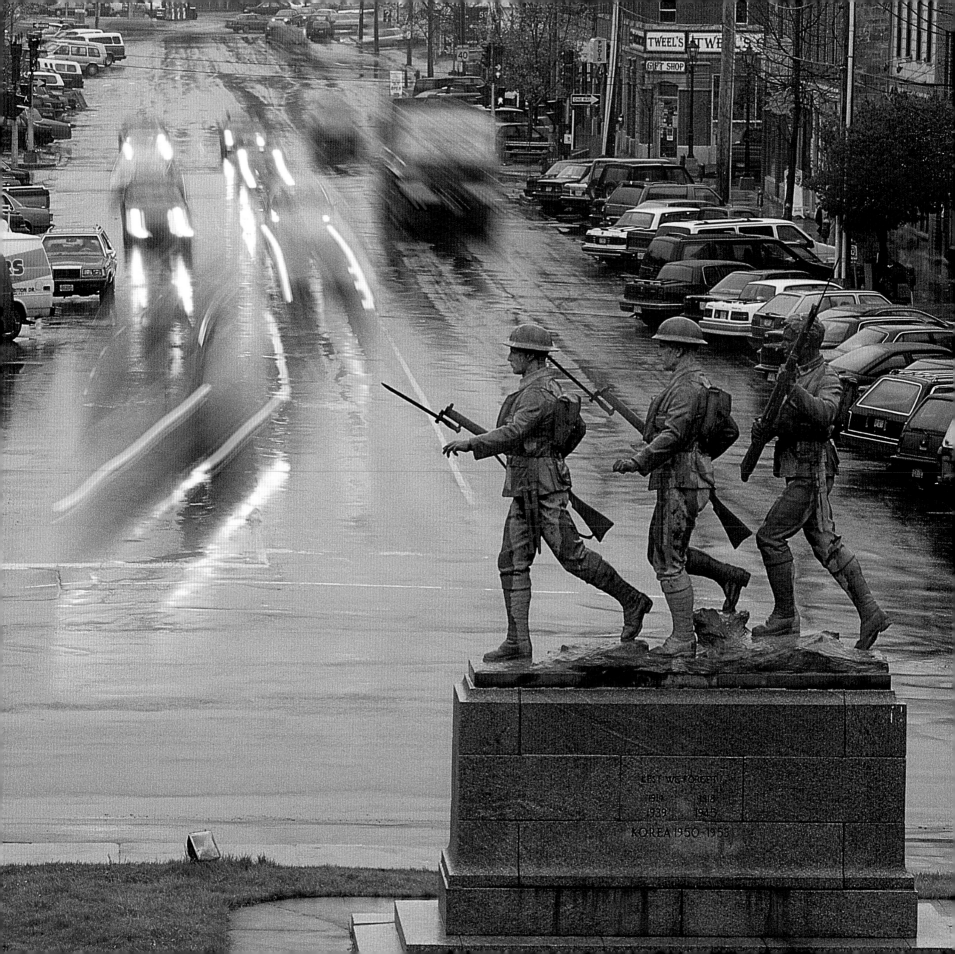

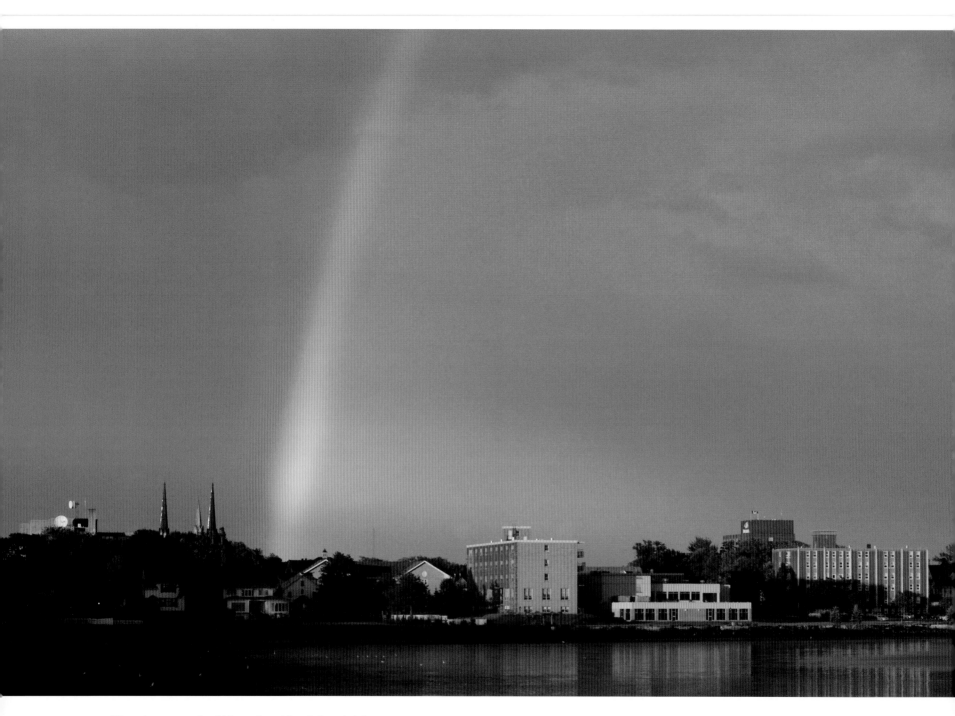

There is no pot of gold here, but this rainbow brightens
up Charlottetown in this view from Victoria Park.

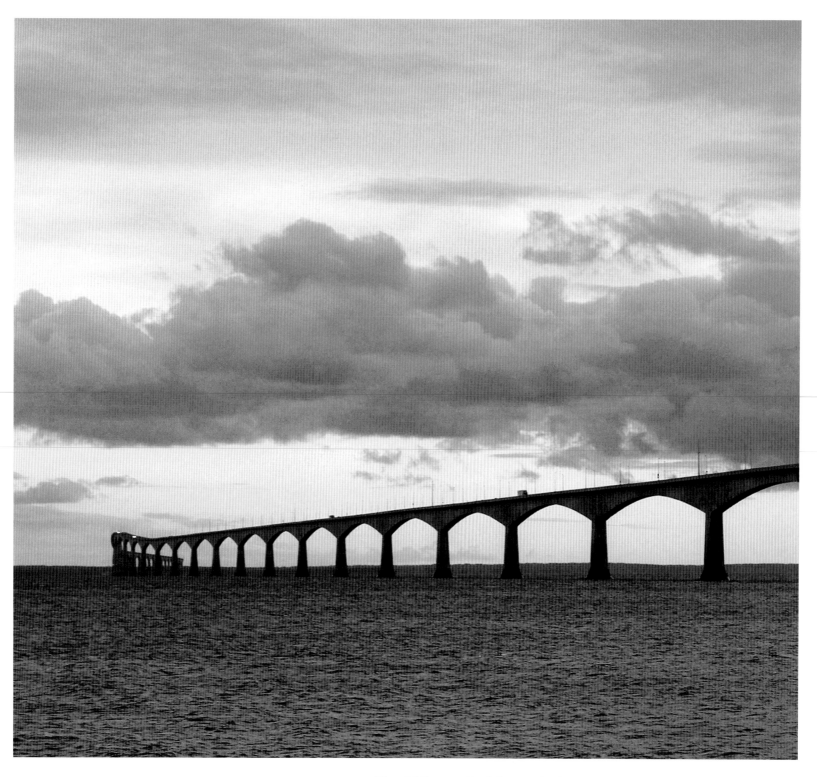

The 13-kilometre Confederation Bridge connects PEI to New Brunswick —
and the rest of mainland Canada. It was completed in 1997 at the cost
of $900 million. The bridge has 44 spans over the Northumberland Strait.

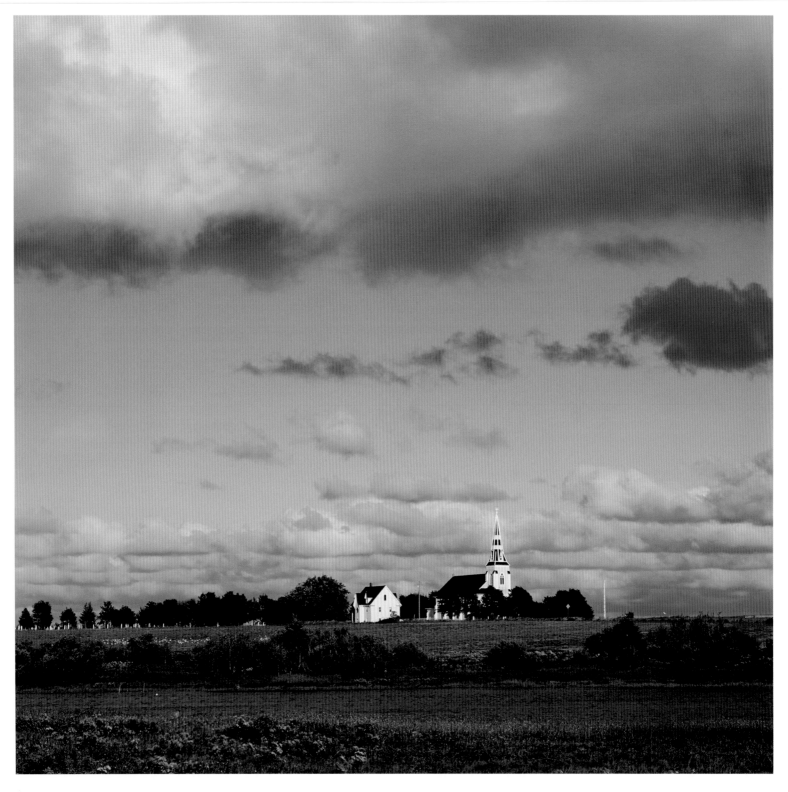

Grand River and the rest of Prince County in western PEI are less travelled than
Charlottetown and Cavendish, but the scenery is spectacular.

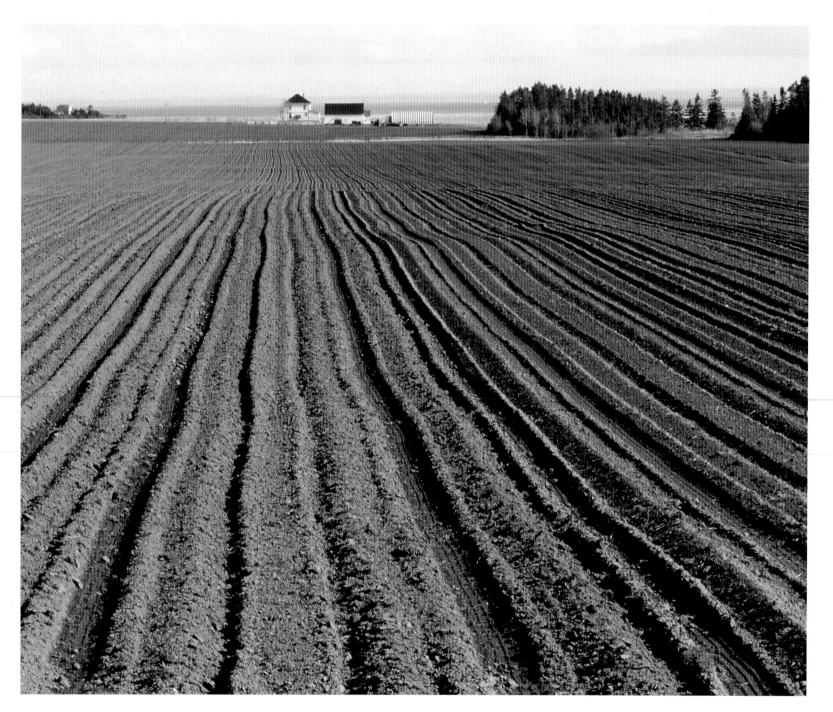

PEI's rich sandy soil is perfect for growing potatoes. The soil's colour comes from broken-down, iron-rich sandstone.

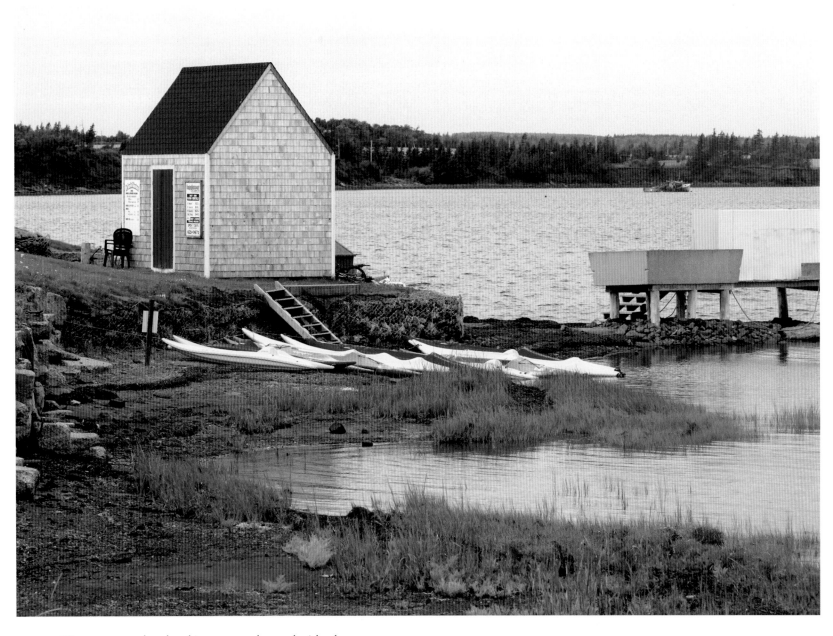

Water sports such as kayaking are popular on the island
because water is seemingly everywhere.

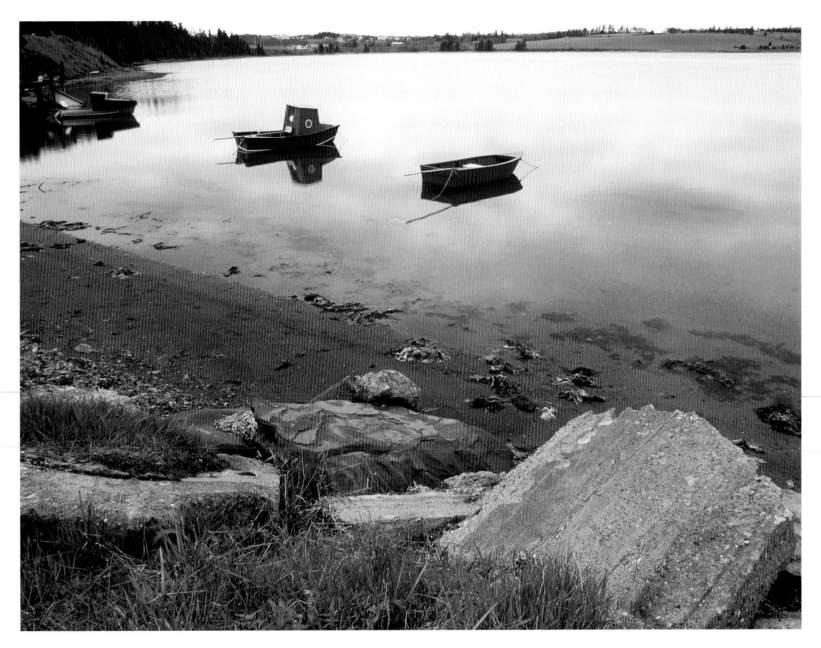

Prince Edward Island has many peaceful, quiet and beautiful places like this.

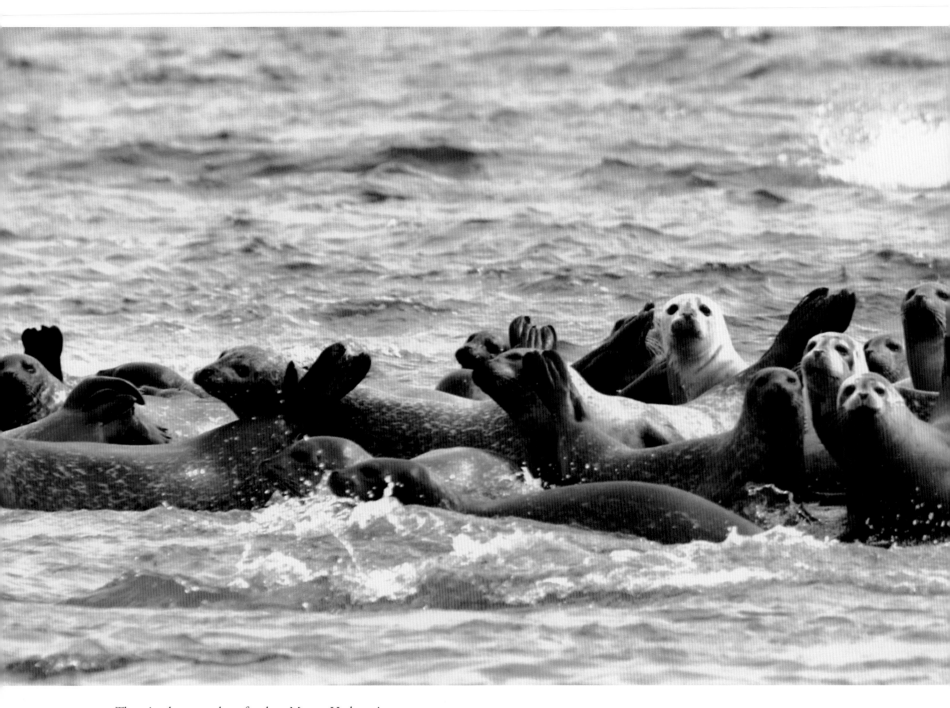

There is a large number of seals at Murray Harbour in
eastern PEI and they're always alert for any possible danger.

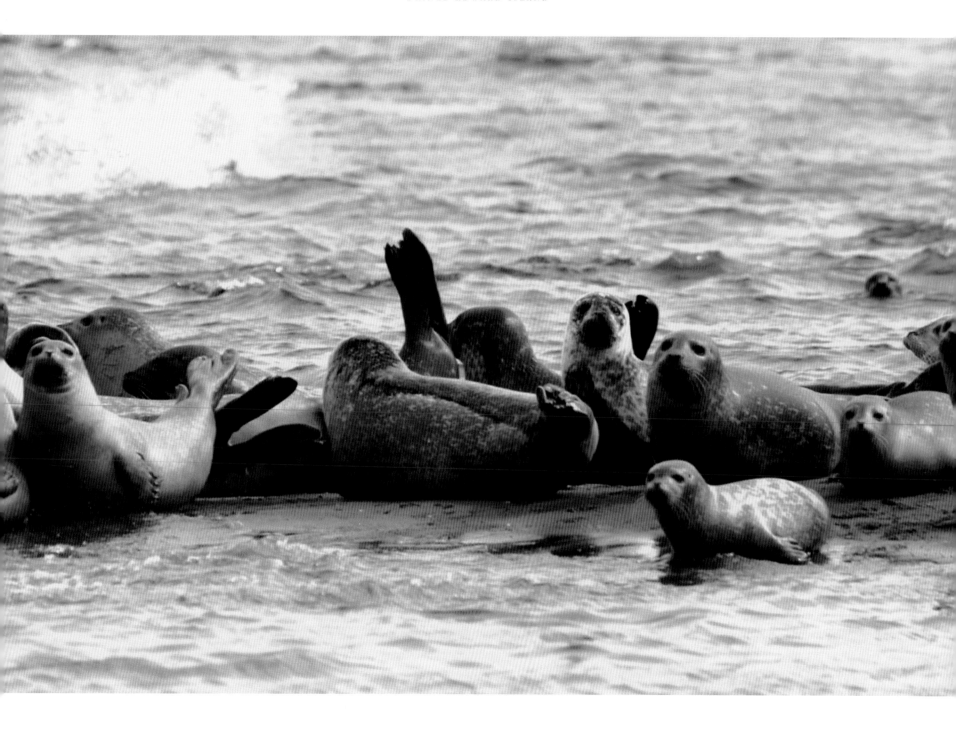

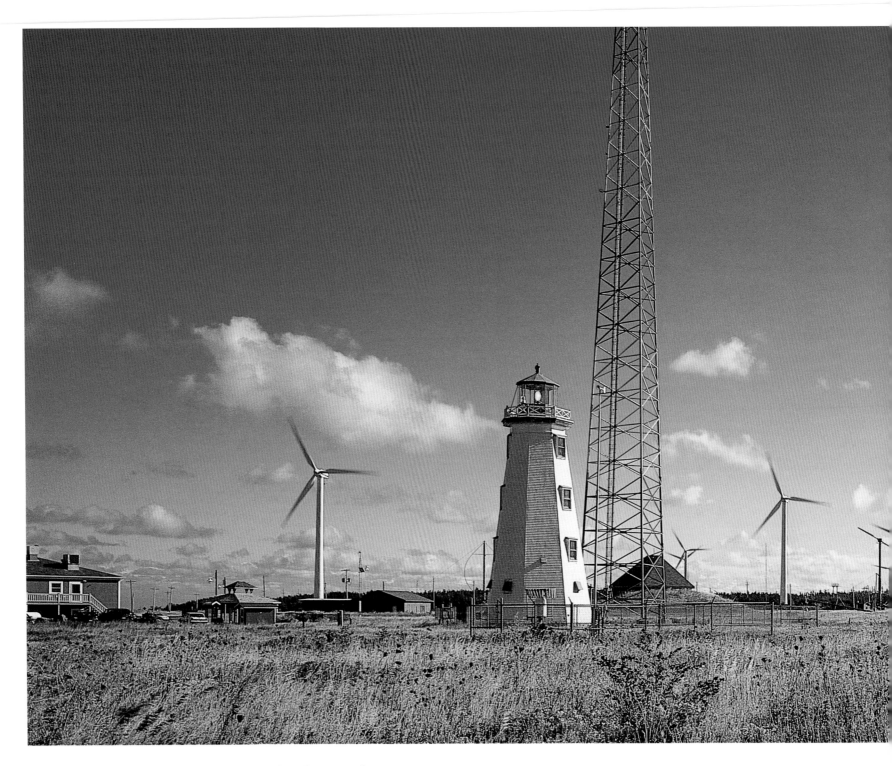

Wind turbines dominate the landscape at the Atlantic Wind
Test Site at North Cape, at the northwestern tip of PEI.

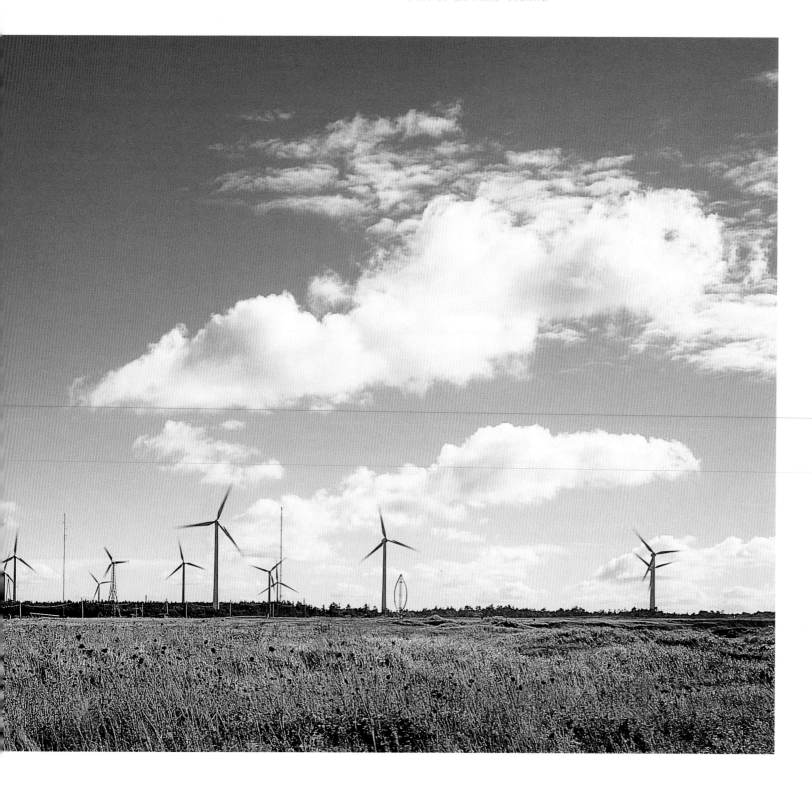

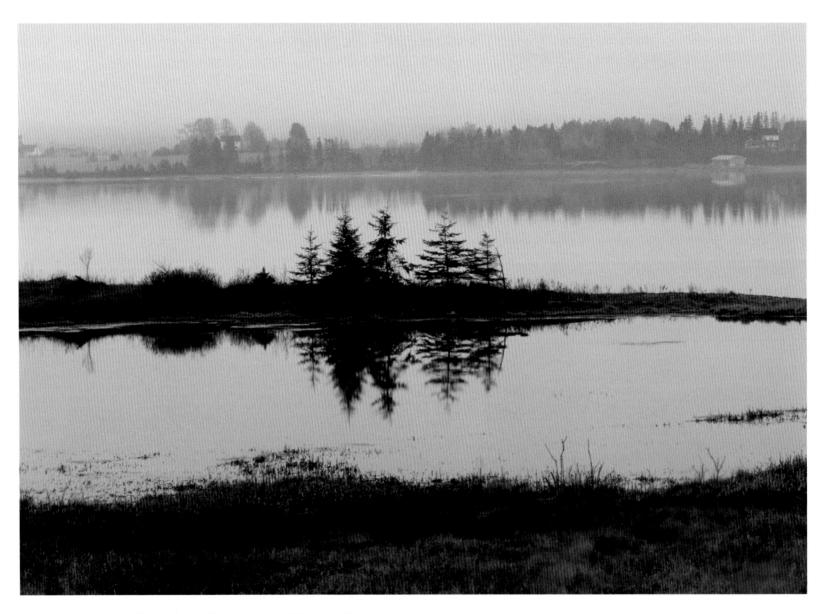

PEI is a long and narrow island spread over 5,700 square kilometres.
The sea is within easy reach no matter where you are.

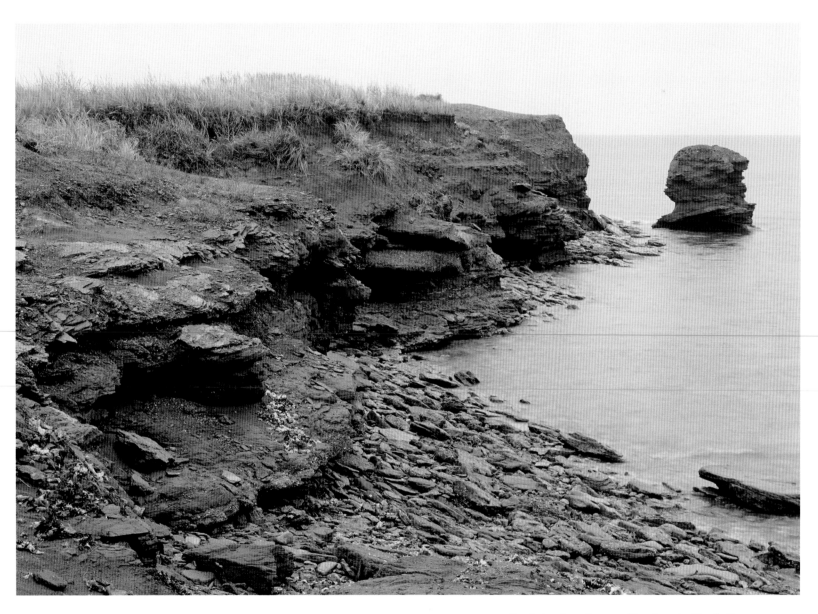

Eroded red sandstones, like these in North Cape, are a common sight.

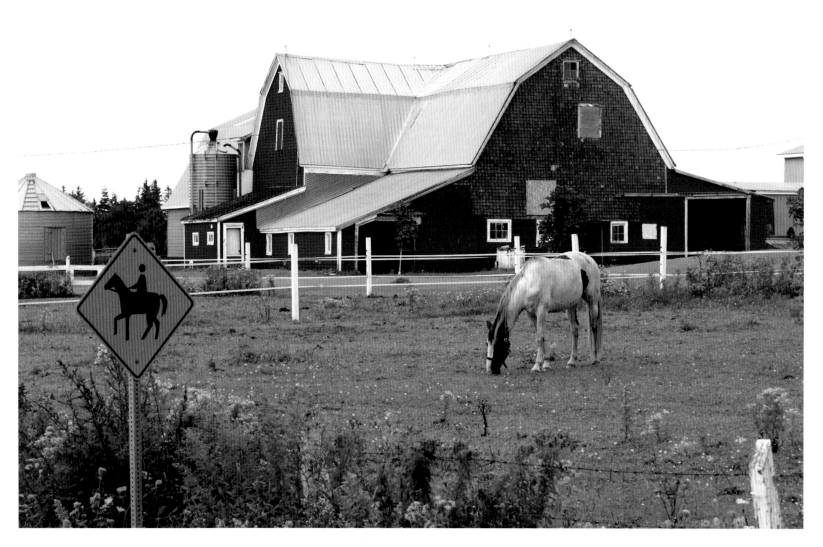

The drive between Cape Wolfe and North Cape
in western PEI offers many scenic views like this.

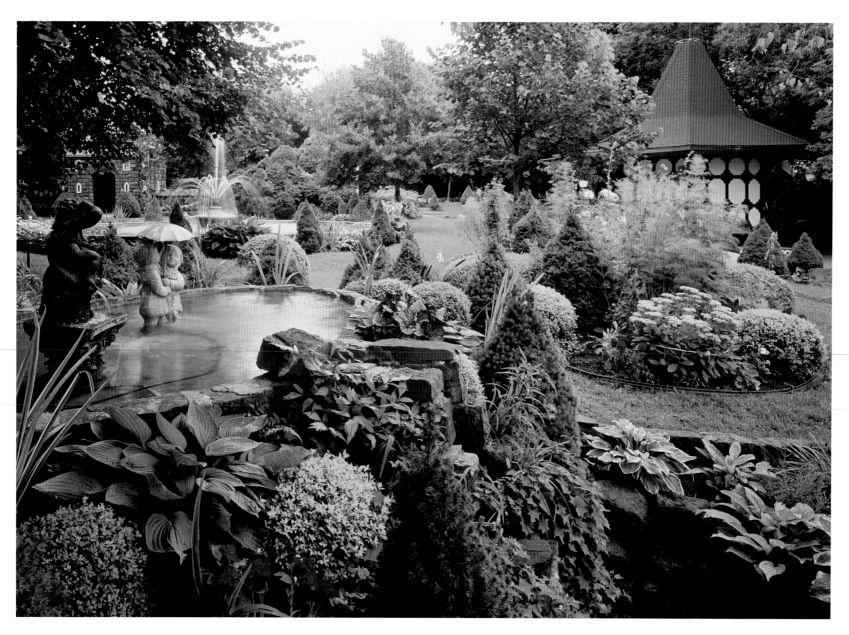

Lush green plants, water fountains and castles of various sizes
are the attractions at Kensington's Towers and Water Gardens.

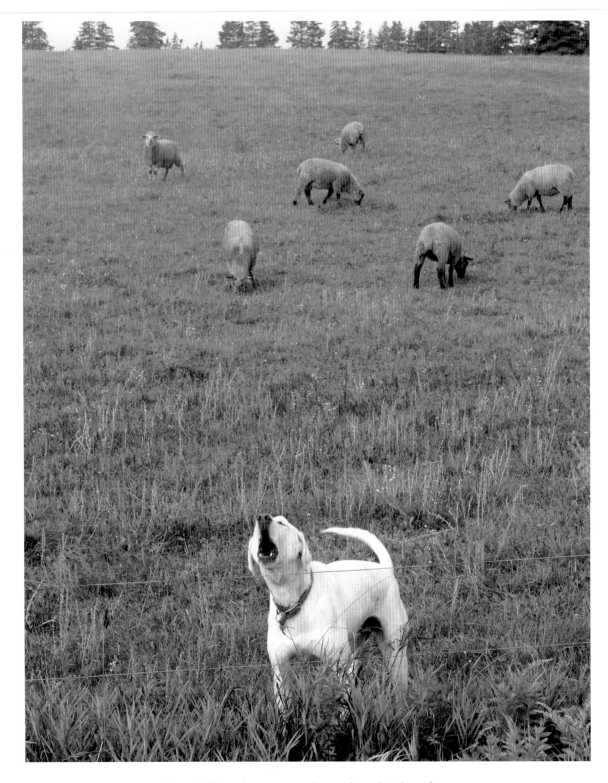

Potential intruders are warned away from this sheep farm
near Wood Islands in southeastern PEI.

PEI produces one-third of Canada's potatoes and O'Leary
(with a population of 900) is the island's biggest producer.

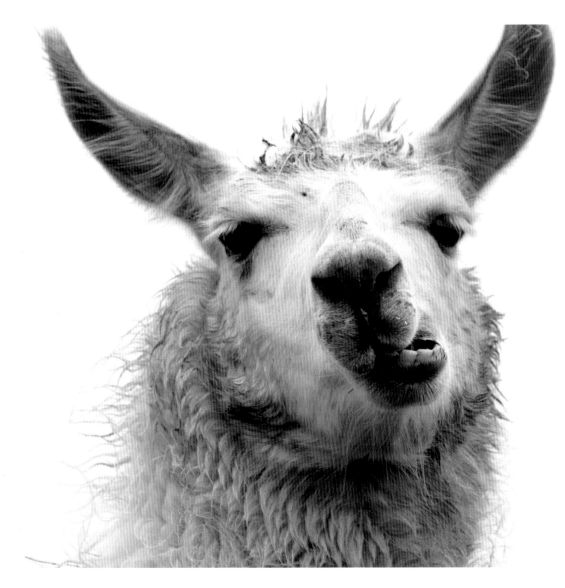

This llama at St. Peters doesn't let this portrait session
interrupt his lunch.

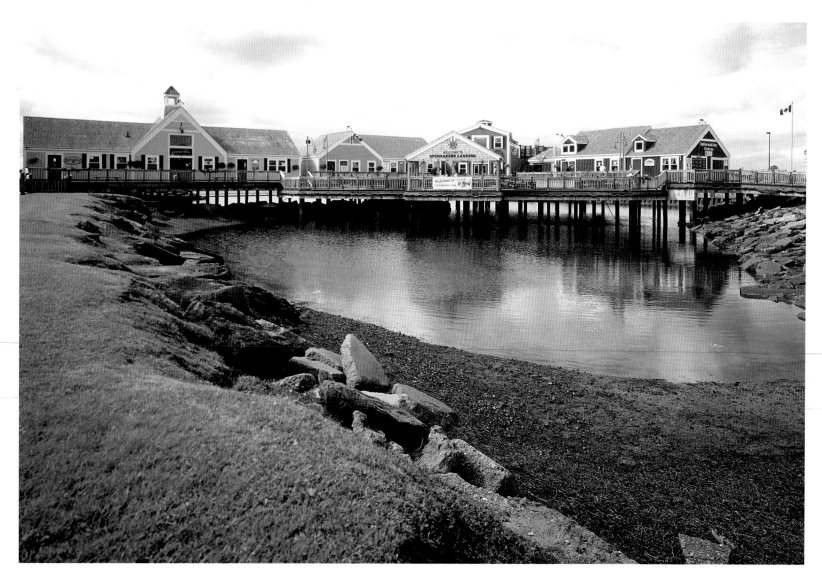

Buildings on stilts are among the unusual sights at Summerside,
a shipping port with a population of 14,000.

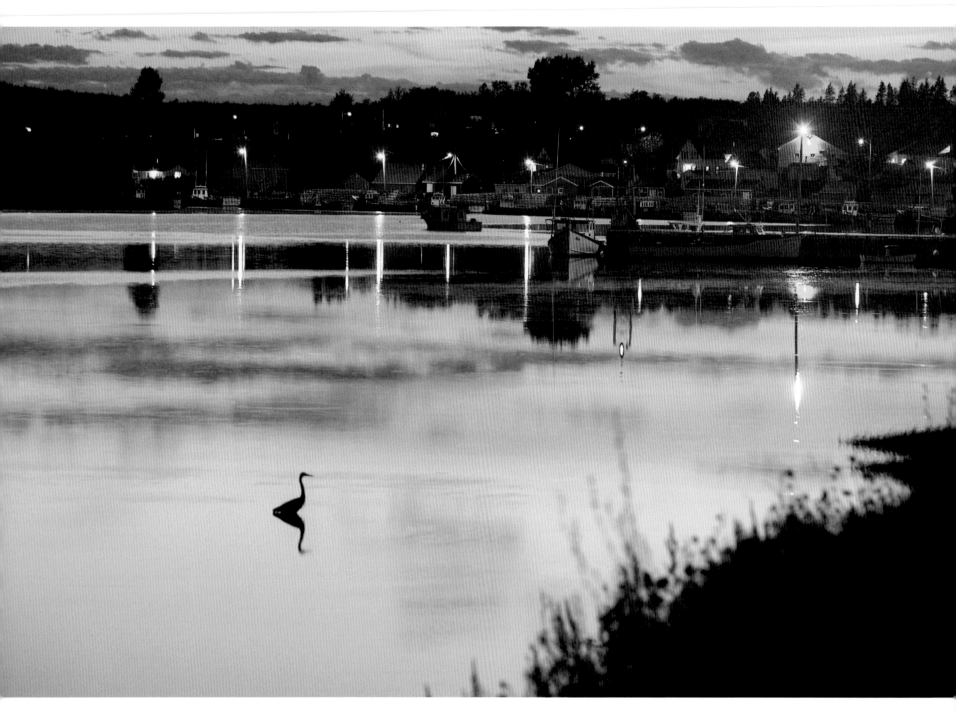

A blue heron waits patiently at dusk for its next meal at
North Rustico, a picturesque village on the north shore.

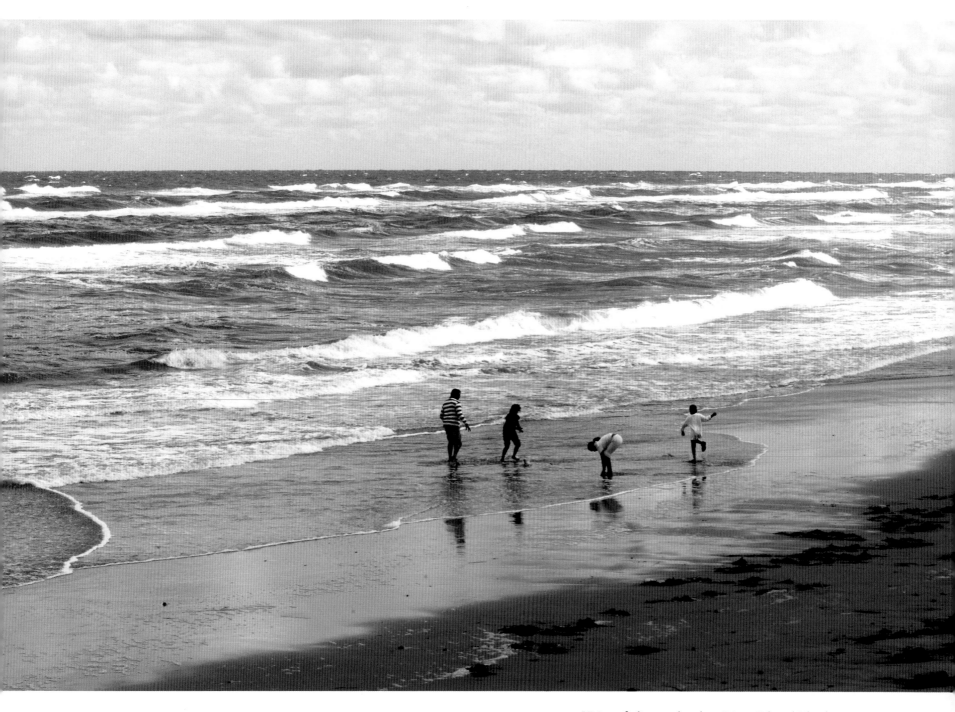

Visitors frolic on a beach at Prince Edward Island
National Park, which has a 45-kilometre coastline.

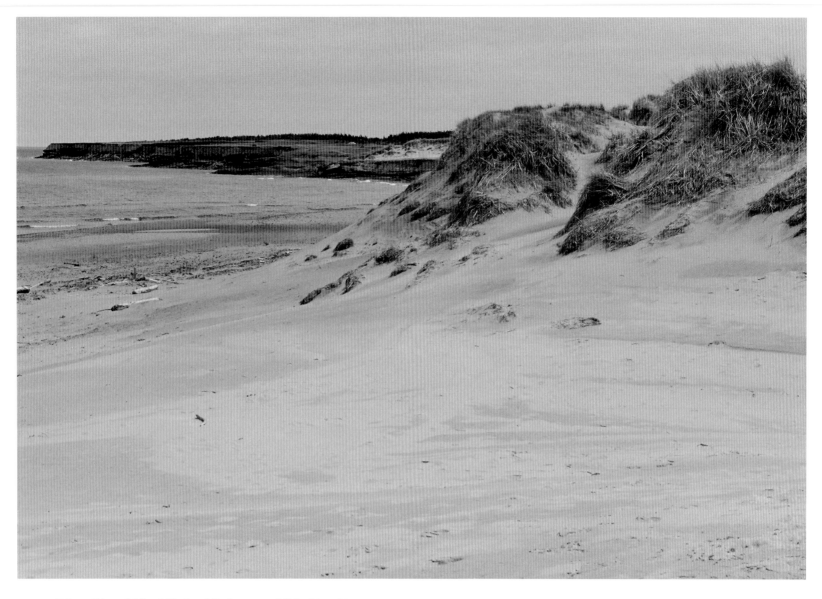

Prince Edward Island National Park was established in 1937
to protect the fragile ecosystem of sand dunes and beaches.

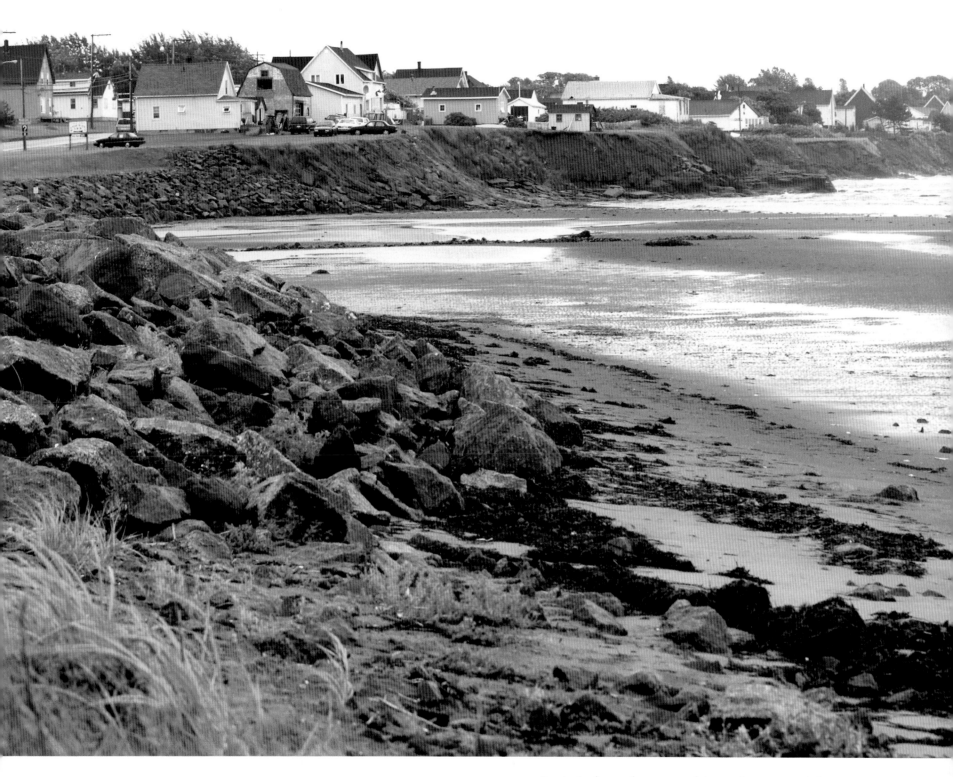

Souris, in the northwest part of the province, was settled
by Acadians in the 1700s. Today, it is a seaport with a ferry
service to Iles de la Madeleine, Quebec.

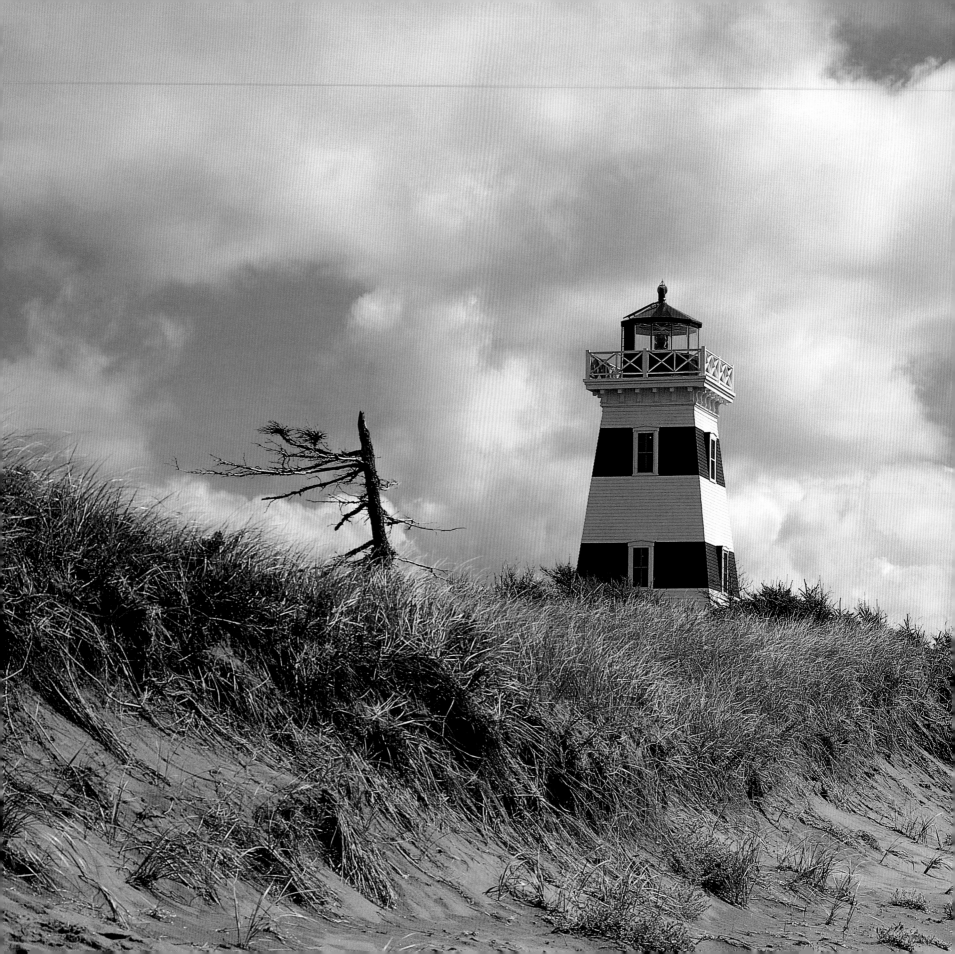

There are many sand dunes like this at the
Prince Edward Island National Park.

Left: The West Point Lighthouse, located in Cedar Dunes
Provincial Park in western PEI, is also an inn.

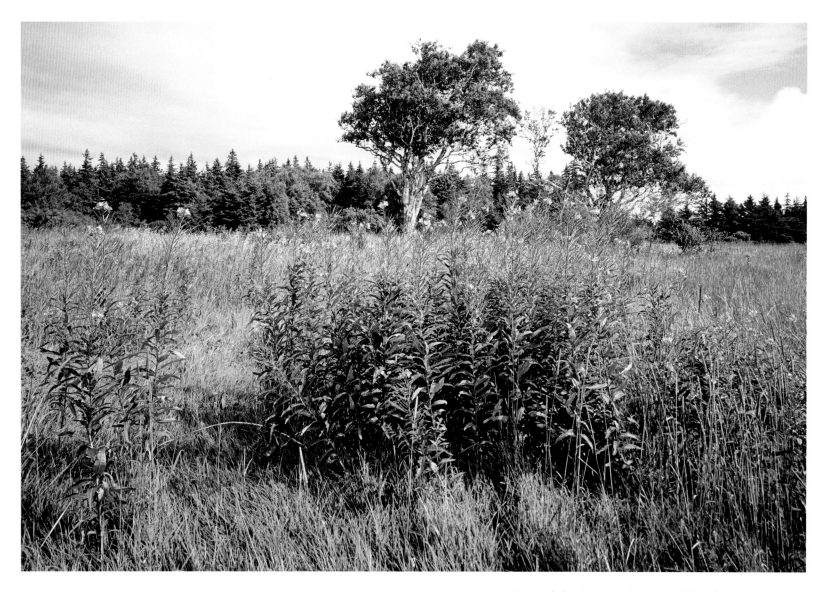

Fireweeds brighten up the Prince Edward Island
National Park at Greenwich.

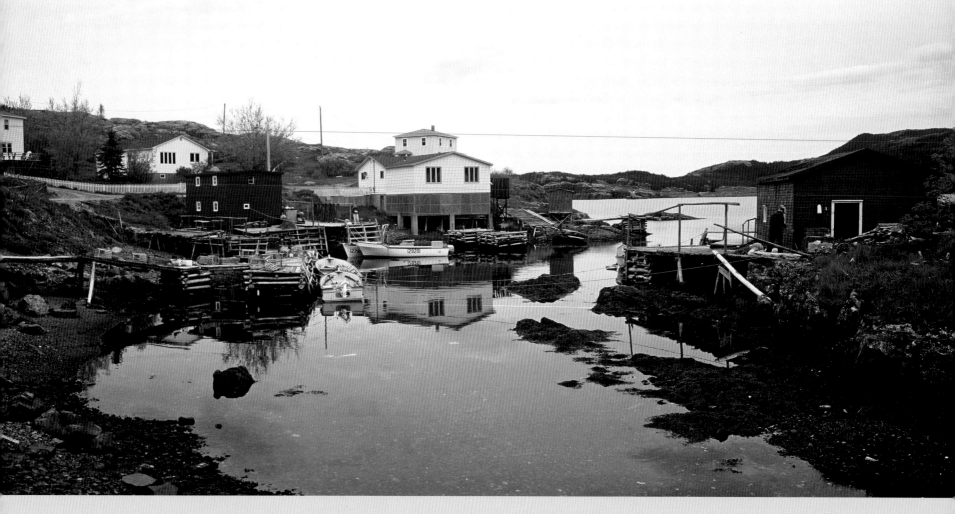

Celebrating

NEWFOUNDLAND AND LABRADOR

Salvage, one of the oldest European settlements, is a scenic
outport located northeast of Terra Nova National Park.

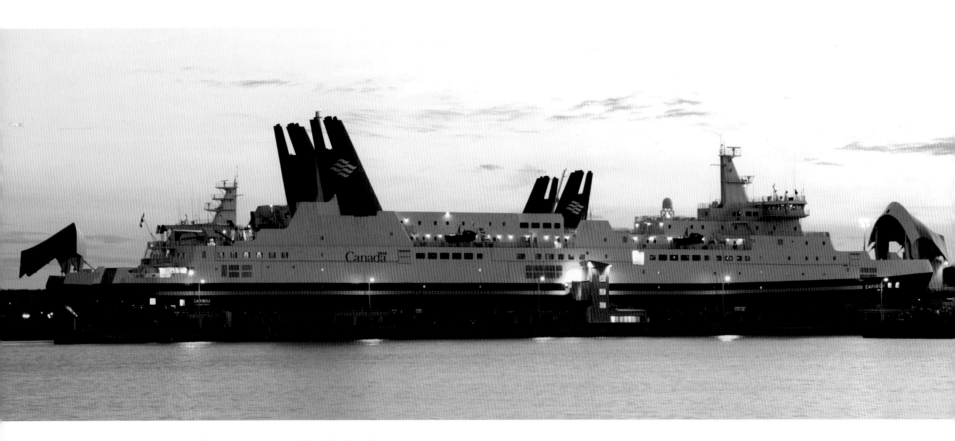

Marine Atlantic's ferries connect Newfoundland and
Nova Scotia. One sails between North Sydney, Nova
Scotia and Port aux Basques, Newfoundland, and the
other between North Sydney and Argentia.

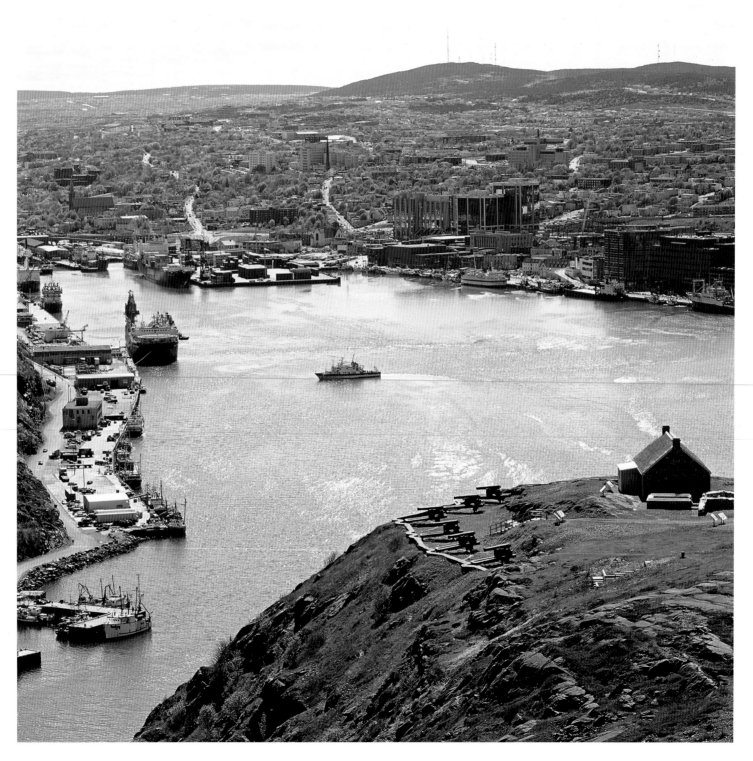

From Signal Hill, one can see much of St. John's (top),
the Battery (right), and the South Side Hills (left).

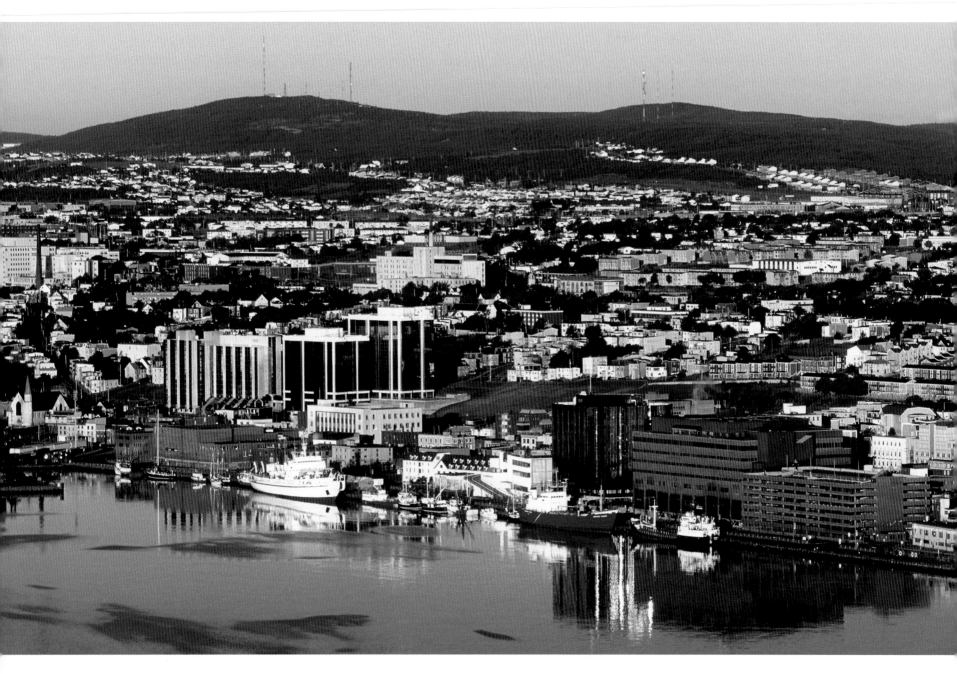

The metropolitan area of St. John's, Newfoundland's capital,
has a population of almost 200,000.

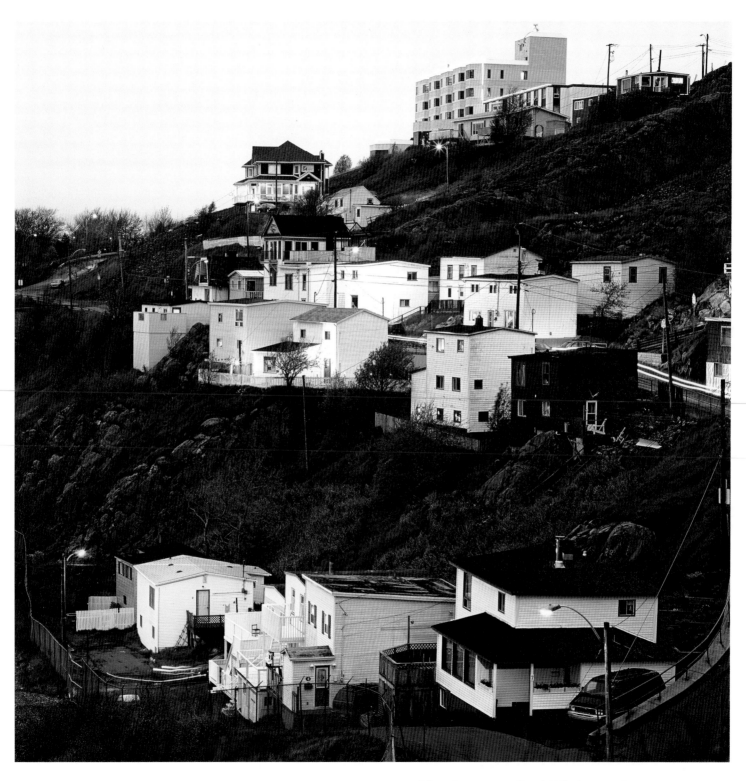

These houses near Signal Hill, the most famous
landmark in St. John's, have three things going
for them: location, location, location.

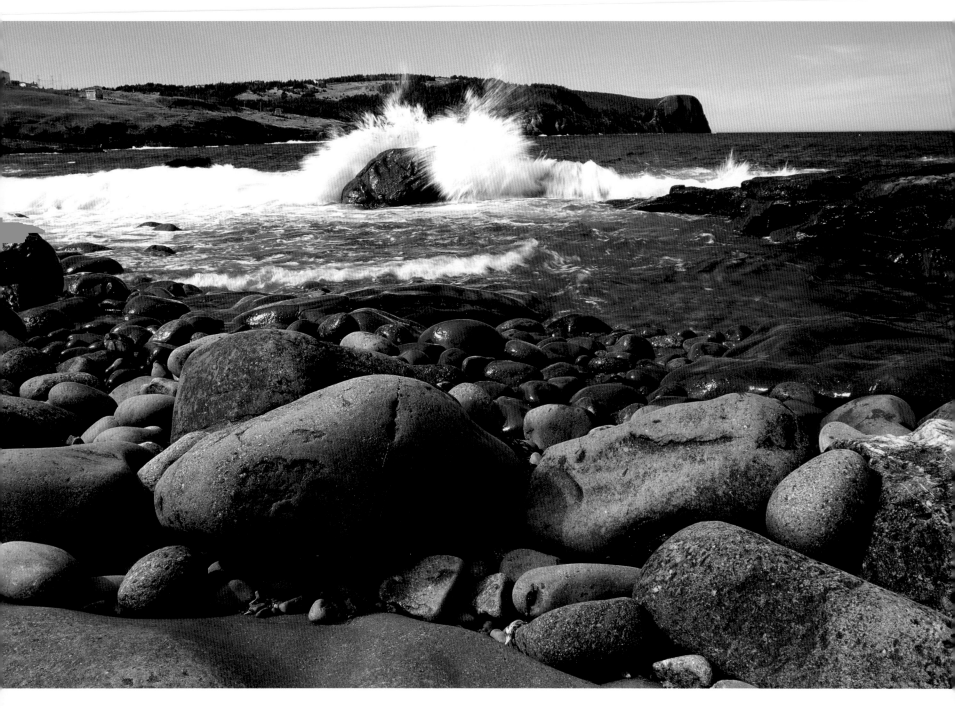

Pounding waves polish stones on the Avalon Peninsula
at Conception Bay northwest of St. John's.

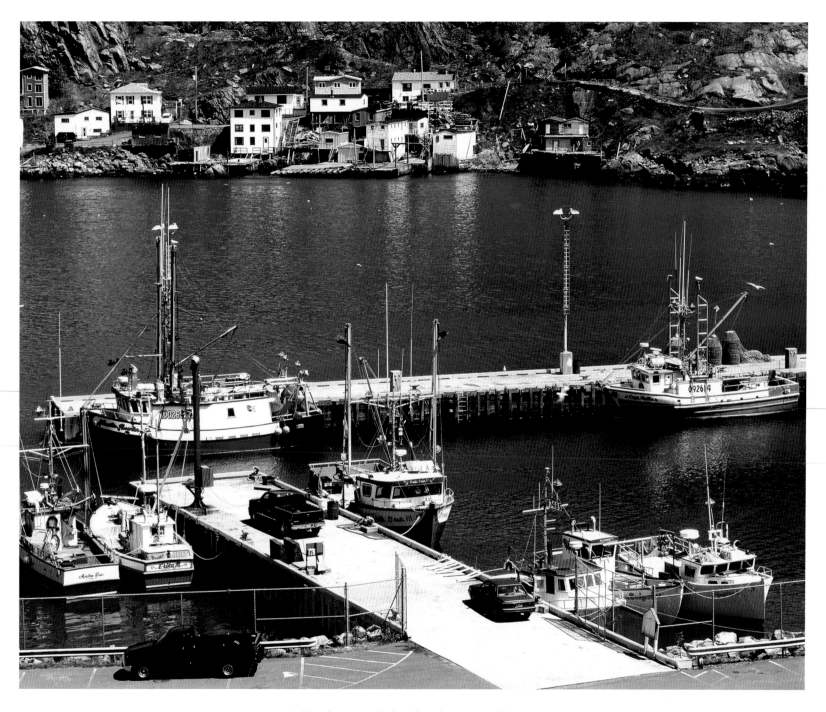

Fishing boats are sheltered in the Narrows between
the Atlantic Ocean and St. John's Harbour.

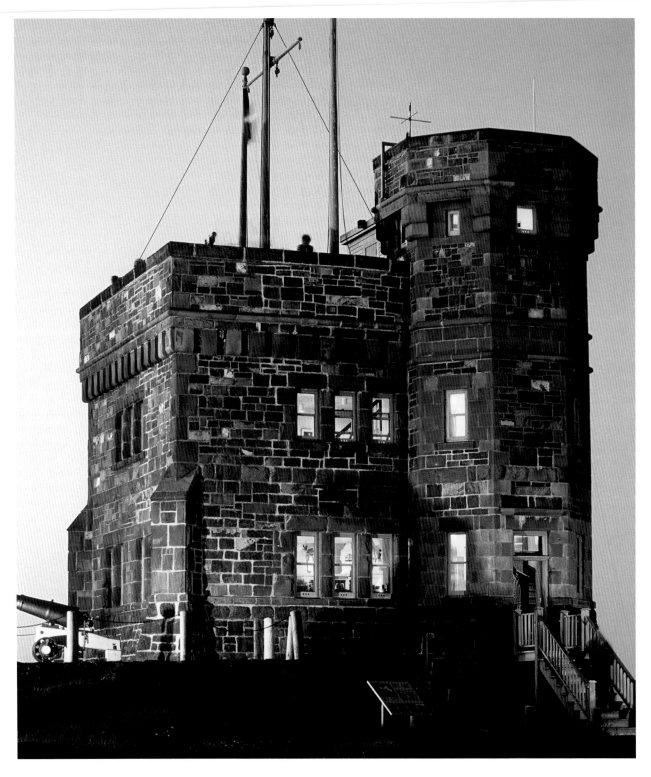

Signal Hill was part of the British signalling system. It was here, in 1901,
that Guglielmo Marconi received the first transatlantic wireless signal.

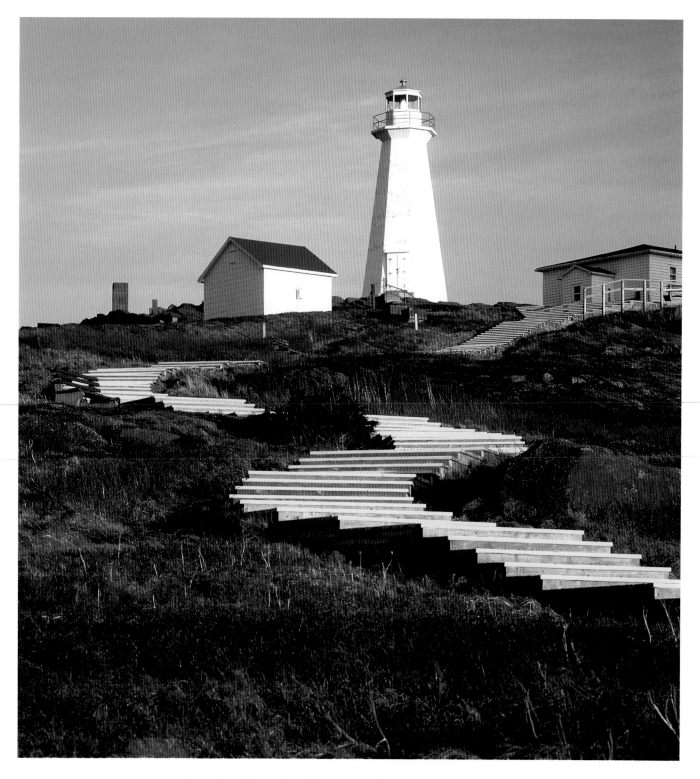

Cape Spear, located six kilometres southeast of St. John's Harbour,
is the most easterly point of land in North America.

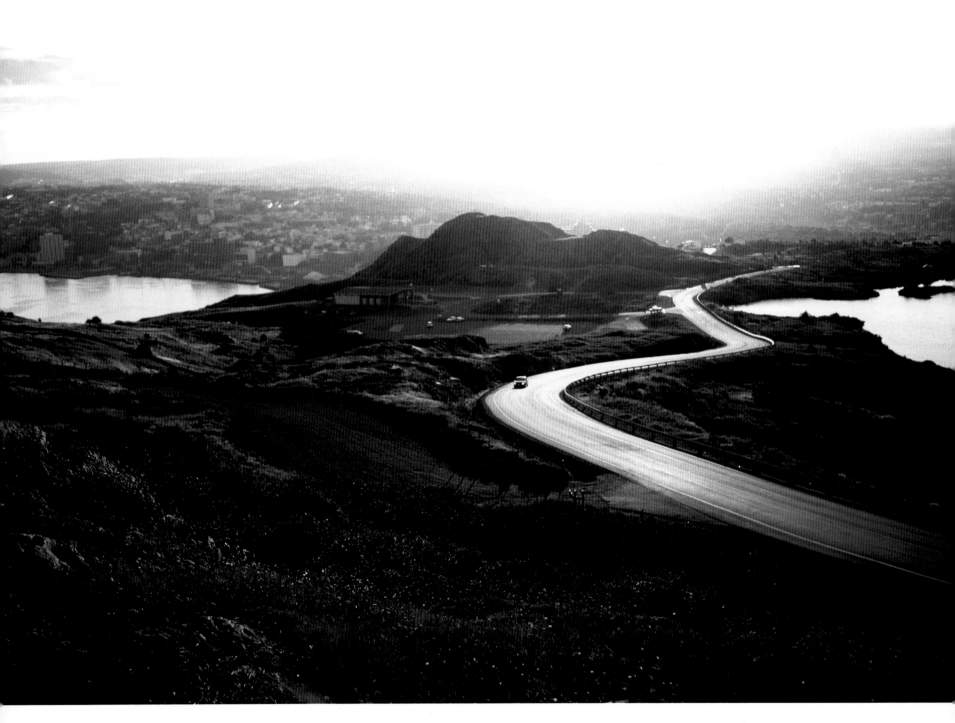

Signal Hill Road is a ribbon of light as the sun
sets over St. John's in the background.

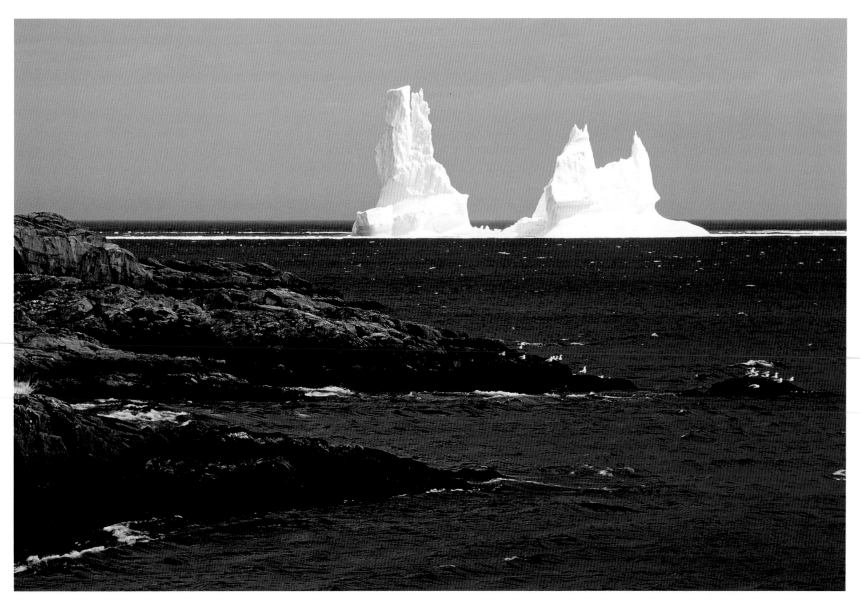

The icebergs that flow past Newfoundland come from Greenland.
Up to 2,000 icebergs make it to the province each year.

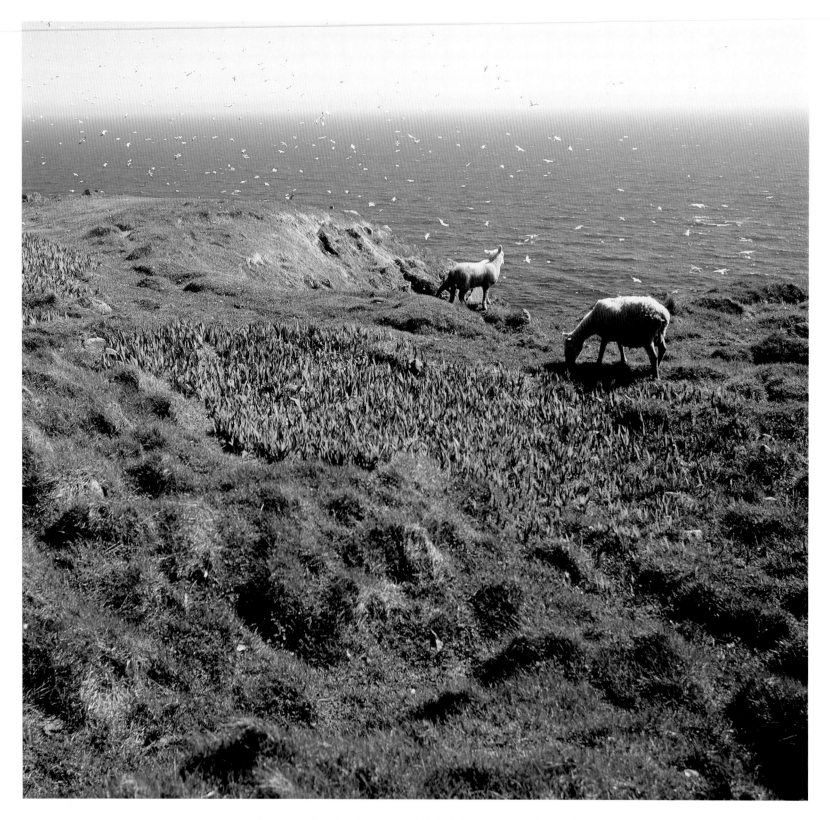

There are only a few sheep but 60,000 birds at the Cape St. Mary's
Ecological Reserve, a must-see destination southwest of St. John's.

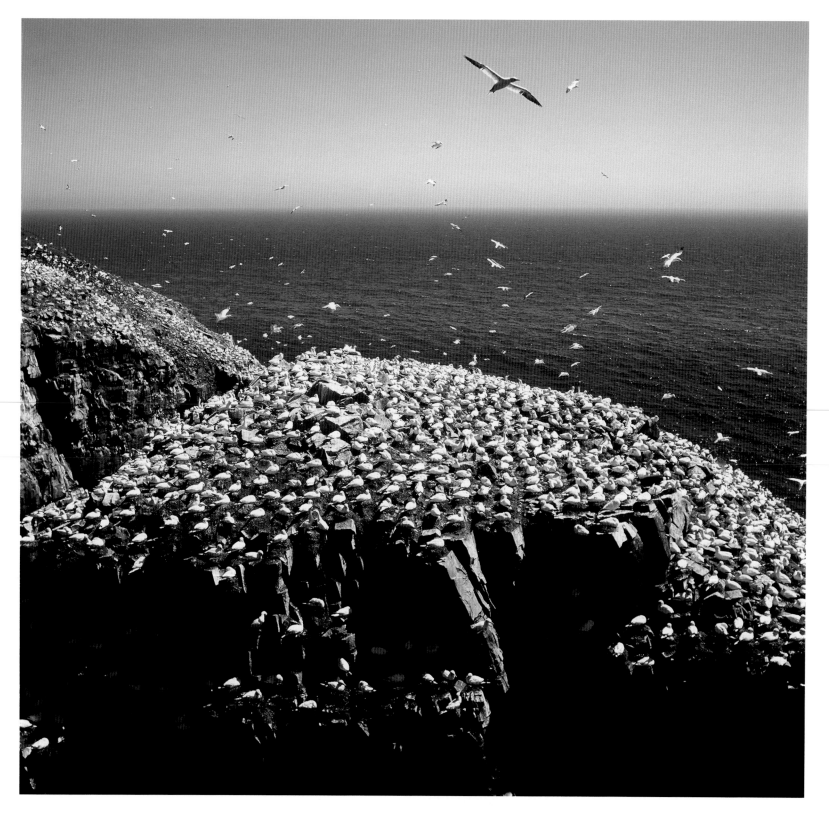

There are an estimated 12,000 northern gannets at the
Cape St. Mary's Ecological Reserve.

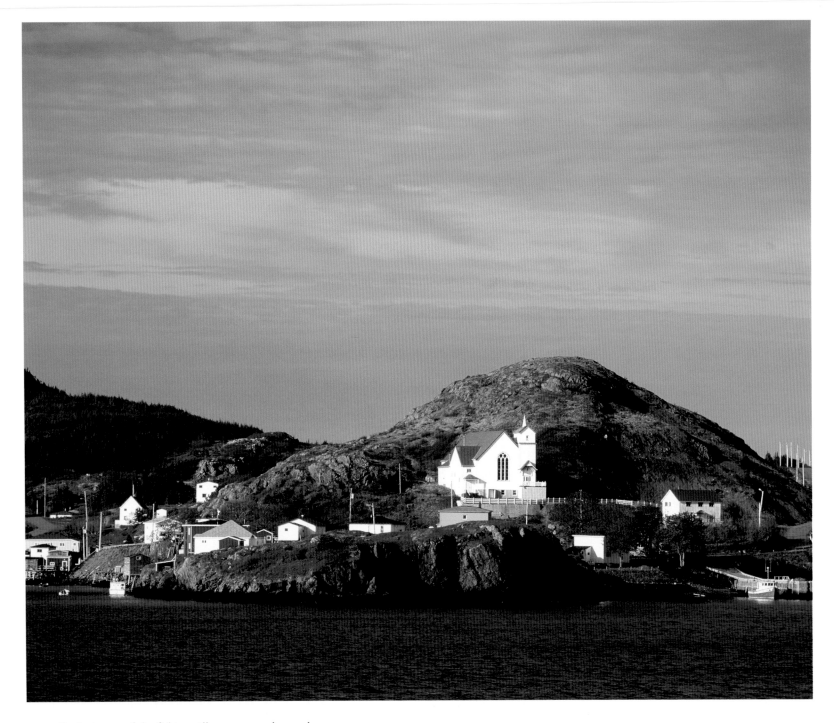

Burin is one of the fishing villages scattered over the
Burin Peninsula, a 200-kilometre stretch of land that
is sparsely populated.

Right: Terra Nova National Park offers more than
60 kilometres of hiking trails and is a good place for
family camping.

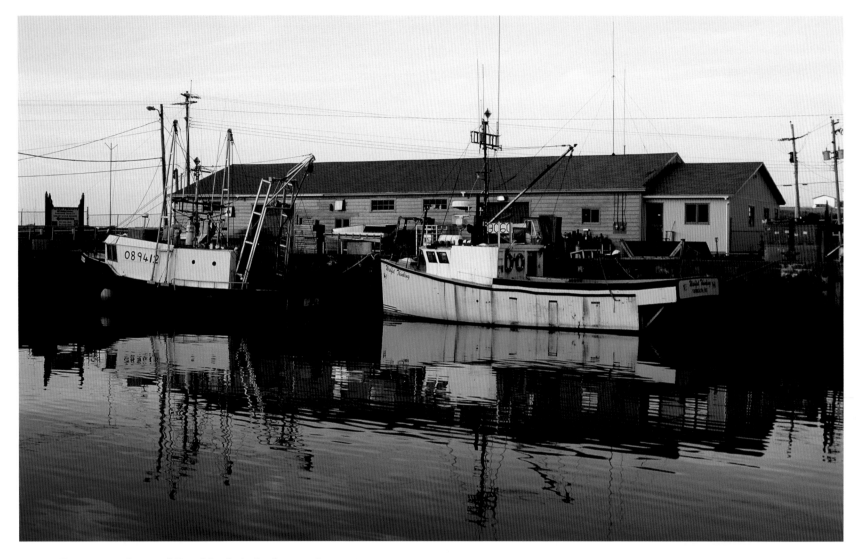

Fortune, southwest of Grand Bank, is the ferry service terminus
to the French islands of St. Pierre and Miquelon.

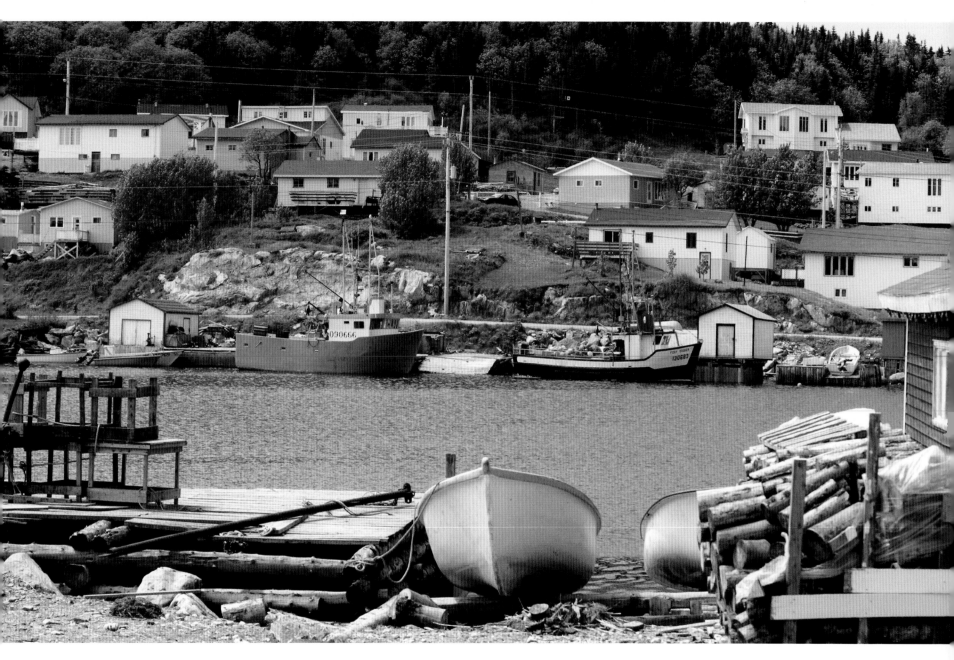

Englee, a small fishing village off the beaten track, is located south of St. Anthony in the Great Northern Peninsula.

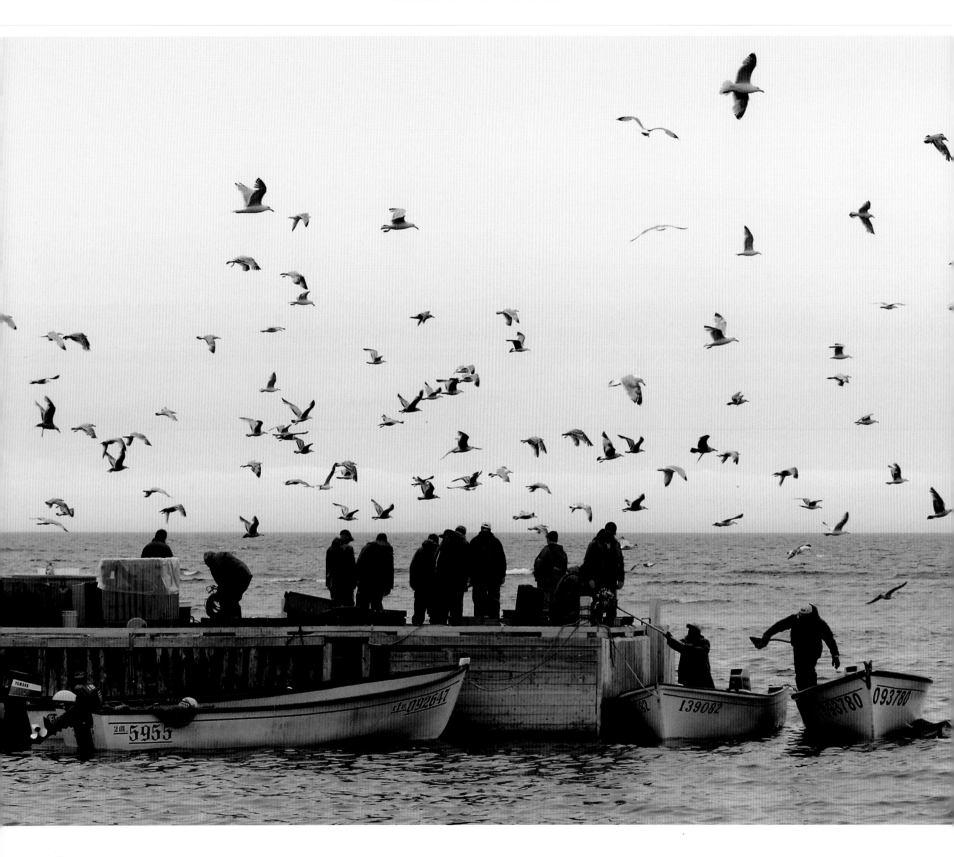

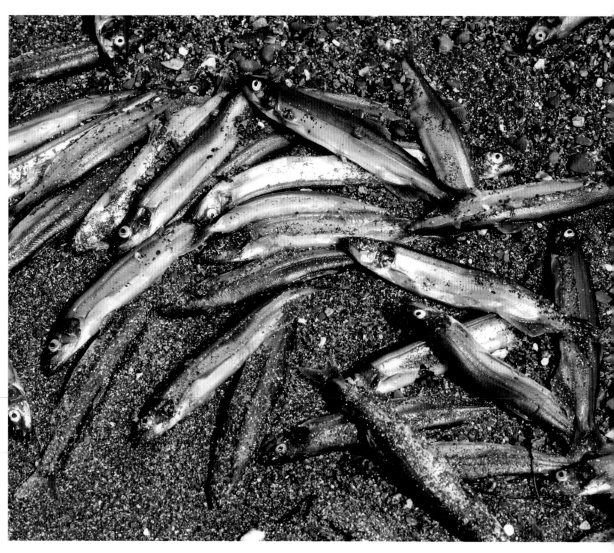

Capelin, photographed here in Raleigh, are an abundant source of food for both people and whales all around Newfoundland.

Left: Hundreds of gulls anticipate a feeding frenzy as fishers unload their catches of the day at Eddies Cove West, north of Port au Choix.

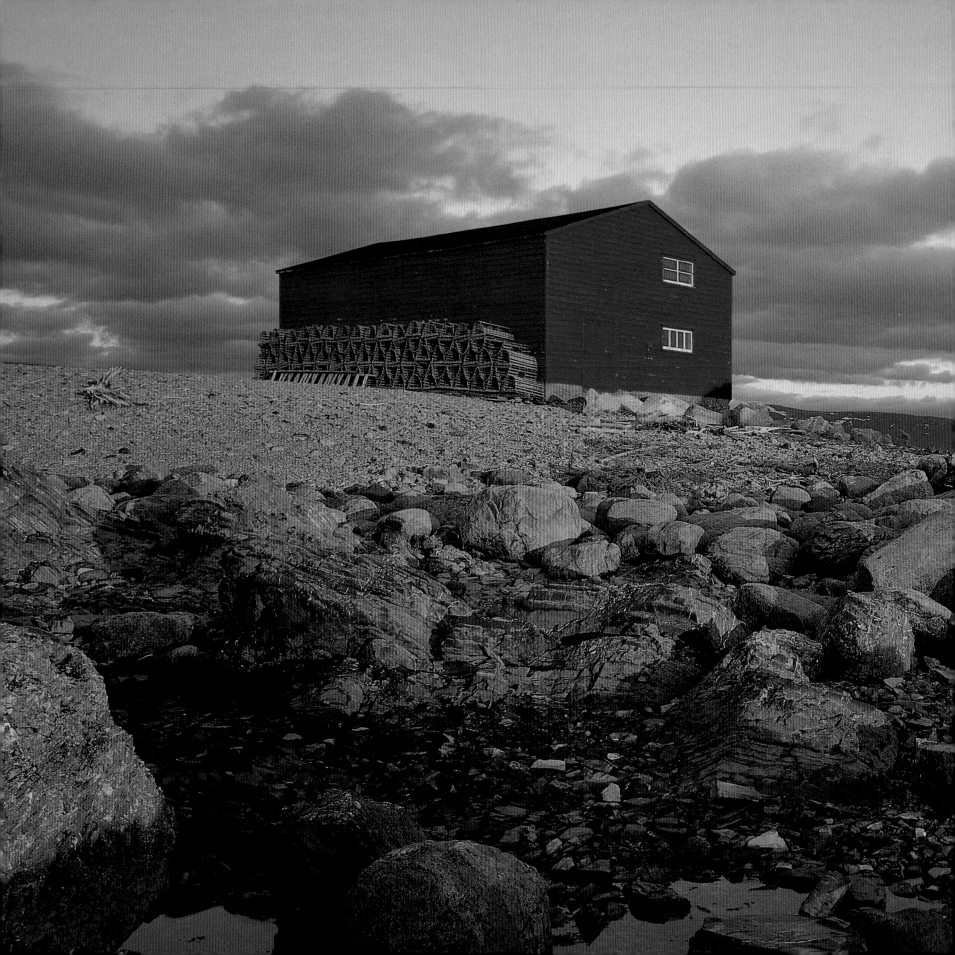

Broom Point became part of Gros Morne National Park in 1975, when the Mudge family sold it to the government. Today, the buildings have been restored and visitors can learn about the family's fishing operations there that spanned from 1941 through 1975.

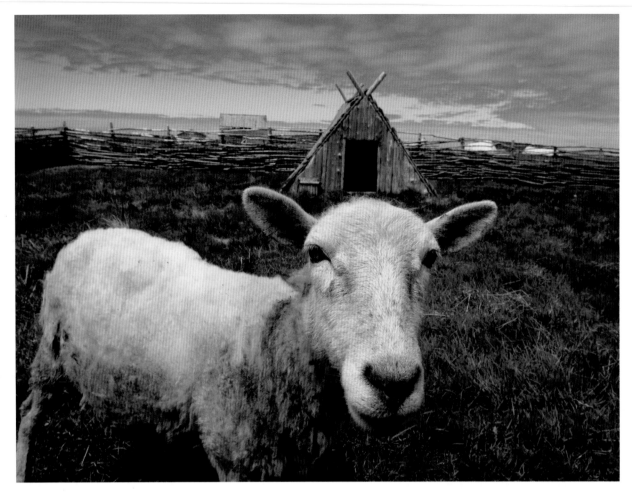

Norstead, a replica Viking village, and the nearby
L'Anse aux Meadows National Historic Site,
both commemorate the brief Norse settlement
some 1,000 years ago.

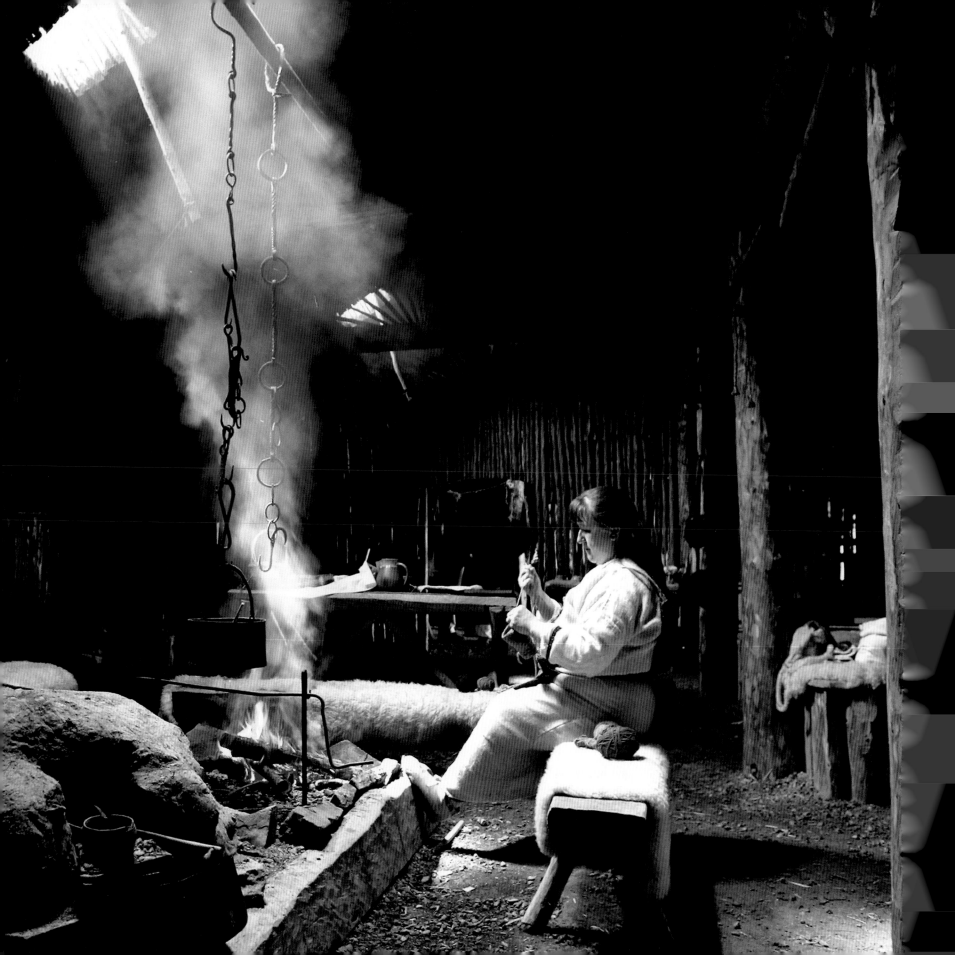

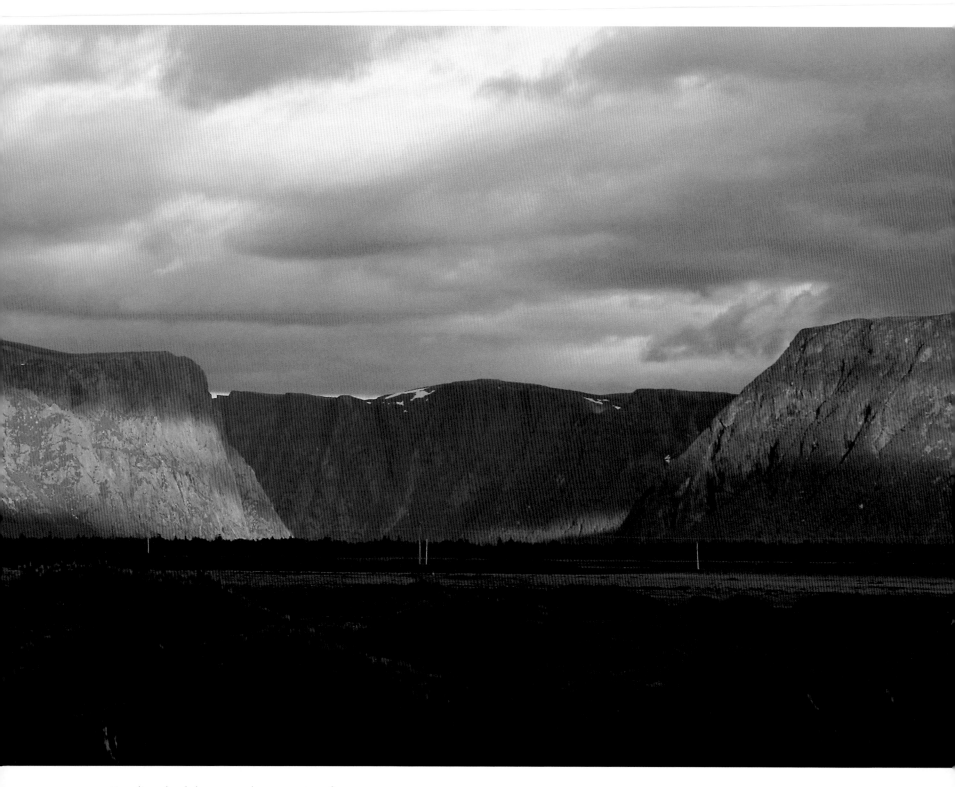

Brooding clouds hang over the mountains of
Gros Morne National Park which, in French, means
big (gros) and gloomy (morne).

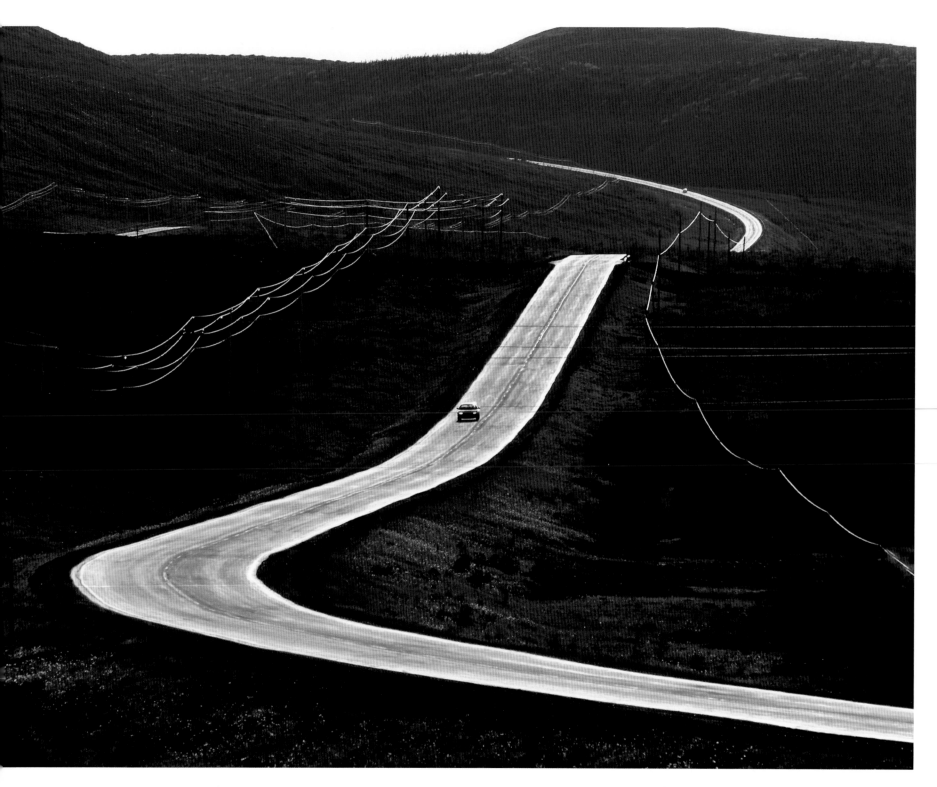

Tablelands, in the southern part of Gros Morne
National Park, once lay on the bottom of the ocean floor.
It was thrust to the Earth's surface by tectonic forces.

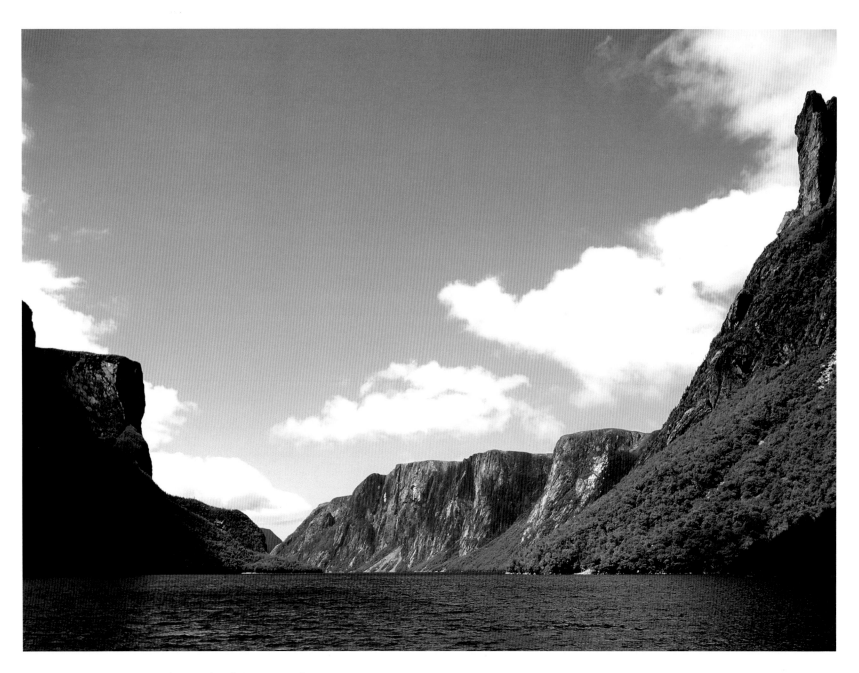

A trip to Gros Morne National Park is not complete
without a visit to one of its fjords — such as the
Western Brook Pond above. These beautiful sites were
carved by huge sheets of ice during the last ice age.

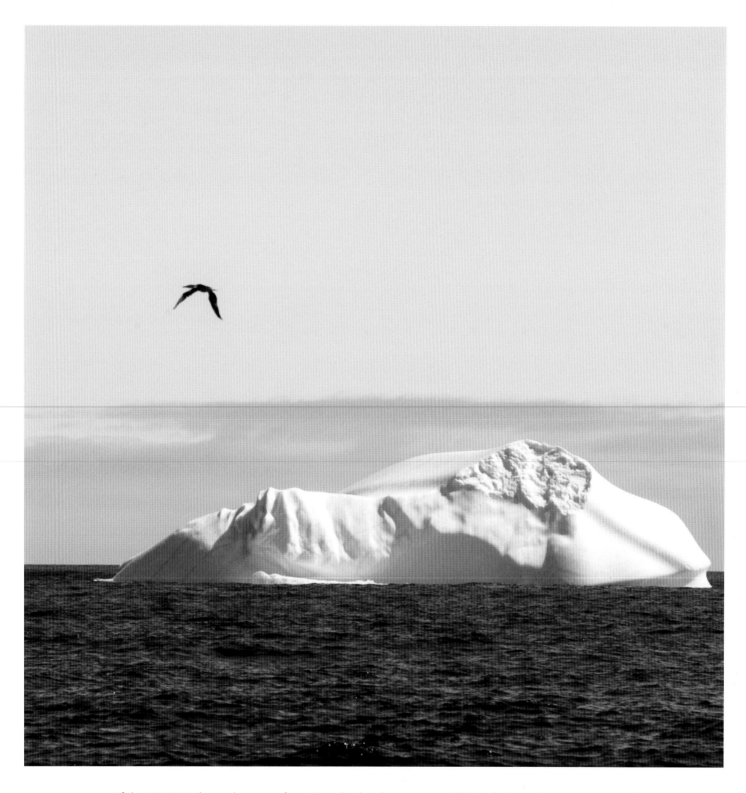

Of the 30,000 icebergs that come from Greenland each year, up to 2,000 make it to the warmer waters of Newfoundland. The best places to watch icebergs are southern Labrador and northern Newfoundland.

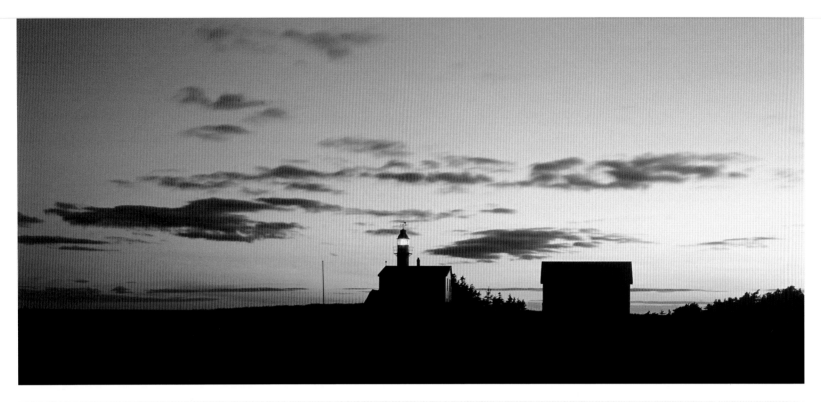

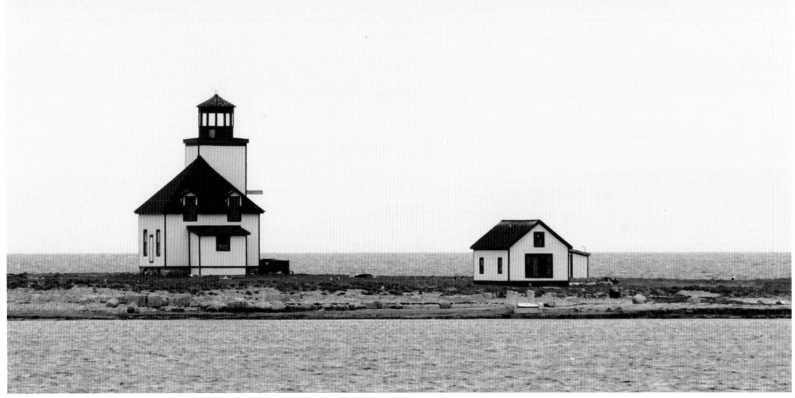

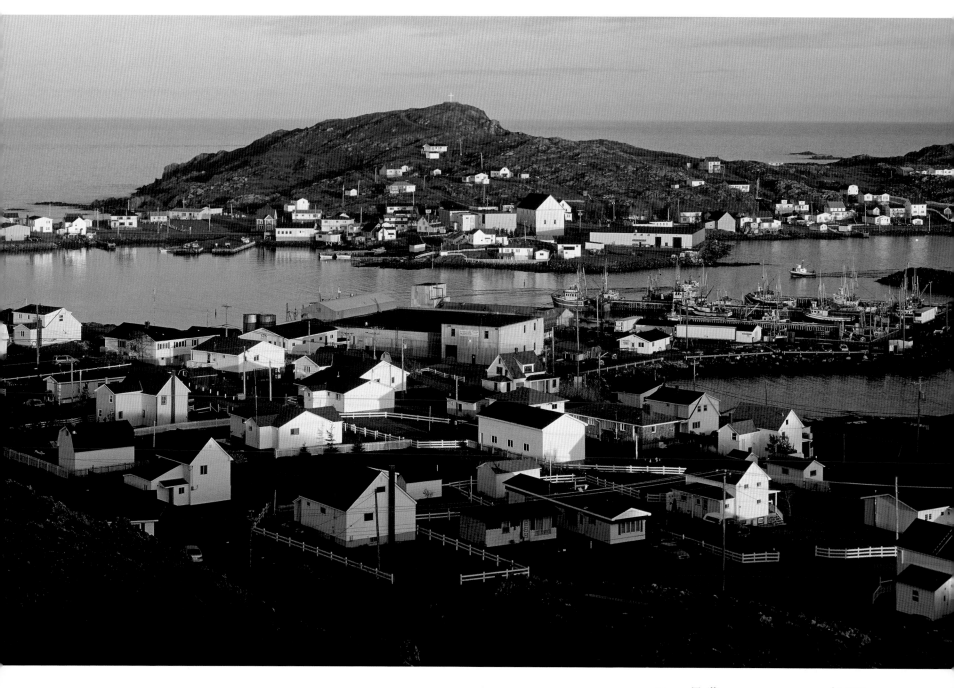

Above: Twillingate, a pretty town of 3,500, is a favourite place to watch icebergs.

Top left: The Lobster Cove Head Lighthouse marks the approach to Bonne Bay and Rocky Harbour.

Left: This unusual lighthouse is located in Flowers Cove, along the busy Viking Trail north of St. Barbe, the terminus for the ferry to Labrador.

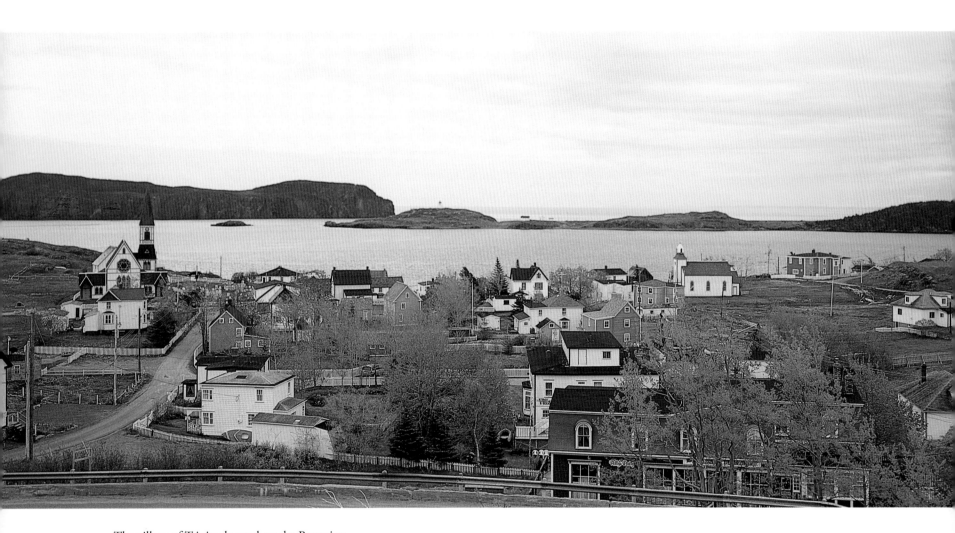

The village of Trinity, located on the Bonavista
Peninsula, is a popular tourist destination.

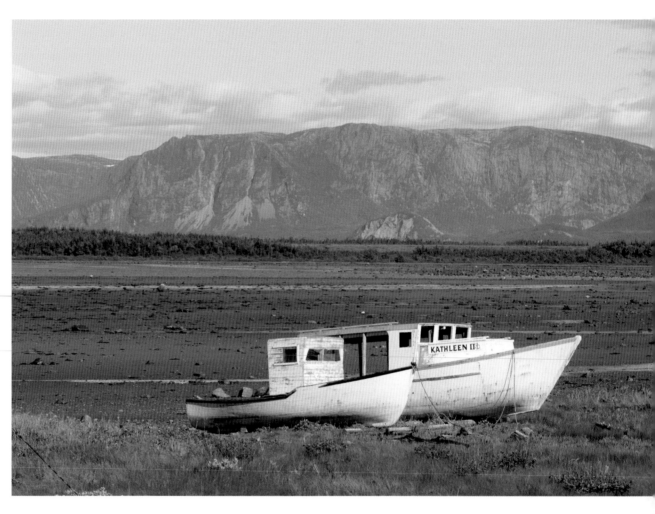

The Long Range Mountains form a backdrop for these
two boats at Parson's Pond, just north of Gros Morne.

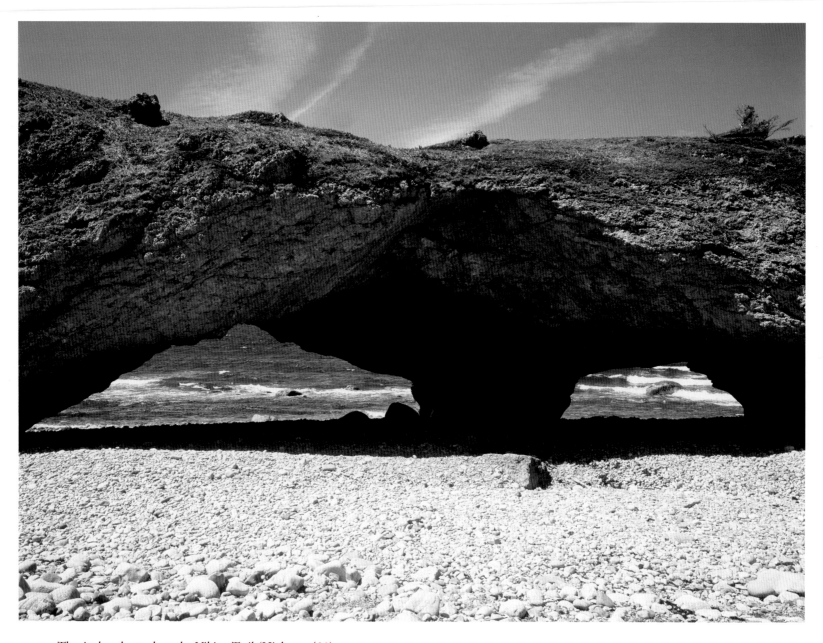

The Arches, located on the Viking Trail (Highway 430) just north of Gros Morne National Park, are the result of rocks constantly eroded by the waves.

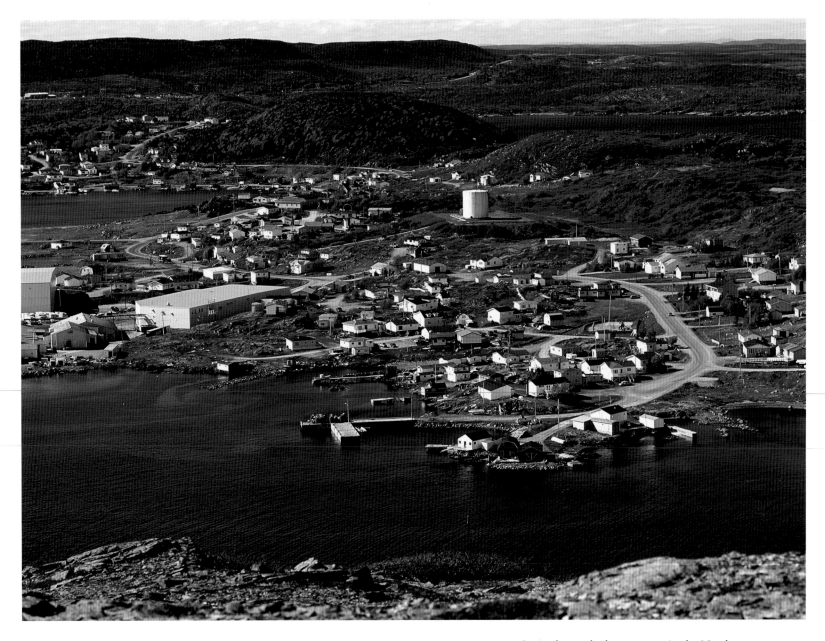

St. Anthony, the largest town in the Northern Peninsula, is seen in this bird's eye view from Fishing Point Head.

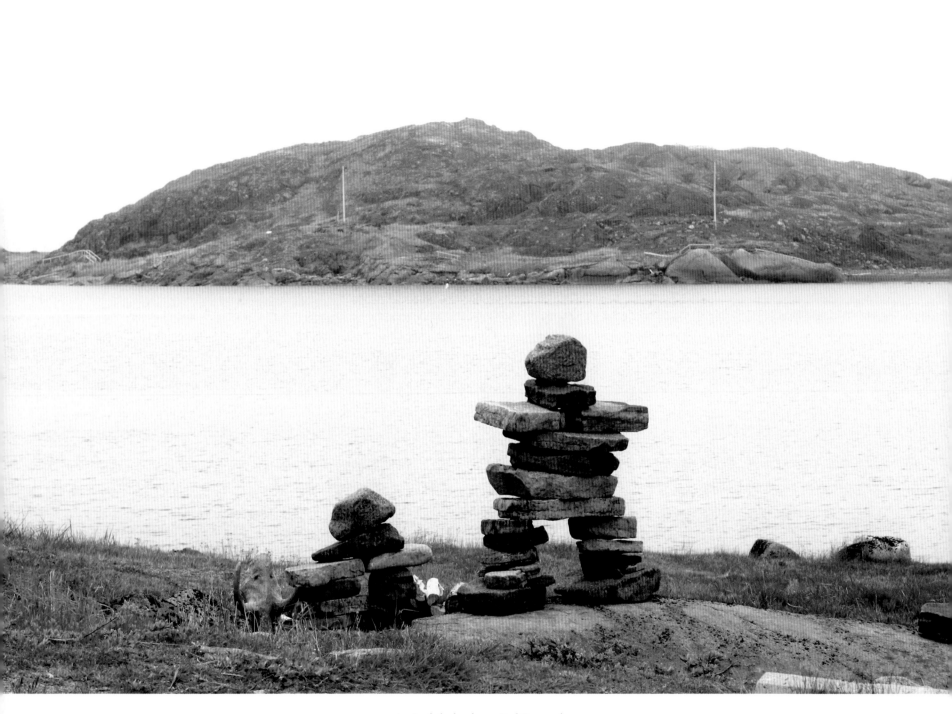

An Inukshuk adorns Red Bay at the
Strait of Belle Isle in Labrador.

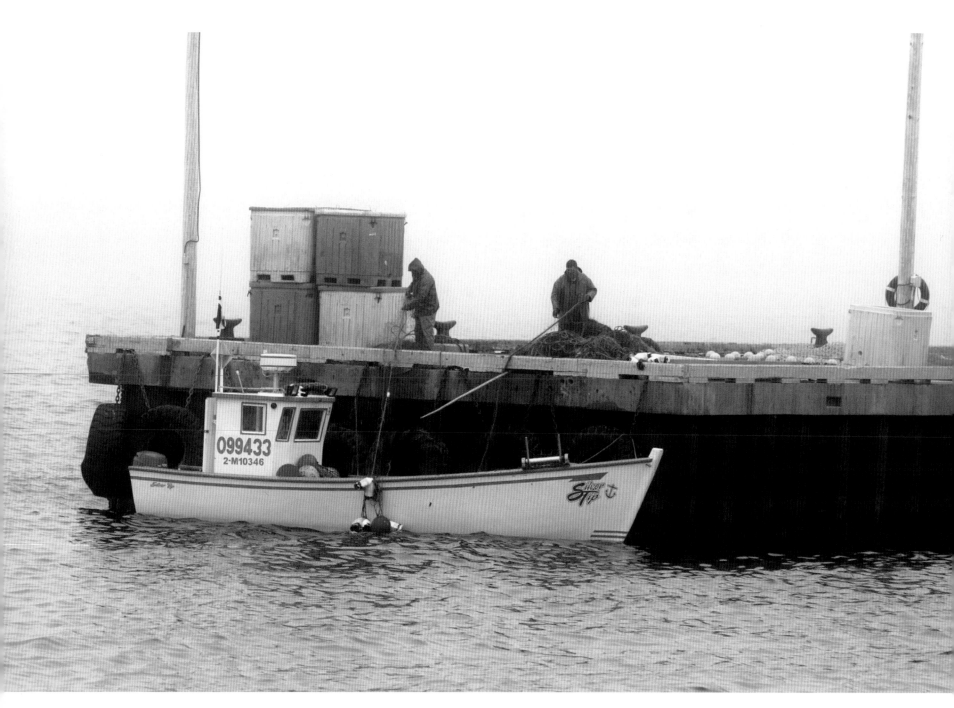

The cold and foggy weather doesn't stop these fishermen
at L'Anse-au-Loop in Labrador.

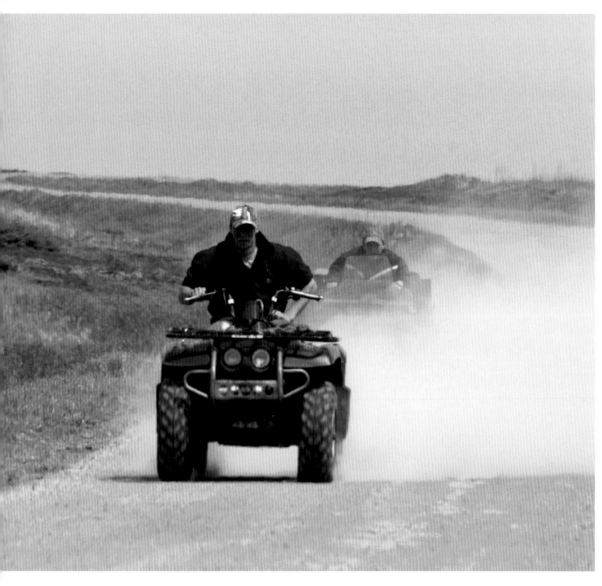

All-terrain vehicles are a good means of transportation in the sparsely populated areas of Labrador.

Right: Labrador's Red Bay was a Basques whaling station between 1540 and 1610.

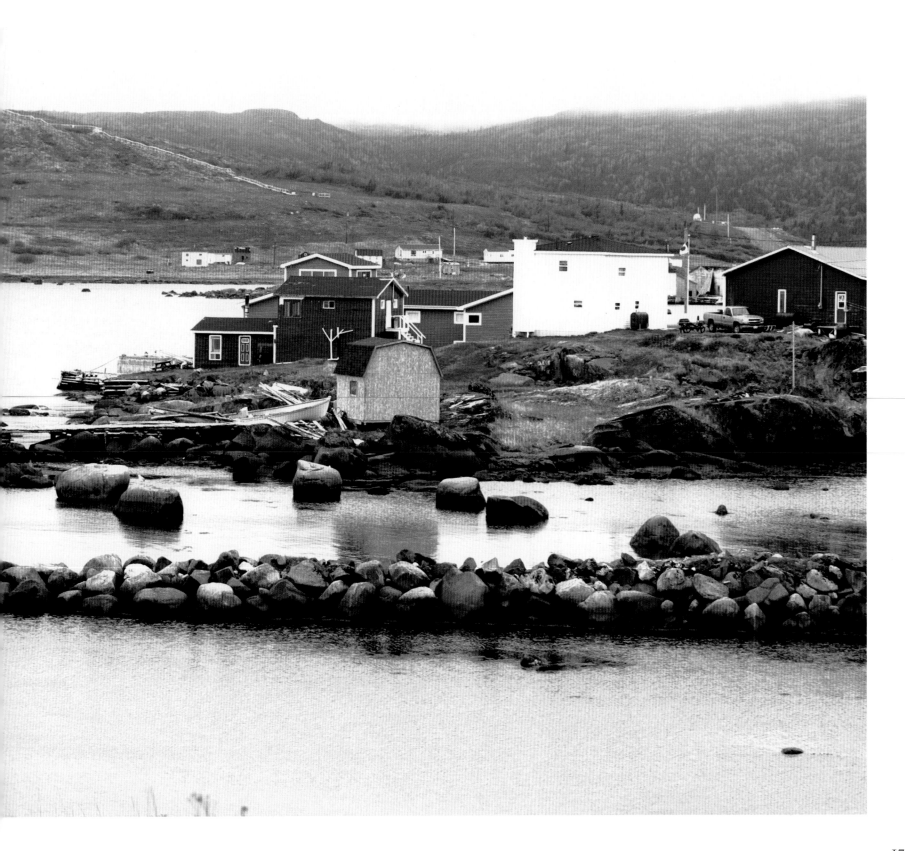

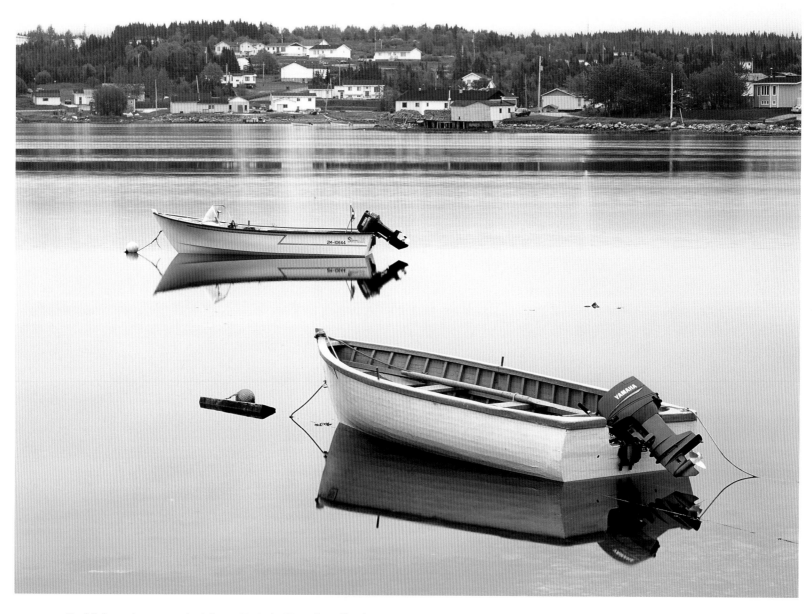

Roddickton, known as the Moose Capital of Newfoundland,
is also a photogenic town.

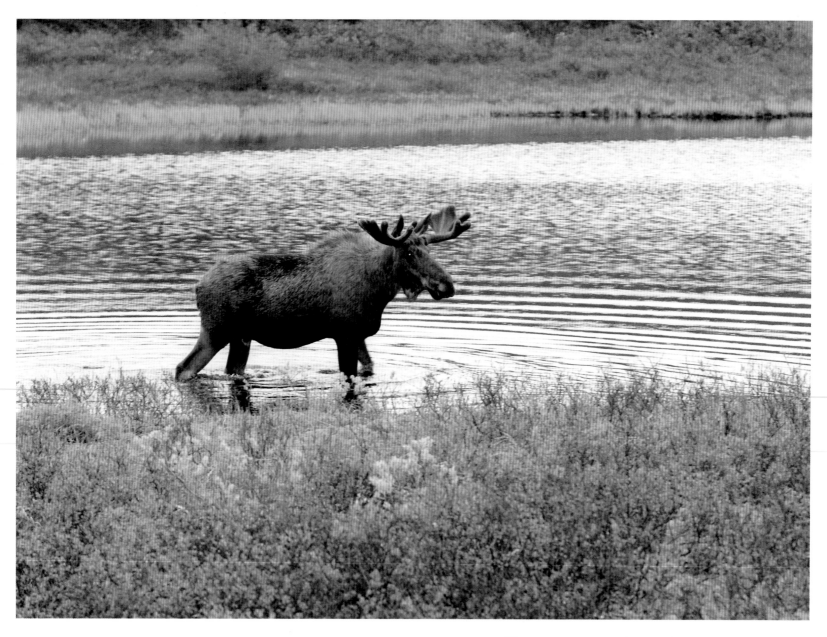

There are more moose than people in the sparsely populated regions of Newfoundland. The Island's 150,000 moose are descendants of the dozen imported from New Brunswick and Nova Scotia in the 1800s.

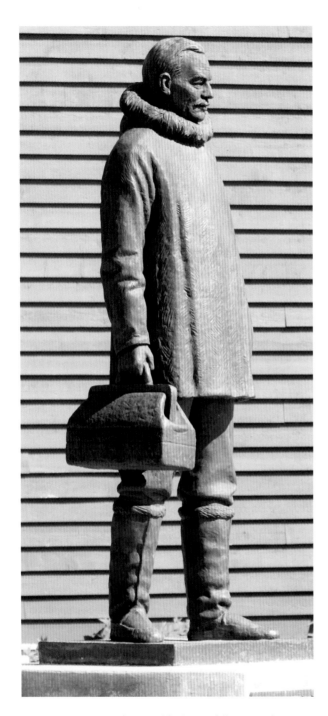

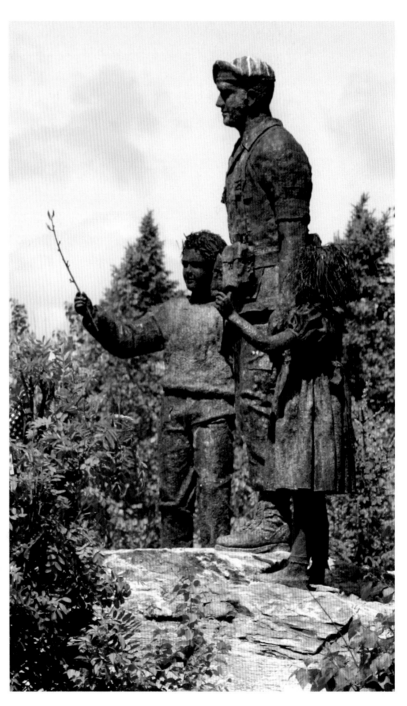

The statue of Dr. Wilfred Grenfell, a British medical missionary, stands tall at the Grenfell Interpretation Centre in St. Anthony.

The Silent Witness Memorial in Gander commemorates the 248 U.S. soldiers who were killed in a plane crash here in 1985.

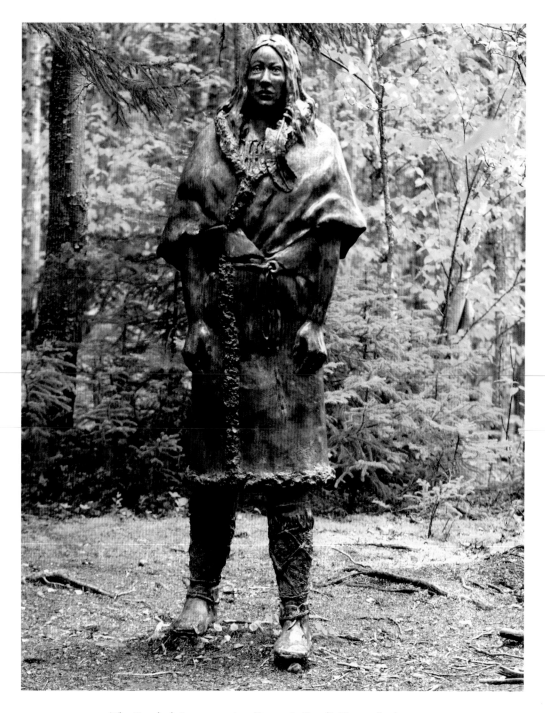

The Beothuk Interpretation Centre in Boyd's Cove tells the story
of Newfoundland's Beothuk Aboriginals. The last of the Beothuck
died in St. John's in 1829.

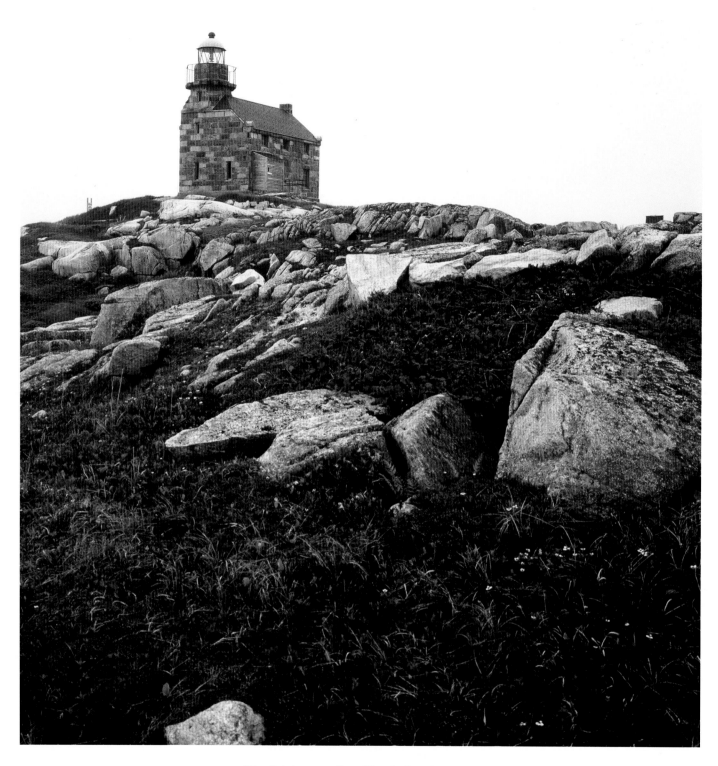

The lighthouse at Rose Blanche is unique —
its exterior walls are made of granite.

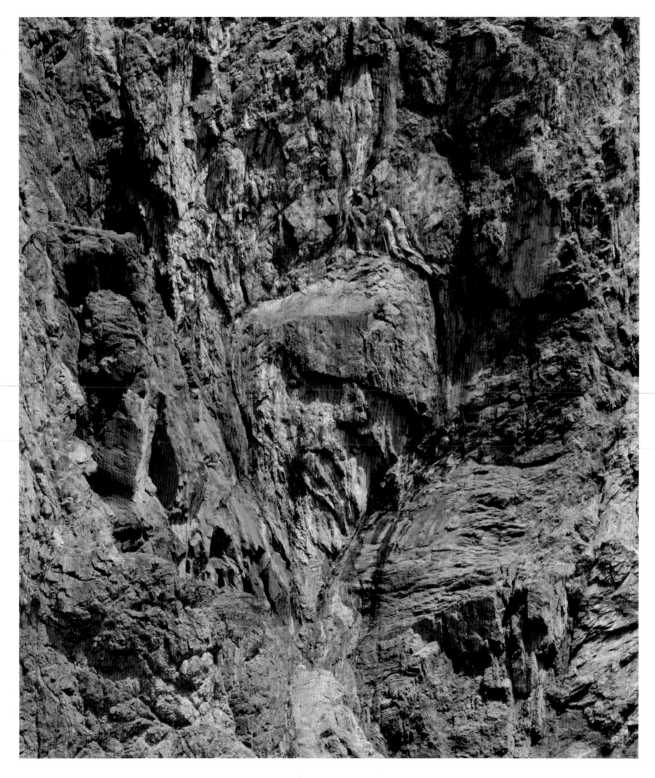

There is a face here somewhere, at
The Old Man in the Mountain in Corner Brook.

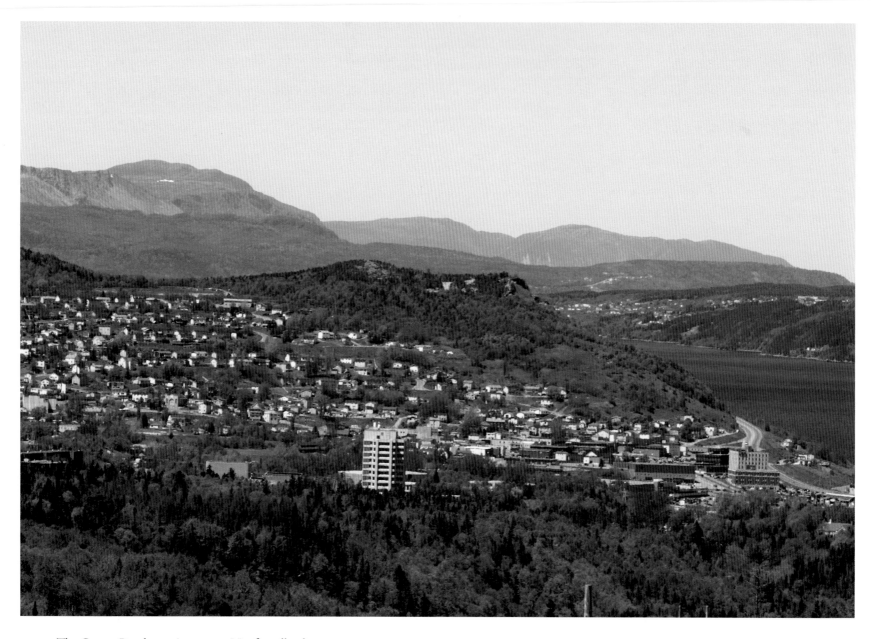

The Corner Brook area in western Newfoundland
is the province's second-largest municipality with more
than 44,000 people.

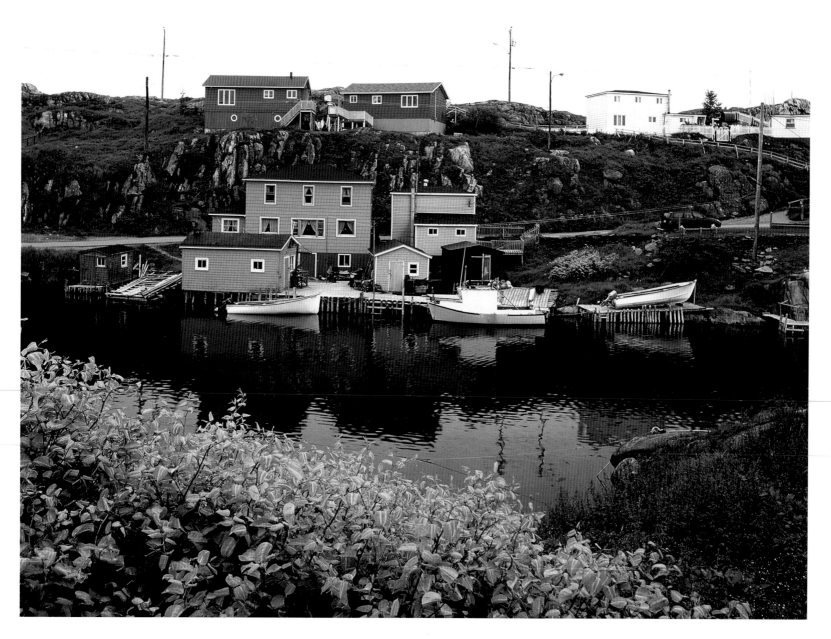

Rose Blanche is a rugged but colourful fishing village
located on the southwest coast, east of Port aux Basques.

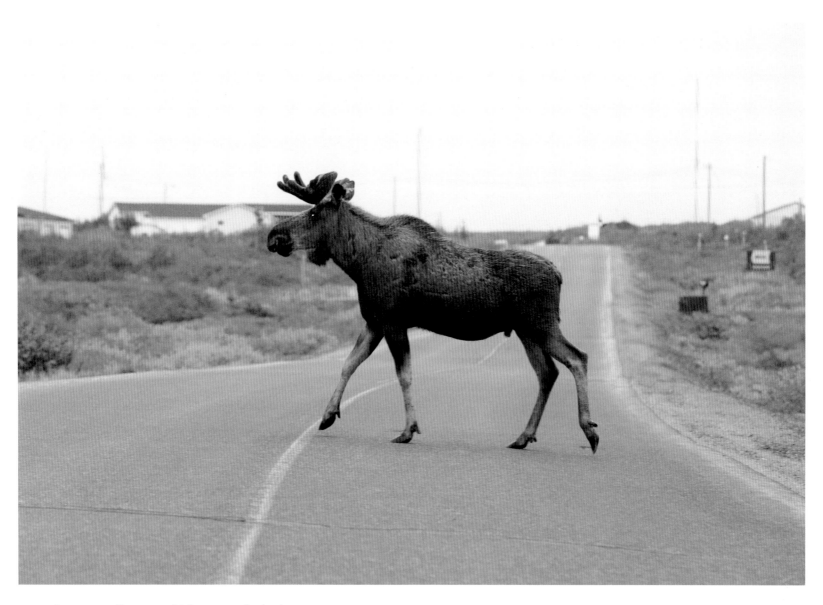

A moose strolls across a highway near Straitsview,
north of St. Anthony.

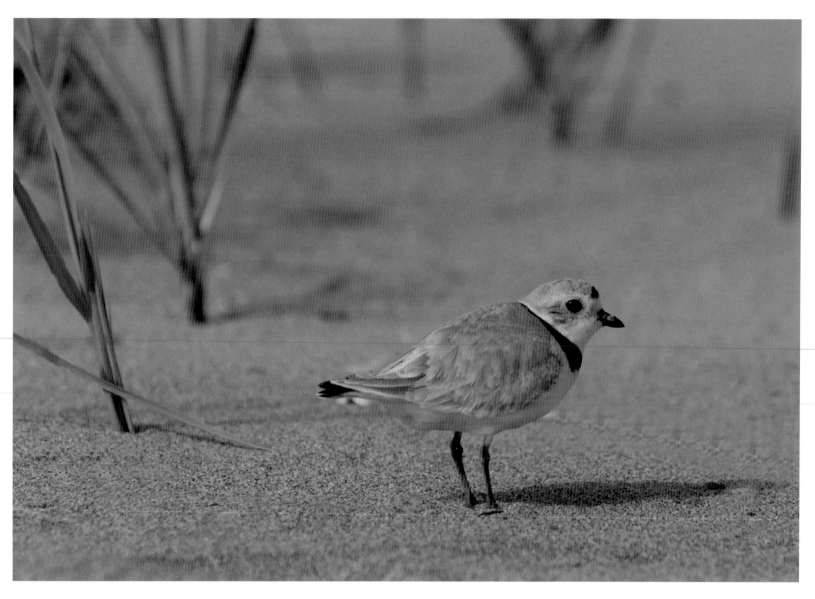

The endangered piping plover, like this one, make themselves at home at J. T. Cheeseman Provincial Park in Port aux Basques.

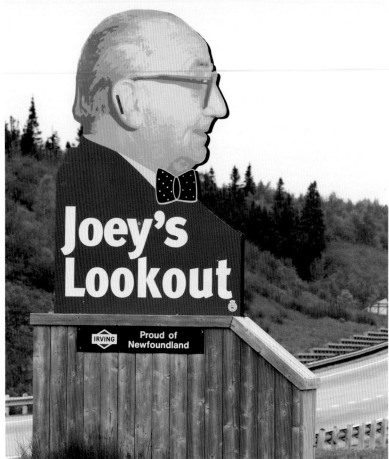

Above: Wildlife officials know how to deal with nuisance bears.

Top right: Joey Smallwood, the man who led Newfoundland into Canadian Confederation in 1949, keeps watch over Gambo, his hometown.

Right: Warning signs like this are everywhere because some 400 vehicle-moose collisions occur in Newfoundland each year.

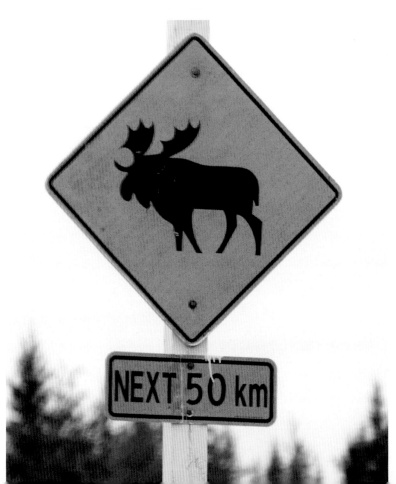

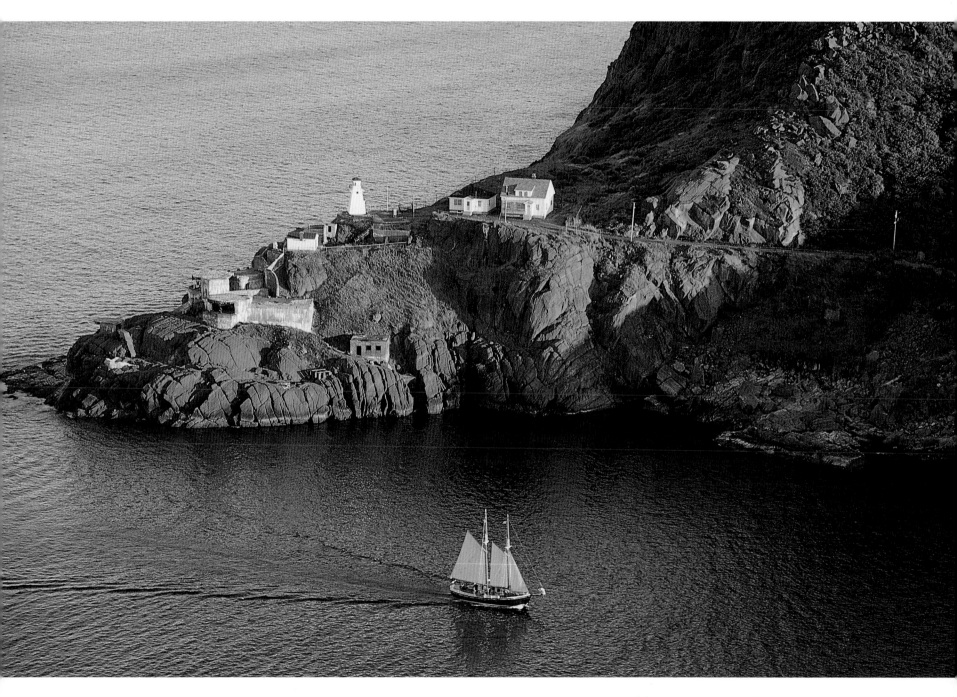

All boats going into St. John's Harbour
must pass through the Narrows between
the South Side Hills (top) and Signal Hill.

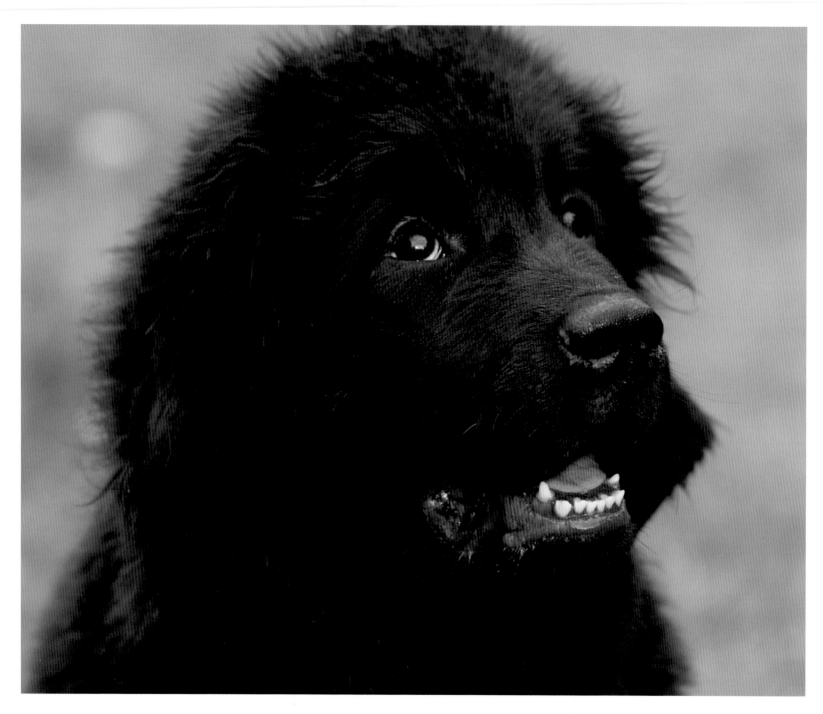

The large Newfoundland dog is a strong swimmer and a fine show dog.

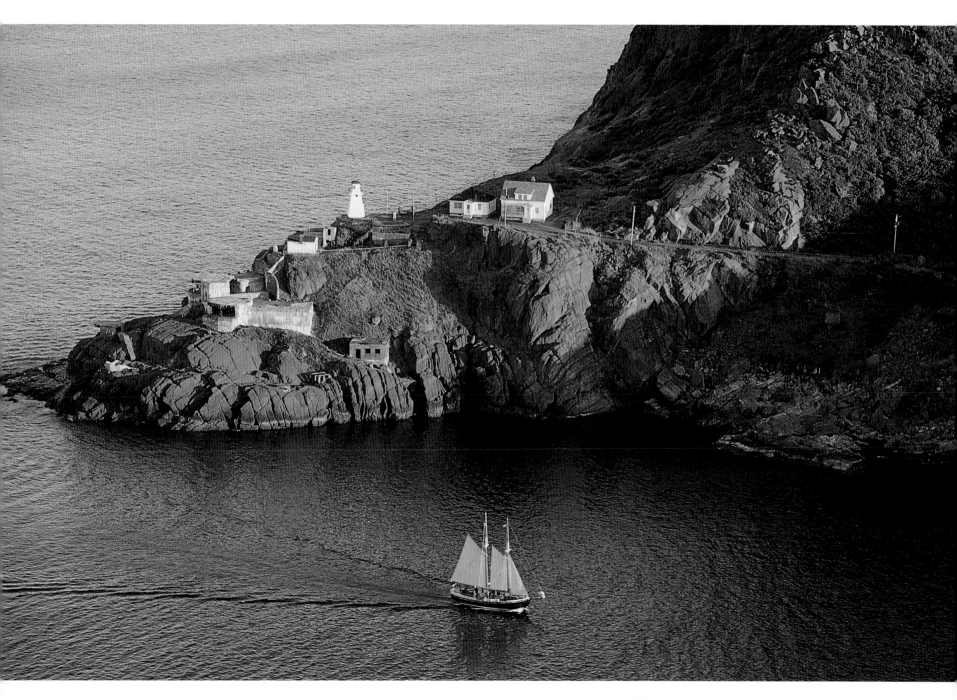

All boats going into St. John's Harbour
must pass through the Narrows between
the South Side Hills (top) and Signal Hill.

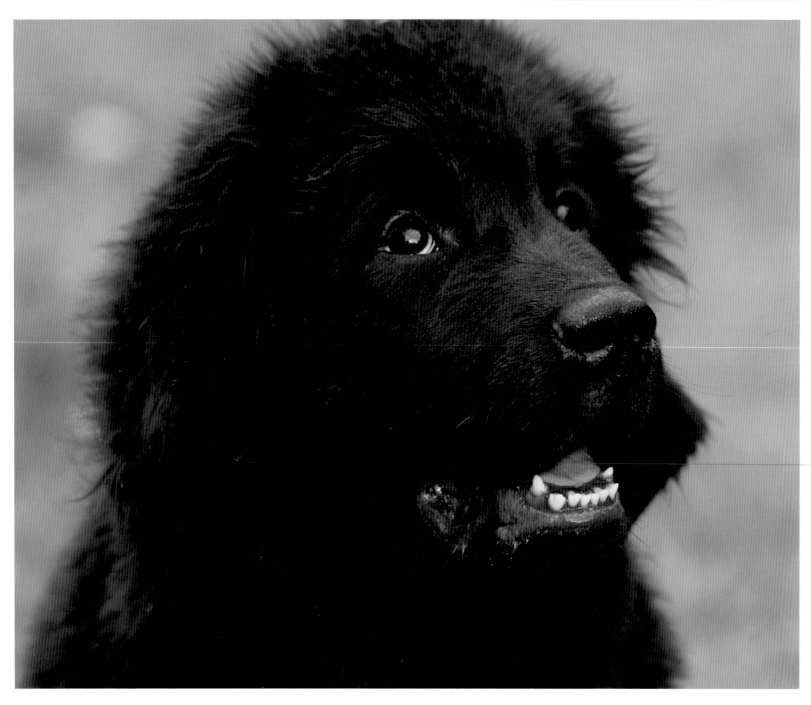

The large Newfoundland dog is a strong swimmer and a fine show dog.

Index